Studies in the History of Art
Published by the National Gallery of Art,
Washington

This series includes: Studies in the History of
Art, collected papers on objects in the
Gallery's collections and other art-historical
studies (formerly Report and Studies in the
History of Art); Monograph Series I, a
catalogue of stained glass in the United States;
Monograph Series II, on conservation topics;
and Symposium Papers (formerly Symposium
Series), the proceedings of symposia sponsored
by the Center for Advanced Study in the
Visual Arts at the National Gallery of Art.

*Forthcoming

Nationalism in the Visual Arts

STUDIES IN THE HISTORY OF ART · 29 ·

Center for Advanced Study in the Visual Arts

Symposium Papers XIII

Nationalism in the Visual Arts

Edited by Richard A. Etlin

National Gallery of Art, Washington

Distributed by the University Press of New England

Hanover and London 1991

Editorial Board
DAVID A. BROWN, *Chairman*
DAVID BULL
NICOLAI CIKOVSKY, Jr.
HENRY A. MILLON
CHARLES S. MOFFETT

Editor
CAROL ERON

Copy Editor
LYS ANN SHORE

Designer
CYNTHIA HOTVEDT

Editorial Assistants
AMY WOODS, SOPHIA H. SEIDNER

Distributed by the University Press of New England, 17½ Lebanon Street, Hanover, New Hampshire 03755

Abstracted by RILA (International Repertory of the Literature of Art), Williamstown, Massachusetts 01267

Proceedings of the symposium, "Nationalism in the Visual Arts," sponsored by the Center for Advanced Study in the Visual Arts, National Gallery of Art, and the Department of the History of Art, Johns Hopkins University, 16-17 October 1987

ISSN 0091-7338
ISBN 089468-176-1

This publication was produced by the Editors Office, National Gallery of Art, Washington Editor-in-chief, Frances P. Smyth

The type is Trump Medieval, set by VIP Systems, Inc., Alexandria, Virginia

The text paper is 80 pound LOE Dull Printed by Collins Lithographing, Inc., Baltimore, Maryland

Frontispiece, page 14: "Il disegno della geografia moderna de tutta la provincia de la Italia," 1561, detail, from A. Lafréry, *Geografia: Tavole moderne di geografia de la maggior parte del mondo . . .* , Rome [1575?]. Library of Congress

Contents

Preface

Between 1982 and 1989, the Center for Advanced Study in the Visual Arts and the Department of the History of Art at Johns Hopkins University cosponsored an annual symposium to address broad issues in the history of art and related disciplines. This publication contains the papers presented at the seventh of these joint gatherings, a symposium on "Nationalism in the Visual Arts" held at Johns Hopkins in October 1987.

The symposium was intended to explore the ways in which art and architecture have been used by politicians and artists to promote or define national identity. Although nationalism is traditionally viewed as a phenomenon and concept of the modern era, a somewhat broader perspective was taken here to consider notions of national identity and their expression in and through the visual arts from sixteenth-century Italy to the United States between the two world wars. The revolutions and counterrevolutions of the nineteenth century provided fertile ground for competing notions of the na-

tional and the traditional, some of which are addressed in the assembled papers.

The Center for Advanced Study and Johns Hopkins are grateful to Richard A. Etlin for agreeing to prepare the papers for publication and to write the introduction to the volume. The Center also would like to express its appreciation to the Arthur Vining Davis Foundation for making its part of these cosponsored gatherings possible.

This is the fourth volume to appear within the symposium series of Studies in the History of Art documenting a scholarly gathering held under the auspices of the Center for Advanced Study and Johns Hopkins University. Future volumes will contain the papers presented at additional meetings sponsored with Johns Hopkins and other sister institutions.

HENRY A. MILLON
Dean, Center for Advanced Study in the Visual Arts

Introduction

Covering a wide range of periods, artistic media, and themes, the papers in this volume when considered as a whole share a common belief that issues of national identity have been crucial to the creation of art in a variety of circumstances. As this volume goes to press, dramatic changes throughout Europe — the fall of Communism in Eastern Europe; the reunification of Germany; the ethnic tensions in Yugoslavia; the threatened dissolution of the Union of Soviet Socialist Republics according to national and ethnic lines; and the reconsideration of the nature of national identity throughout the Common Market with the approach of the economic union of 1992 — lend an immediacy to the issues raised by these papers.

It is not surprising that five of the seven papers deal with aspects of nationalism that informed the arts during the period ushered in by the romantic revolution. From the late eighteenth and early nineteenth centuries onward, the search for national identity in the creation of contemporary art was a widespread goal. Perhaps Renate Prochno's essay, "Nationalism in British Eighteenth-Century Painting: Sir Joshua Reynolds and Benjamin West," presents an early instance of what might be called the nationalist imperative in the arts in the aftermath of the romantic movements. Historians of architecture have noted that the Gothic revival in England toward the middle of the eighteenth century was associated in part with the expression of national identity;[1] in her study of British painting, Prochno explores the degree to which issues of national pride and identity informed the rivalry between Reynolds and West in the fields of portrait and history painting. Using Joseph Warton's lament of 1764 — "I cannot forbear wishing, that our writers would more frequently search for subjects in the annals of England" — as a point of departure, Prochno discusses the careers of these two painters within the context of the rise of both the Royal Academy and the new literary genre in England, the art review.

The one paper that does not at all belong to the romantic era, Charles Dempsey's "National Expression in Italian Sixteenth-Century Art: Problems of the Past and Present," may prove, beyond its merits as art-historical scholarship, to be the most important for the cultural issues resulting from today's dissolution of nation states. The paradox to which Dempsey refers in his opening lines, about beginning this volume with a paper on a country that did not acquire national political identity until three hundred years later, holds a further irony at this time when the conditions of regional identity that he discusses seem ready to re-emerge throughout Europe. Journalist John Ardagh has observed that "as Europe integrates and the power of the nation-state wanes, individual regions from Scotland to Andalusia will increasingly come into their own, and regional patriotism will find pow-

erful new outlets. 'Loyalty to the region,' claims Pascal Motte, of the Winners Club [Club des Gagnants in the region of Nord-Pas-de-Calais, France], 'is today more important than national loyalty.' "[2] Dempsey in his paper explores the differences and rivalries between regional schools of sixteenth-century Italian art within the context of a shared identification with a national culture. Dempsey situates his study of the visual arts within the context of regional cultural politics that included, for example, the promotion of regional dialects. The success of Vasari's *Lives*, sponsored by the new Accademia Fiorentina, has its equivalent in the primacy to this day of Tuscany in Italian language and literature. Yet there is also a significant difference. Whereas Vasari distinguished between a superior Florentine and an inferior Venetian art, "it is with the Carracci that for the first time we find clearly stated a concept of regional schools, and regional excellences—the Florentine, the Roman, the Venetian, and finally their own Lombard school," Dempsey maintains, stressing the synthetic and hence national cultural expression that the Carracci forged from the accomplishments of the regional schools. The current state of affairs in Europe suggests that the arts will have a new opportunity to recreate a dynamic balance between regional and national identities.

Of the papers devoted to nineteenth- and twentieth-century subjects, June Hargrove's "Shaping the National Image: The Cult of Statues to Great Men in the Third Republic" has the most in common with discussions of preromantic uses of art. Hargrove chronicles how republicans, monarchists, and Bonapartists used commemorative public statues to further their respective causes. Situating the practice of "recognizing individuals for accomplishment rather than birth" within the "same egalitarian philosophy in the Age of Enlightenment that fostered the Revolution," Hargrove examines the multiple purposes behind the erection of statues to great men and women in the Third Republic. Erected to honor the dead person and to stimulate emulation of his or her virtues or deeds among the living, these statues also were imbued with political messages only superficially masked by "an individual's apol-

itical fame." It was a question not only of a mode of government, but also of a related vision of culture. Positivism, secular education, and religious toleration were among the issues debated through the erection of the "150 statues of persons of merit" in the public spaces of Paris between 1870 and 1914. "The evolution of these public homages," Hargrove concludes, "incarnates the history of a nation forging its identity, wedding the past to the present in bronze and marble."

The four remaining papers raise issues central to the quest for a national style in contemporary art that was so important from the romantic revolution at least until World War II. In her study of Gerald Murphy and "Américanisme," Wanda M. Corn argues that it is not sufficient to speak of American art in the period between the two world wars in terms of style. Rather, from organic abstractionists to precisionists there was a common search for "an American voice." Corn explores the drive for "Americanness" in artists such as Alfred Stieglitz, Joseph Stella, and Gerald Murphy. While situating the desire to create American art within a nineteenth-century romantic tradition, Corn emphasizes that the period she is studying presents a particularly "virulent and pervasive" impetus in this direction. Corn provides multiple perspectives on her topic by considering subject matter and stylistic technique as well as American intentions and European commentary. At the same time she documents the cultural changes that were making life at that time seem functionally and symbolically different from that of past eras: "To write with a fountain pen, type a letter, or shave oneself with a safety razor marked one as progressive." These modern appurtenances were the subject matter of Murphy's painting, which Corn analyzes in the context both of the French version of that European myth about America as the civilization of modernity and of Murphy's self-conscious American persona and way of life in Paris.

Barbara Miller Lane, in "National Romanticism in Modern German Architecture," studies the strength of the Romanesque revival as a parallel to the better known neoclassical tradition in modern German architecture. Lane shows that the medievalism known today as "national roman-

ticism" featured prominently in the early phases of the romantic revolution and continued as an important index of national German identity throughout the nineteenth century and into the twentieth, reaching beyond the Nazi period. While tracing this trajectory and examining its variegated character, Lane also reevaluates the importance for Germany of H. H. Richardson's American brand of Romanesque revival architecture; she later postulates a link between German national romanticism and the so-called international style. "It is significant that [Franz] Roeckle initially sought for a radically new style in the most distant Germanic past, before turning to the solutions of the modernists. Apparently he saw no conflict between these two approaches to the avant-garde. For Roeckle, and perhaps for other architects of the Weimar Republic too, the international style represented a different way to realize a modern German architecture, through greater abstraction, rather than a repudiation of the national past."

This last point raises an issue shared with Nancy J. Troy's "Le Corbusier, Nationalism, and the Decorative Arts in France, 1900–1918" and my "Nationalism in Modern Italian Architecture, 1900–1940." Troy demonstrates that the young Le Corbusier came to appreciate the potential of late eighteenth- and early nineteenth-century French neoclassical decorative arts to serve as the basis for a modern French style through an abstraction, rather than literal copying, of its comparatively severe lines and forms. Likewise, as I have argued earlier and then again in my paper, the avant-garde Italian rationalists from the late 1920s onward sought to create a nationally based modern Italian architecture through the process of abstraction.[3] The prismatic forms so closely associated with the international style were arranged to carry clear references to a traditional Italian architectural heritage. I have also argued elsewhere that Le Corbusier similarly grounded his avant-garde villas of the late 1920s in French artistic traditions.[4] Now we can see that Le Corbusier had been thinking in these terms throughout the pre-

ceding decade while he was intensely involved in one of the most important design issues of his time, the nature and role of the decorative arts within a nationalist context of economic growth and cultural identity.

My paper in this volume traces the changing and pluralistic idea of modernity in Italian architecture and the decorative arts. Many of the successive movements treated here – which start with art nouveau, proceed to a modern vernacular coupled with Sittesque urban design, and pass first into a modern neoclassicism called the Milanese Novecento and then into Italian rationalism – present points of contact with those discussed by Lane and Troy. In her study of French decorative art and architecture, Troy notes that it is "particularly striking" that "vanguard artists felt compelled to claim allegiance to tradition and to describe their aims in the same nationalist terms used by the opponents of modern art." The scholarly study of the nationalist mind-set shared by architects and critics of all persuasions in the nineteenth and twentieth centuries has tended to emphasize the amazement felt at such discoveries. It is to be hoped that the three papers on modern architecture in this volume will help to integrate these findings into the mainstream of art-historical thought.

RICHARD A. ETLIN
University of Maryland

NOTES

1. Michel Baridon, "Ruins as a Mental Construct," *Journal of Garden History* 5 (January – March 1985), 88–94; Michael McCarthy, *The Origins of the Gothic Revival* (New Haven, 1987), 30–31.

2. John Ardagh, "Lille Gets Ready for '92," *New York Times Magazine* (3 December 1989), 96.

3. See Richard A. Etlin, "Italian Rationalism," *Progressive Architecture* 64 (July 1983), 86–94.

4. See Richard A. Etlin, "Le Corbusier, Choisy, and French Hellenism: The Search for a New Architecture," *Art Bulletin* 69 (June 1987), 264–278; and "A Paradoxical Avant-Garde: Le Corbusier's Villas of the 1920's," *Architectural Review* 181 (January 1987), 21–32.

MARE DI TOSCANA

CORSICA

CHARLES DEMPSEY
Johns Hopkins University

National Expression in Italian Sixteenth-Century Art:

Problems of the Past and Present

There is an obvious paradox in opening a volume devoted to the theme of nationalism in the visual arts with a paper on national expression in Italian art of the sixteenth century,[1] for Italy did not acquire national political identity until three hundred years later. Nevertheless, national cultural identity was a dominant concern of the sixteenth century, most famously appearing in the debates on the *questione della lingua* held in the literary academies of Italy, with the aim of defining common standards of language and literary expression for the whole of the peninsula. The same concern also manifested itself slightly later in the early academies of art, whose efforts were motivated by the similar desire to define universal standards for visual and plastic expression. A confusion of the shifting and constantly developing political and cultural concepts of national self-definition has been common in art-historical writing about the sixteenth and seventeenth centuries, and continues to appear, for example, in discussions about the centrality of Rome (and earlier, Florence) as set against the peripherality of Bologna (and earlier, Venice). The same confusion of differing and nonsynchronous concepts of national identity also appears in writing about related themes, such as the enduring classicism of the art of the capital as set against the simpler naturalism and provinciality of the art of the cities of north Italy, or the normative histories of art written by Vasari and Bellori as distinguished from the eccentric and biased *municipalismo* of Ridolfi and Malvasia. I will argue, however, that the true opposition is not so much one of center versus periphery as it is one between Tuscany and the States of the Church in the quest for national preeminence in visual culture. This lengthy contest was marked by two critical moments. The first occurred when the new style developed in the Papal States by Perugino, Francia, and the young Raphael — which Vasari named the final step in the progress of art before it at last reached perfection — was defeated in Rome by the Florentine modern manner of Michelangelo and the later, reformed Raphael. The second occurred, again in Rome, when the modern manner itself was defeated by a revival and sophistication of the humanly affective values inherent in that earlier regional style of the Papal States, achieved by the Carracci. Rome itself, for all its centrality, was not the site of cultural ferment. This took place instead in the workshops and academies of the contending regions; the conduits transmitting their discoveries and contending ideals to the ancient capital were the ancient post roads of the Via Cassia and the Via Flaminia, both of which led to Rome.

Thus, Giovanna Perini has remarked that the great biographer of the Bolognese artists, Count Carlo Cesare Malvasia, never had nor apparently sought a personal acquaintance with the Tuscan grand-ducal court or the Florentine literati until the

summer of 1666, when he briefly visited Florence on his way home to Bologna from Rome. By this late date Malvasia was already well along in the writing of his *Felsina pittrice*, and moreover he had made the trip between Bologna and Rome many times. And Perini shrewdly remarks, "It is my suspicion that before the unification of Italy in 1860 citizens of the States of the Church may have found it more convenient to travel to and from Rome via the longer routes through the Church territories of the Marches or Umbria rather than through Tuscany, which was a foreign state. A visit to Florence, which entailed the normal border taxations and controls, was not so casual an affair as it is nowadays."[2]

Malvasia arrived in Florence with a letter of introduction written by Ferdinando Cospi, one of the two official Medici representatives in Bologna, but Cospi had earlier written privately to Prince Leopoldo de'Medici to say that Malvasia had left Bologna for Rome and that "he has taken the route through Loreto, and after Easter will return via Florence."[3] It is clear from this letter that Malvasia had not visited Florence before, and that, as Perini suggests, he normally must have traveled to Rome following routes lying entirely within the Papal States. Moreover, given the quite slender contacts that can be traced between Florence and the great artists of Bologna, it seems that Malvasia followed the same pathway surely taken by these artists before him — Guido Reni, Guercino, Domenichino, Annibale and Agostino Carracci, and many others going back three quarters of a century to the time of Marcantonio Raimondi, Bagnacavallo, and Francesco Francia. This was without doubt the great postal road of the Via Flaminia and its extension the Via Emilia, which for centuries had been the primary route followed by travelers and pilgrims from northern Italy and transalpine Europe to Rome. From the time of the papacy of Julius II at the beginning of the century this route had been kept in good repair; it was equipped with inns and changes of horse at postal stages situated at about twenty-mile intervals, and was reasonably well protected from the predations of bandits.[4] The Via Flaminia extended from Rome northward through Narni, Terni, and Spoleto to Foligno, from which Perugia was easily accessible. It then branched into two forks not far from Fabriano, allowing the traveler to follow either the ancient route over the pass at La Scheggia to Fano on the coast and hence northward to Rimini and Bologna, or else to follow the newer route through Macerata and Loreto to the port of Ancona, about thirty-seven miles south of Fano. The latter was the route taken by Malvasia in 1666, and we should add to the conveniences noted by Perini, of avoiding the border controls and taxations that passage through the foreign state of Tuscany would have entailed, the observation that his trip would have taken no longer than traveling the geographically shorter route via Florence, and certainly would have been more comfortable. Rodocanachi has shown that papal couriers regularly made the trip between Rome and Bologna along the Via Flaminia in five days and the trip between Rome and Florence along the Via Cassia in three. The leg from Florence to Bologna, however, ascending the Apennines at Pistoia or over the Futa pass — both more difficult traversals than that taken by the Via Flaminia at La Scheggia — normally consumed an additional two days.[5]

Any art historian can immediately see the consequences of these observations. Even today the drive from Bologna to Urbino, which is easily accessible via gently ascending roads from Pesaro and Fano along the valleys of the Foglia and Metauro rivers, takes about two hours, while that from Florence to Urbino, which entails some steep mountain ascents, takes twice as long. When the young Raphael was growing up in Urbino the most important master of the region was Francesco Francia in Bologna, only about ninety miles distant via broad, flat roads. This fact in itself is enough to lend strong credibility to the indications in the early sources, stoutly resisted by scholars since the time of Morelli, that Raphael knew Francia well from an early age. Similarly, the diffusion of Perugino's style of painting, which we call Umbrian after the modern redrawing of the map of Italy, spreads northward from Perugia into the Marches and Romagna along the line of the Via Flaminia and its dependencies; indeed, major altarpieces by Perugino himself can still be found

in Fano and in Bologna. In the same way, anyone tracing the diffusion of the dominant late sixteenth- and early seventeenth-century Bolognese manner of the Carracci and their followers must take the Via Emilia south through Imola and Forlì again to Fano, where major paintings by Domenichino, Guercino, Tiarini, and Guido Reni are still to be seen in the churches and museums of that city.

The many local catalogues and surveys produced in celebration of the Raphael quincentenary in 1983 amply document the existence of a coherent style of painting throughout the Papal States at the beginning of the sixteenth century, a style with values of its own quite distinct from contemporary developments in Florence.[6] This is indeed the style explicitly described by Vasari as the dominant manner in the whole of Italy between about 1490 and 1510, which he identified jointly with the discoveries of the Perugian Perugino and the Bolognese Francia. He further wrote that this style had reached its high point with the *Sposalizio* signed by the young Raphael in 1504, which surpassed even the paintings of his master, Perugino. The new style of Perugino and Francia, characterized by its softness and sweetness of color and its affective piety, took Rome by storm, replacing the old, dry style then being practiced in Florence. Vasari called this new style the penultimate step along the path to the true modern manner of Michelangelo, who in turn characterized it as a *maniera devota* and despised it for what he called its clumsy and devotional sentiment — and who immediately eclipsed it with the unveiling of the Sistine ceiling in 1512. In a different but related way, the same contest for national dominance — meaning the conquest of Rome — between the modern manner of Tuscany and the naturalistically affective style of the cities of the Papal States was to be reenacted at the end of the century, when we can trace similar correspondences and interactions, involving artists such as Barocci in Urbino, Lilio in Ancona, and the Carracci in Bologna.

We are now in a position, I think, to make a few observations about an issue forcefully raised in connection with the exhibition of Emilian painting held in 1986 in Bologna, Washington, and New York — an issue that concerns the alleged provincialism (whether viewed in a positive or negative light) of north Italian painting as set against the centrality of Tuscan, and especially Roman, painting. It is a moot point whether such a question could ever credibly have been raised if the treasures of Dresden had never left their home in Modena (or, better yet, had been restored to the churches and collections of Modena and Reggio Emilia from which the Este themselves plundered them), or if the Farnese treasures in Naples had been returned to Parma, which, as Giuseppe Bertini has shown, was at the beginning of the eighteenth century an obligatory stop on the grand tour, as Florence and Rome remain today.[7] The perceived provincialism of Emilian art derives more from the irreparable loss of a great regional patrimony than from any marginality in the art itself. And, paradoxically, the removal of so much art to more remote outposts, far from its place of origin and from a local context that might have kept its cumulative grandeur self-evident, has also contributed to a mistaken sense of its peripherality. One of the most melancholy comments I know was written by Charles de Brosses, who had seen the Farnese paintings after their arrival in Naples and described what he had seen in his *Lettres familières écrites d'Italie en 1739 et 1740:* "Que de détails et d'exclamations j'aurais faits sur les admirables tableaux de la maison Farnèse, qu'on y a transportés! Mais ces barbares Espagnols, que je regarde comme les Goths modernes, non contens de les avoir déchirés en les arrachant du palais de Parme, les ont laissés pendant trois ans sur un escalier borgne où tout le monde allait pisser. Oui, monsieur, on pissait contre le Guide et contre le Correge!"[8] An even more bitter response to the decline of reputation suffered by Emilian art was written by Roberto Longhi after the 1944 bombing of Bologna, which he rightly perceived was more vulnerable to fortune because it lacked the national and international fame that had helped protect Florence and Rome from attack. "Art is by its nature mute and without defense," he wrote to Giuliano Briganti, "it can protect itself only by its fame, and fame needs an ever alert critical approach."[9] Critical laxity was in part the product of loss, of an artificially created sense of cultural

marginality; if this loss, with its corresponding decline of critical interest, had not occurred, "who knows if Bologna would be weeping such bitter tears today." But before addressing directly the question of regional versus national style, or at least of center versus periphery, we must briefly return to the problems of geography and political history.

It is well known, as Dennis Mack Smith has written, that until March of 1861, when Cavour proclaimed the birth of the kingdom of Italy, the term *Italia* served to designate not so much a nation as a peninsula, so that Metternich had been able to refer to Italy disparagingly as this mere "geographical expression."[10] And it is also true that Italy, long before becoming a national state, had existed for many centuries as a geographical unity, bounded on three sides by the sea and separated from the rest of Europe by the Alps, while at the same time being sharply divided by the spine of the Apennines stretching from one coast to the other. Thus it was that men from Dante to Machiavelli could dream of an idea of political unity, whether under the sovereignty of emperor or of pope, while at the same time individual loyalties remained bound to particular cities and regions, with their own frontiers and customs barriers, with different histories and traditions of government and legislature, with their own monetary systems, classes of weights and measures and methods of working the land, with their own forms of literary and artistic expression, and their own regional vocabularies and dialects. Both history and geography conspired to produce that *municipalismo*, or *campanilismo*, that nineteenth- and twentieth-century historians and public figures have seen (and still see) as impeding the progress of national unification and political and economic advancement.

The subsequent history of Cavour's dream of creating a new liberal national state, prosperous and powerful, is too well known to need summarizing here; and indeed Mack Smith's book is devoted to an investigation of how Italy, which in 1861 was the country most admired by political liberals the world over, first developed into an imperalist power, then fell after 1919 into totalitarian fascism, and finally with the elections of 1948 saw the crushing defeat of the liberals and anticlericalists at the hands of the communist and Catholic parties. We need only recall that before 1861 the history of Italy had been the history of its regions and that only afterward did the need arise to write the history of the new nation. Just as it had been necessary at that point for liberal thinkers to discover the seeds of their political faith in historical precedent, so too, and for the same reasons, did Mussolini find it necessary to appoint one of the *quadrumviri* of the March on Rome to the post of director general of historical research, with the duty of promoting discovery of the authentic *stile fascista* in the historical writing and thought of the past.

This example dramatizes two important problems in Italian historiography of the past century. The first, in the absence of a historically unified polity, is that of defining the country's unifying cultural values, generally dependent upon an idea of classicism, as the foundations for discovering a national *stile* in the sense of the charge given Mussolini's minister. The second is the awkwardness, in the context of the postfascist era, of identifying such unifying "classical" values with an unwanted and debased idea of nationalism. So it is that Giuliano Briganti with great wit introduced his essay for the catalogue of the exhibition of Emilian painting by coining the concept of *Emilianità*, or the "Emilianness" of that art, in homage, as he wrote, to Pevsner's famous study of the "Englishness" of English art.[11] At one stroke English art itself is wryly relegated to the perceived provincial status of modern Emilia. And at the same time Briganti is able to avoid identifying the dominant classicizing art of sixteenth- and seventeenth-century Rome with *Italianità*, with all its unwanted and dangerous associations, even as he is able to characterize (following Longhi and Arcangeli) the provincialism of Emilian art as arising from an instinctive naturalism and simplicity of affective sentiment. This is important because the idea of Italian national unity for obvious historical reasons has always centered on Rome, the city both of the Caesars and the pope, for which reason the Risorgimento could not consider itself complete until the surrender of the city in 1870.

In the sixteenth century any spirit of true nationalism was still a long way off, despite the determined efforts of succeeding popes to extend the territories of the Church. These included Julius II's securing of the Romagna from the Venetians and his conquest of Perugia and Bologna at the beginning of the century, and the later assimilation under direct papal governorship of the feudal duchies of Ferrara by Clement VIII in 1598 and of Urbino by Urban VIII in 1623 (the latter event marking the farthest extension of the Papal States and ending forever the contending ambition of grand-ducal Tuscany to create a kingdom in central Italy). But it is also true, as Bruno Migliorini has emphasized in his *Storia della lingua italiana*, that by the sixteenth century a consciousness of belonging to a common civilization was already quite general among the inhabitants of the peninsula, at least among the literate classes. Indeed, the very "controversies on the nature of the language" — the famous *questione della lingua* — "show that those participating thought of such a language as the vehicle for a single national culture."[12] This same awareness is also the motivation for the analogous controversies on the nature of the visual arts — what we might call the *questione della lingua visiva* — initiated at the same time.

Thus it was that the Florentine duke Cosimo I in 1542 took the recently founded literary academy, called the Accademia degli Umidi, and officially reincorporated it as an organ of the Tuscan state, calling it the Accademia Fiorentina. He gave it rooms in the university, the Studio Fiorentino, and the consul of the academy was by statutory decree made ipso facto rector-general of the university, and the academy was given general jurisdiction over the professors, students, and affairs of the university, also including the publication of books. Even more important than this, Cosimo's statutes made of the Accademia Fiorentina, as Michele Maylender wrote, virtually a state corporation, in support of what Michel Plaisance has called the cultural politics of the Medici, endowing it with a ducal privilege that Armand De Gaetano recognized as being "without equal in the history of those Italian [literary] academies," in that the interests of the state and those of the

academy were thereby made to coincide.[13] One of the first publications sponsored by the new academy was Vasari's *Lives*, which appeared in 1550. Thirteen years later the first artists' academy in Europe, the Accademia del Disegno, was officially incorporated by Cosimo along lines strictly analogous to those regulating the Accademia Fiorentina. It too was a state corporation, and also an instrument of state policy, since it was made up of elite groups deriving authority from the duke and owing him allegiance. These groups in turn were given authority over the preexisting institutions that had governed the affairs of artists, even as the Accademia Fiorentina had been given authority in the duke's name over the university and other academic institutions concerned with the profession of letters.

There is nothing abstract about these observations. As a consequence of Cosimo's incorporation of the Accademia Fiorentina, succeeded by the conservative revolt that led to the foundation of the equally official Accademia della Crusca, Italian language and literature remain to this day predominantly Tuscan. This is to say that what began as a regional concern, seeking to establish the claims of Tuscan poets as set against the poets of Sicily and Bologna, and of the Tuscan language as set against the dialects of the Venetians and the papal Curia, ended with the establishment of that literature and language nationally, beginning with the conquest of the spiritual capital, Rome. A similar pattern of intention can clearly be seen motivating Vasari's *Lives* with regard to national style in the visual arts. Vasari's well-known argument is that after the fall of the Roman Empire the arts first reappeared in Tuscany and ascended to perfection there, finally to attain their apotheosis in Rome with the sublime attainments of Michelangelo in the Sistine Chapel and of Raphael in the Stanze. To be sure, Raphael had been an artist trained in the style of the Papal States, but after the painting of the *Sposalizio* he abandoned that humanly affective style, remade himself in Florence, and finally achieved immortality by being the first to assimilate the Tuscan Michelangelo's stupendous discoveries in Rome. From that point the art of Tuscany, like its language, had conquered Rome.

Vasari therefore argues further that anyone with serious ambitions to become an artist must make the pilgrimage to Rome in order to master the modern manner by studying first the ancient statues and then the marvels created by Michelangelo and Raphael. Nor does he fail to mention which artists (like Parmigianino) made that pilgrimage, which artists (like Garofalo) lamented that their styles were formed before having a chance to study the works of Michelangelo and Raphael, or which artists (like Correggio) missed true greatness by never seeing Rome at all. Furthermore, he tells how the modern manner began to establish colonies in northern Italy and indeed northern Europe, being carried to Mantua by Giulio Romano, to Parma by Parmigianino, to Bologna by Vasari himself (who bitterly castigates the local artists for resisting it), and, most impressively, to the French royal court at Fontainebleau by the Florentine Rosso and the Bolognese Primaticcio.

It is an extraordinary story, and by no means untrue in its general outlines, even though Vasari's undervaluation of the achievements of northern Italian painters, and especially the Venetians, is well known, and indeed notorious. This story also gives a glimpse of the enormous stakes that were involved, for while the inhabitants of the Italian peninsula were fully aware that the various states of Italy were no match for the political and military power of France and Spain, they brilliantly understood and exploited the more subtle, but nonetheless very real advantages to be gained from cultural resources, and indeed from sustained superiority of cultural achievement. It is thus a matter of great interest and importance that, even though the *questione della lingua* was resolved in favor of the Tuscan language and its literature, the same is not true for the visual arts. Less than a generation after Vasari's death in 1574 the Tuscan-Roman modern manner that he had championed — essentially the style we know today as mannerism — had been definitively overturned and replaced by a new style, one that conquered not only Rome and Italy, but also the whole of Europe for the next three hundred years. This is, of course, the style we now generically call the baroque,

together with its offshoots. The visual conventions defining and regulating that style were first analyzed, codified, and put into practice by the Carracci in Bologna, which was the second most important city after Rome in the States of the Church.

It is well known that Vasari's Tuscan- and Roman-centered vision of the history of the arts was not slow to provoke strong municipal reaction from other cities, especially in north Italy, and especially after the second and definitive edition of the *Lives*, again an academy-sponsored production, appeared in 1568. Ludovico Dolce in Venice, Alessandro Lamo in Cremona, and the Faentine Giovanni Battista Armenini all published before the mid-1580s lively defenses of the artists of their native cities and regions, often castigating Vasari's omissions and negative judgments of northern Italian art in very spirited terms indeed. It is highly significant that one of the earlier manifestations of such local response is the famous *postille*, or annotations, written by the Carracci themselves in the margins of their copy of the 1568 edition of Vasari. The following, quite typical quotation gives an indication of their tone:

O listen to the malignant Vasari, he says that the rivals of Titian were not men of valor when these were Giorgione, Pordenone, Tintoretto, Giuseppe Salviati, Veronese, and Palma Vecchio, all of whom were painters of great importance; yet Titian overcame them all, while if he had had to compete against the Ghirlandaios, Bronzinos, Lippis, Soggis, Lappos, Gengas, Bugiardinis, and others of Vasari's Florentines with names as obscure as their works, he could easily have beaten them painting with his feet, excepting, however, the divine Michelangelo and Andrea del Sarto.[14]

Or again, writing of Vasari's observation that Titian painted portraits well, one of the Carracci scornfully writes that Titian was certainly excellent "in this part of painting and in the others too, but because he did not avail himself of the odious rules of the Florentine painters Vasari thumbs his nose at him as a man who never had good taste in painting."[15]

Such remarks were never intended for publication, but although their language is strong, the sentiment they express is profoundly consistent with a debate that was

to have a long history. One of the most important moments in this debate occurred about a century later in the pages of the *Lives* written by the Roman Bellori, the greatest seventeenth-century exponent of the centrality of the art of the capital, and in the *Felsina pittrice* written by the Bolognese Malvasia, whose passionate defense of the painting of his native city has made his name virtually synonymous with the word *campanilismo*. However, as is always true when one invokes an unquestioned cliché of the scholarly literature, it is necessary here to sound a note of caution. Although the north Italian reaction against Vasari has been understood at least since Julius von Schlosser as evidence of an ingrained *municipalismo*, meaning a backward and provincial injured civic pride resisting the national centrality of Rome insisted on by Vasari and Bellori after him, the very words *campanilismo* and *municipalismo* themselves carry anachronistic and inappropriate connotations for describing the true situation. Both are in fact neologisms of the Risorgimento that were specifically coined by patriots to characterize and to castigate provincial resistance to the cause of national unity and to the political and economic progress of the new country as a whole. As we have already indicated, before 1861 the history of Italy is the history of its regions; Malvasia and Bellori, and the Carracci before them, saw themselves as participants, not in any defensive rear-guard action to preserve outdated or defeated regional traditions and values, but in a debate of the utmost national and indeed international importance between different regions for the future of art itself. Bellori's *Vite*, after all, is dedicated to Colbert, Louis XIV's minister of culture, while the *Felsina pittrice* is dedicated to the Sun King himself.

It is certainly true, on the other hand, that the stigma of provincialism had been attached to the schools of painting north of the Apennines, and aggressively so, by another regional writer, Vasari. Ever since he preempted the issue, so to speak, by being the first to appear in print with a powerful view of the history of painting in Italy, northern advocates of their own traditions had found themselves on the defensive. All alternate histories were placed in the position of being responses to or elaborations of Vasari, and the same is true of the position in which artists themselves were placed. As Elizabeth Cropper has argued, from the moment of the publication of the *Lives* artists inevitably worked with the consciousness of a history, based on a powerfully conceived canon of excellence, that had never before existed.[16] Michelangelo and Raphael had acquired in Vasari's pages the status of ancients, and their achievement had above all been linked to that most especially ancient of cities, Rome itself, capital of an empire that once encompassed not only Italy but the whole world.

Even as Vasari was writing the *Lives*, however, the values of the modern manner had come under sharp and increasingly hostile attack. Vasari alludes to this attack at various places in the *Lives* and in his *Ragionamenti*: for example, in the life of Fra Angelico, in which his description of the painter's devout character and art prompts him to respond to criticism of the modern manner as being both lascivious and incapable of expressing devotion; or when he tells of being compelled to cover the nudity of a personification of the Vatican in his frescoes celebrating the papacy of Paul III in the Sala dei Cento Giorni. But without question the central episode of the reaction against the modern manner concerns Michelangelo himself. It was provoked by the unveiling of the *Last Judgment* at just the moment when Church policy turned definitively toward the Counter-Reformation, and it marks the first great confrontation of the period (often to be repeated in subsequent years, most notoriously in the cases of Tasso and Galileo) between individual discovery and the demands of ecclesiastical and political authority.[17] It is especially important that at the heart of the criticism leveled against Michelangelo lay a rejection of that art which displays its own skill and exalts itself as art, together with a call for a return to natural persuasion in the arts, the purpose of which was to reinforce faith through an appeal to affective and devotional sentiment.

The reformation of painting thus called for was the great historical and artistic achievement of the Carracci, who based their reform on an appeal to the native traditions of north Italy, not only the naturalism and

sentiment of Correggio and Titian, but also the affective values inherent in the art of the region from the time of Perugino and Francia — what Briganti would call the art of *Emilianità*, but what I would prefer to call the art established in the States of the Church at the time of Julius II's conquest and unification of its territories. Their response to the challenge of Vasari — whose *Lives* they knew thoroughly — was not simply to reject the canonical status of Michelangelo and Raphael, although they certainly scorned the art of their epigones, but instead to insist that, great as these masters were, the example they set was a limited one. In this regard, the young Ludovico Carracci's celebrated decision not to go to Rome to study is absolutely extraordinary, and in the light of Vasari's repeated insistence that young painters must assimilate Michelangelo and Raphael, as well as the art of antiquity in Rome, it can only be regarded as polemical. It is the assertive statement of a critical stance taken in opposition to the older painters of Bologna who had known Michelangelo in Rome and who themselves preached the canon codified by Vasari.

Ludovico instead planned for himself a new *studioso corso*, or travel for the purpose of study, sending his younger cousin Annibale on the same path. The journey took them to various cities in northern Italy, and above all to Parma and Venice, in order to assimilate the alternative excellences of what Vasari had called an inferior canon, the examples set in the paintings of Correggio and the great Venetians. Agostino Carracci (who had engraved the frontispiece for Lamo's anti-Vasarian *Life of Bernardino Campi*) made many engravings after the works of the northern masters, and with the same purpose that Raphael had had in mind when he hired Marcantonio to engrave his inventions: to make these exemplars widely known and imitated. As one result, in the words of Ridolfi, Veronese's fame throughout the Italian peninsula was greatly increased, and indeed the canon was thereby expanded to include values inherent in his painting, as well as those of Tintoretto and Titian, together with values that had been extolled by Vasari and exemplified in the art of Michelangelo and Raphael.

But most important, the Carracci put the effects of their study to work in their paintings, and in ways that forever altered the course of Italian and European painting. It is for precisely this reason that charges of *campanilismo* and provincialism levied against their Bolognese production and the account of it given by Malvasia — terms carrying with them all the anachronistic freight of the Risorgimento's mission to create a politically unified Italy — strike very wide of the true historical mark.

Malvasia was born while Ludovico Carracci was alive, and he knew Guido Reni, Guercino, and Francesco Albani in Bologna and its environs, where all of them spent the greater part of their working lives and were universally perceived as among the greatest painters, not only of Bologna, but also of Europe. Malvasia's battle with Bellori, like that of the Carracci with Vasari, was not simplistically based in regional history, but rather concerned the destiny of art nationally and internationally. When he waged it, the issue of Tuscan primacy had long ago been settled. The dispute between Malvasia and Bellori was instead whether one Bolognese painter, Annibale Carracci, had been the greater artist in his native city or only afterward in Rome, and whether a second Bolognese artist, Ludovico Carracci, by refusing to go to Rome at all deserved a status equal to that of his cousin.

For reasons such as these, it seems to me that the foundations for discussion assumed by Briganti in his brilliant essay on the *Emilianità* of Emilian art are insecurely based, and even more seriously that the foundations for our general accounts of the development of art in seventeenth-century Italy are also shaky. By repeated insistence on Malvasia's provincialism, his *campanilismo*, modern scholars have inadvertently cast on the artists of whom he writes the shadow of a secondary status, making them grand provincials to be sure, but provincials nonetheless. Briganti himself writes as a Roman, for whom the centrality of the capital is unquestioned. Hence, for him Annibale inevitably had to go to Rome just as Correggio had to precede him there, despite Vasari's assertion to the contrary, for without Rome their achievement would be inconceivable. Although his position has a

lengthy historical ancestry, Briganti is in particular picking up an argument advanced by Roberto Longhi, who took on himself the daunting task of convincing his students in Bologna that the art of their region, then in the darkest part of the nearly total eclipse that baroque art in Italy generally was suffering, was indeed carrying on a fruitful and vital dialogue with the art of Rome. This argument was continued in the work of Francesco Arcangeli, whose vision of Bolognese and Emilian painting was determined by an idea of authentic regional and local expression set against the classical and, as he suggested, oppressive superstructure imposed by the official art emanating from the capital.

But the truer position I think is this. From the beginning of the sixteenth century, a clearly perceived and understood alternative presented itself, a choice between the humanist values inherent in the art of Florence, with its great and long established tradition, and the affective naturalism of the art of the Papal States, perfected in the new manner discovered by Perugino and Francia, the latter of whom was also revered as the founder of the first nationally important school of painting in Bologna. This style was defeated, indeed virtually crushed, by the achievement of Michelangelo. But even as Michelangelo's art soon came under attack by the forces of the Counter-Reformation, so too were the naturalistically affective and pious qualities inherent in what I would prefer to call the initial unitary style of the Papal States, characterized by a deceptively simple naturalism that identified the divine with everyday human experience, perceived as offering the foundation for an alternative national expression — especially in its more modern manifestation in the art of Correggio. The truth of this appears in Malvasia's account of the Carracci, who he says not only studied the work of Francia (as well as Raphael's *Santa Cecilia*) but also sought to appropriate into their own work something of its *inerudita semplicità lombarda*, its unlearned Lombard simplicity, or directness of affective expression. At the same time there could be no question of returning literally to the old-fashioned style of Francia and his followers, ignoring the stupendous achievements of the modern manner as though it had never existed, so it became necessary to study the secrets of not one but several modern manners as they had found individual perfection, in Tuscany and in the regions of northern Italy. Vasari conceived Italian painting as developing on two lines, the relatively greater idealism of Florentine art on the one hand, and the relatively more enhanced (and inferior) naturalism of the Venetians on the other. Significantly, it was with the Carracci that for the first time we find clearly stated a concept of regional schools and regional excellences — the Florentine, the Roman, the Venetian, and finally their own Lombard school (a system of art-historical classification that continued to be followed for two hundred years). The style they forged out of these various excellences, one formed on profound critical analysis and synthesis, was woefully misunderstood earlier in this century as merely a species of eclecticism. In fact, it was not at all the product of indigenous regionalism, but instead was the first style of painting that could lay claim to being truly a national style, looking beyond the strictly local (but most excellent) traditions of their native Bologna and Emilia toward the equally regional (and most excellent) styles of Venice, Rome, and Florence itself. In the art of the Carracci, for the first time, the politically fragmented peninsula of Italy found its own unified cultural expression, its own history, its own *lingua visiva*.

1. In this paper I have aimed to establish a broader context for ideas I have earlier developed in related arguments in the following essays: "Some Observations on the Education of Artists in Florence and Bologna During the Later Sixteenth Century," *Art Bulletin* 62 (1980), 552–569; "Mythic Inventions in Counter-Reformation Painting," in *Rome in the Renaissance: The City and the Myth*, ed. Paul A. Ramsey (Binghamton, N.Y., 1982), 55–75; "Malvasia and the Problem of the Early Raphael and Bologna," in *Raphael Before Rome*, ed. James Beck, Studies in the History of Art 17 (Washington, D.C., 1986), 57–70; "The Carracci *Postille* to Vasari's *Lives*," *Art Bulletin* 68 (1986), 72–76; "The Carracci Reform of Painting," in *The Age of Correggio and the Carracci* [exh. cat., National Gallery of Art and Metropolitan Museum of Art] (Washington and New York, 1986), 237–254 (also published as "La riforma pittorica dei Carracci," in *Nell'età di Correggio e dei Carracci* [exh. cat., Bologna Pinacoteca] [Bologna, 1986], 237–254); "The Carracci and the Devout Style in Emilia," in *Emilian Painting of the Sixteenth and Seventeenth Centuries: A Symposium* (Bologna, 1987), 75–87; and "The Carracci Academy," in *Academies of Art Between Renaissance and Romanticism*, ed. Anton W.A. Boschloo et al., *Leids Kunsthistorisch Jaarboek* 5–6 (1986–1987), 33–43.

2. Giovanna Perini, "Carlo Cesare Malvasia's Florentine Letters: Insight into Conflicting Trends in Seventeenth-Century Italian Art-Historiography," *Art Bulletin* 70 (1988), 273–299, esp. 274.

3. See the letter as published by Perini 1988, 275.

4. Eduardo Martinori, *Via Flaminia: Studio storico-topografico* (Rome, 1929).

5. Emmanuel Rodocanachi, "Les courriers pontificaux du quatorzième au dix-septième siecle," *Revue d'histoire diplomatique* 26 (1912), 392–428.

6. Among the vast number of books, catalogues, and articles published in celebration of the quincentenary of Raphael's birth, I will cite here only those of Guido Guidi et al., *Pittura in Umbria tra il 1480 e il 1540* (Milan, 1983); and Maria Grazia Ciardi Dupré dal Poggetto et al., *Urbino e le Marche prima e dopo Raffaelle* (Florence, 1983).

7. Giuseppe Bertini, *La Galleria del Duca di Parma: Storia di una collezione* (Bologna, 1987).

8. Charles de Brosses, *Lettres d'Italie*, 2 vols. (Dijon, 1928), 1:246 (also quoted by Bertini 1987, 51).

9. See Elizabeth Cropper, review of the exhibition *The Age of Correggio and the Carracci*, in *Burlington Magazine* 129 (1987), 270–272.

10. Dennis Mack Smith, *Storia d'Italia dal 1861 al 1969* (Bari, 1972), 11–13.

11. Giuliano Briganti, "La natura lombarda, le idee romane, i demoni etruschi e l'antico, nella pittura emiliana del Cinquecento e del Seicento," in Bologna 1986, xv–xxxii; published in English as "Lombard Character, Roman Ideas, Etruscan Spirits, and the Antique in Emilian Painting of the Sixteenth and Seventeenth Centuries," in Washington and New York 1986, xv–xxxii.

12. Bruno Migliorini, *La storia della lingua italiana* (Florence, 1960), 309.

13. See Michele Maylender, *Storia delle academie d'Italia*, 5 vols. (Bologna, 1926–1930), 3:4; Michel Plaisance, "Une première affirmation de la politique culturelle de Côme Ier: La transformation de l'Académie des 'Umidi' en Académie Florentine," in *Les Écrivains et le pouvoir en Italie à l'époque de la Renaissance*, ser. 1, ed. André Rochon (Paris, 1973), 361–438; Michel Plaisance, "Culture et politique à Florence de 1542 à 1551: Lasca et les 'Humidi' aux prises avec l'Académie Florentine," in *Les Écrivains et le pouvoir en Italie à l'époque de la Renaissance*, ser. 2, ed. André Rochon (Paris, 1974), 148–242; Armand De Gaetano, *Giambattista Gelli and the Florentine Academy: The Rebellion Against Latin* (Florence, 1976); and Dempsey 1980.

14. Dempsey, "Carracci *Postille*," 75.

15. Dempsey, "Carracci *Postille*," 75.

16. Elizabeth Cropper, "Tuscan History and Emilian Style," in Bologna 1987, 49–62.

17. See further Dempsey 1982, 71.

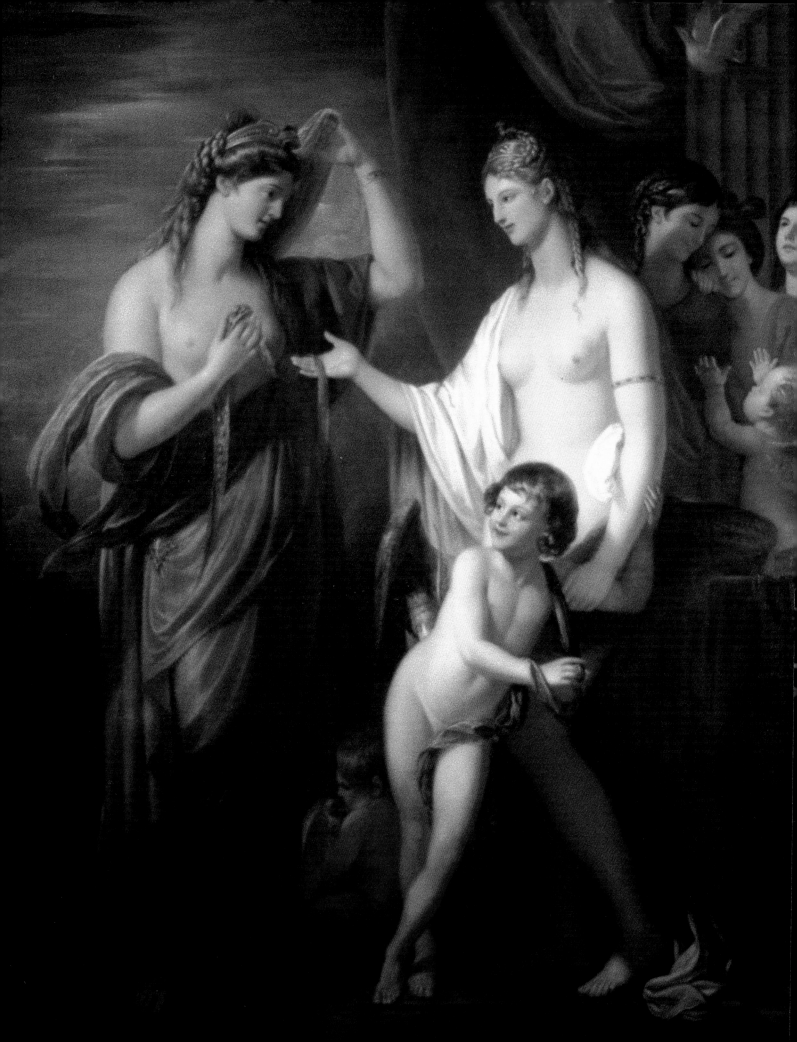

RENATE PROCHNO
University of Munich

Nationalism in British Eighteenth-Century Painting:

Sir Joshua Reynolds and Benjamin West

In the classical hierarchy of the arts, history painting holds the top position, while portraiture ranks at the bottom. At the time of the founding of the Royal Academy in 1768, painting in Britain was almost synonymous with portraiture, and this branch of painting had been developed by artists not born in Britain, such as Hans Holbein, Anthony van Dyck, Peter Lely, and Godfrey Kneller. Even the memorandum that preceded the founding charter of the Royal Academy was signed by eight non–British-born artists in a list of twenty-two. The founding of the Royal Academy was a major step toward the development of a national school of painting, because it institutionalized art to a degree hitherto unknown. The official tasks of the Royal Academy were the formation of young artists and the annual exhibition. The king himself considered "the culture of the arts as a national concern."[1]

To understand the efforts to promote British art it is necessary to consider the special situation of painting in Britain.[2] Britain's emergence as a world power in the eighteenth century made the island nation more susceptible to continental influences. For example, the trade in prints, especially with France, developed rapidly, making French art much better known to Britons than before. With the "grand tour" now an essential element of upper-class male education, Italian art became better known to patrons, who brought it back to England as a prestigious proof of their connoisseurship.

The intensified contact with continental art gave birth to the painful consciousness that there was an English or British Nation,[3] but no native tradition of painting. George Vertue and Horace Walpole could not write a "History of British Painting," but only *Anecdotes of Painting in England* (1762–1771).[4]

Various academies and associations of artists were founded in the eighteenth century to promote the arts.[5] Some of them organized yearly exhibitions. Beginning in 1760 the Society of Artists had provided an annual forum where art was made easily accessible to a large public. These exhibitions were not only aimed at potential patrons for British paintings, sculpture, and prints, but were also intended to educate British public taste. The promoters wanted to create a taste for British art other than portraiture.

The exhibitions were organized by the artists themselves, not by art critics. They were a presentation of the artistic capacities of individual artists and were supposed to serve as a showroom of British art. Therefore, they came to be seen as a national institution. At the same time, they were manifestations of these artists' awareness of the incongruence of the political and artistic power of Britain.

As the exhibitions grew in importance, a new literary genre came into being: art reviews, which were usually published anon-

ymously either in periodicals, or, less frequently, as small books.[6] The critics of this period functioned as creators and arbiters of public taste. Although they often made superficial and banal comments, they were sometimes sensitive to innovations. To attract attention on the crowded walls of the Royal Academy and other exhibition rooms, a painting had to be striking in invention, composition, color, and expression, and also in its hanging-place. Therefore, the public display of works of art stimulated rivalry among artists. The reviews of the exhibitions that discuss these rivalries disclose a public debate on contemporary art that was entirely new in Great Britain. Besides the paintings themselves, these reviews are the most revealing sources we can use to reconstruct the "pictorial debates" of the era.

One of the most significant of these rivalries was between Sir Joshua Reynolds and Benjamin West. While Reynolds, the first president of the Royal Academy, was mostly a portrait painter, West, who was to become the academy's second president, was known primarily as a history painter. Both artists were eminent in their respective fields and highly influential for their contemporaries and the following generation.

When West settled in London in 1763, he had to make his living from portraiture, because there was no market for British history paintings. But in 1764, the first time he participated in a British exhibition, he sent two historical paintings and only one portrait to the Society of Artists.[7] In 1768 he gained royal patronage, and by the mid-1780s he practically ceased painting portraits in favor of painting historical or religious subjects for King George III.

Reynolds, on the other hand, was never favored by the king. He did not receive royal commissions for either portraits or historical paintings. In his *Discourses on Art* (1769–1790) he preached the superiority of history painting above any other genre. His later efforts as a history painter seem due to this belief. Although Reynolds was a portrait painter, it was inevitable that as president of the Royal Academy he would paint at least a few pictures in the upper hierarchy of his profession, where he was bound to encounter West. Their "pictorial discussion," that is, their excursions into each other's field, may help to clarify the way they presented themselves to the public during the first years of the Royal Academy.

Development of Historical Portraiture

Reynolds aimed at upgrading "face painting" to the status of a liberal art. In a land that lacked a painterly tradition, but possessed a splendid literary heritage, he had to join painting to literature by way of the classic doctrine of *ut pictura poesis.* This doctrine was a leitmotif for both portraiture and history painting. The English authors most suited for this purpose were Shakespeare, Milton, and Spenser.

Spenser's literary style was described as "sweet and amiable," showing "tender and pathetic feeling . . . and a certain pleasing melancholy in his sentiments . . . that casts a delicacy and grace over all his compositions," as Warton put it.[8] In painting, this Augustan interpretation of Spenser was coupled with the classicism of Claude Lorrain, as will be illustrated below with portraits that show the sitter as Una, a figure from Spenser's *Faerie Queene* (figs.4, 6). With the discovery of the "Gothick" Spenser by Thomas Warton and Bishop Richard Hurd, Salvator Rosa became the source for the transmission of Spenserian imagery into painting.[9] The style of Rosa's paintings made him the master of the picturesque and the sublime — qualities now also discovered in Spenser's writing. The terms *picturesque* and *sublime* were equally applicable to both poetry and painting under the all-embracing concept of *ut pictura poesis.* Spenser's imagery transformed into painted images helped to deepen the taste for picturesque romantic subjects.

In 1764, Warton complained about the lack of patriotic concern: "I cannot forbear wishing, that our writers would more frequently search for subjects in the annals of England . . . we have been too long attached to Grecian and Roman stories."[10] The usual sources for historical paintings were history and literature. The subjects for the contests of the Society of Artists were "to be taken from the English [changed in 1763 to "British or Irish"] History only," in order to promote the Britishness of British painting.[11] In 1712, Joseph Addison had equated an-

tique sculpture and English portraiture: "what the antique statues and bas-reliefs which Italy enjoys are to the history-painters, the beautiful and noble faces with which England is confessed to abound, are to the face-painters."[12]

Addison was not the only one to regard the English as the true heirs to the antique. In his influential treatise, *An Essay on the Theory of Painting* (1715), Jonathan Richardson wrote that "No Nation under Heaven so nearly resembles the Ancient Greeks and Romans as we. There is a Haughty Carriage, an Elevation of Thought, a Greatness of Taste, a Love of Liberty, a Simplicity, and Honesty among us, which we inherit from our Ancestors, and which belong to us as Englishmen."[13]

For Reynolds, the classicism that rested on antique art was a major means for promoting the traditional branch of British painting, that is, portraiture. In order to elevate this genre, he endeavored to couple it with historical painting. In the early 1760s, he developed the basic patterns of his historical portraits, a rapprochement of portraiture with historical painting. According to Reynolds' definition, "a painter of portraits retains the individual likeness; a painter of history shews the man by shewing his actions."[14] The combination of the two created the so-called historical portrait. In such a portrait, the action should be representative of the sitter's life and character as an individual as well as of his or her social status. The portrait should focus on a decisive moment in the sitter's life, or at least should be descriptive of his or her life in general. This is an application of Shaftesbury's theory of the "most fruitful moment." According to Shaftesbury, the story of the subject should be represented in its climax, when the whole plot was focused as "repeal" (the preceding events) and "anticipation" (the following events). Shaftesbury had intended this as a guideline for history painting, but Reynolds transferred it to portraiture.[15] Thus portraiture could acquire a value beyond the mere mimetic function of "face painting" and could represent moral standards as in history painting. Consequently, both the portrait and the portrait painter were elevated in the hierarchy of the arts.

Reynolds' historical portraits needed a pretense for an occupation that ennobled the sitter. There were plenty of possibilities for male sitters: they could be shown in uniform with a commanding gesture as a hero, sometimes even on a battlefield, or against the background of the sea with a ship; or at a desk surrounded with books, maps, and casts after the antique, thereby advertising the sitter as a man of letters. It was more difficult to find appropriate actions for female sitters, because they seldom had a profession. The "man of letters" and the "military hero" had no female counterparts.[16]

Normally, the social function of women was restricted to the role of wife and mother, securing the continuity of the dynasty. In historical portraiture, this fact of life resulted often in representations of women together with their issue, usually in patterns of the Virgin and Child. Female ideals were grace and beauty. Therefore, Reynolds made women adopt "classical roles" to celebrate the sitter as a personification of these values, depicting them as Juno, Venus, Hebe, or, if they had a talent for music, as Saint Cecilia. To fulfill the demands of decorum, the dress of the sitter had to match the role. This led to a mixture of contemporary dress and classical drapery for women, which came to be seen as "timeless classical" dress. Men were usually portrayed in their professional dress, for example, in military or clerical habit, while men of letters wore their informal dressing gowns. These garments seemed to be sufficiently "timeless."

The likenesses were idealized to represent the sitter at his or her best. The idealization visualizes the "idea" of the sitter. It is an approach to the classic notion of nature as a perfect model of truth and beauty. Sometimes denounced as flattery, it intended to show the best possibilities of the sitter, styling him or her as a model of virtue. Portraiture thus could become an example of *delectando docere*, which previously had been solely a characteristic of history painting.

In 1769, at the first exhibition of the Royal Academy, Reynolds exhibited four female historical portraits. One of these shows Lady Annabella Blake as Juno (fig. 1).[17] She stands

on Mount Ida, dressed in pseudo-classical drapery, receiving the cestus with which she will seduce Jupiter from Venus in the clouds above her. When Reynolds painted this portrait, he could not know that Lady Blake was later to leave her husband. Such a picture works only as a metaphor. Care had to be taken that the sitter's role – the comparison – was not incongruous and that the rules of decorum were maintained. This almost exaggerated effort recalls Jonathan Richardson's remark about the British resemblance to the ancients.

Three years later, West exhibited his version of the subject, *Juno Receiving the Cestus from Venus* (fig. 2). In this picture, Juno and Venus are represented as standing on the same level. Cupid clings to his mother while looking back to Juno. One newspaper review pointed out that neither Cupid nor the Graces in the background were mentioned in the passage by Homer that had provided the literary source.[18]

The three figures in the background can indeed be interpreted as the three Graces joined by a winged Cupid. But the composition of the group recalls as well the traditional composition of the Charity motif.[19] Misericordia, the main figure, looks down to illustrate God's love for mankind. She is the most important trait of Charity. Spes, Fides, and Caritas, as Misericordia's derivatives, surround her. Thus, in West's painting, the "cupid" with upward-stretched arms would personify Spes; the one embracing Misericordia, or rather leaning on her shoulder, would be Caritas; and Fides would be the figure looking heavenwards to the white dove above the group. In combination with Venus, the white dove is a symbol of love, like the one with whom the "cupid" plays at her feet. In Christian iconography, though, the white dove signifies the Holy Spirit. This ambiguous group adds a new layer of meaning to the purely mythological content of Venus and Juno. Pagan or sensual love is complemented by its counterpart of Christian love. Eros and Agape are represented together but, in accordance with the main subject of the picture, the emphasis is placed on Eros.

It is tempting to relate Reynolds' portrait of Lady Cockburn and her three sons (fig. 3), exhibited in 1774, to West's painting of

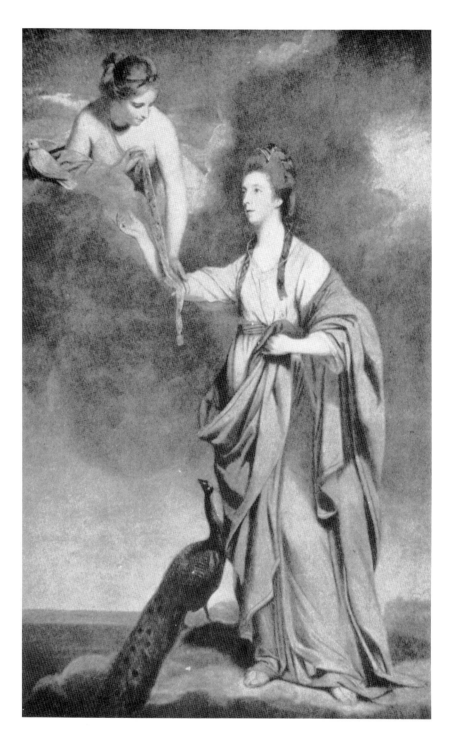

1772. Reynolds' portrait of Lady Cockburn is based on the Charity pattern, but it already plays with this formula, almost parodying it. Its detachment presupposes the remembrance of the traditional Christian representation.[20] In about 1780, Reynolds even painted two Charities,[21] following the

1. Joshua Reynolds, *Lady Blake as Juno*, exhibited 1769, oil on canvas
Present location unknown

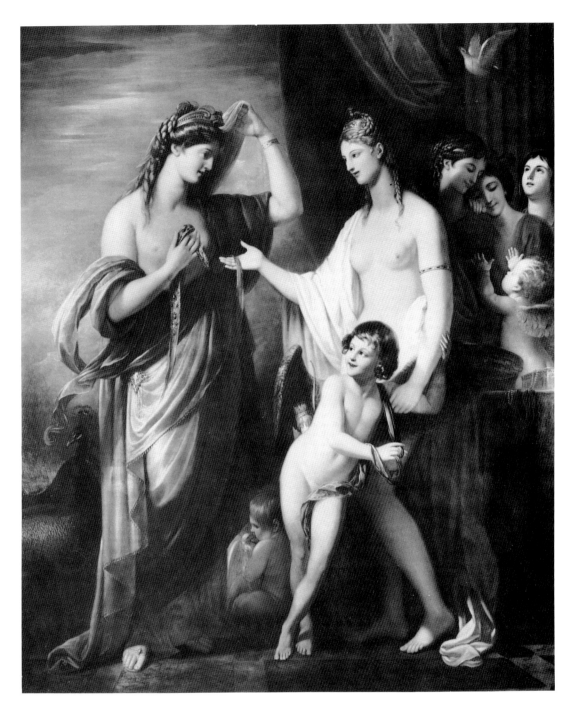

traditional iconography of the subject. These paintings were purely religious, they have no allusions to portraits.

All these pictures display the English qualities enumerated by Richardson. West's version was reviewed at length, the reviewer quoting the appropriate lines from Homer and citing the painting as an instance of *ut pictura poesis*. Walpole com-

mented that "the head of Juno has dignity and that of Venus grace; but too many straight lines." These long straight lines had been described by Reynolds as essentials of the grand style, the style of historical paintings.[22] They may also reflect Winckelmann's ideas about the imitation of Greek sculpture. West was familiar with classical art theory. He knew that the artist should

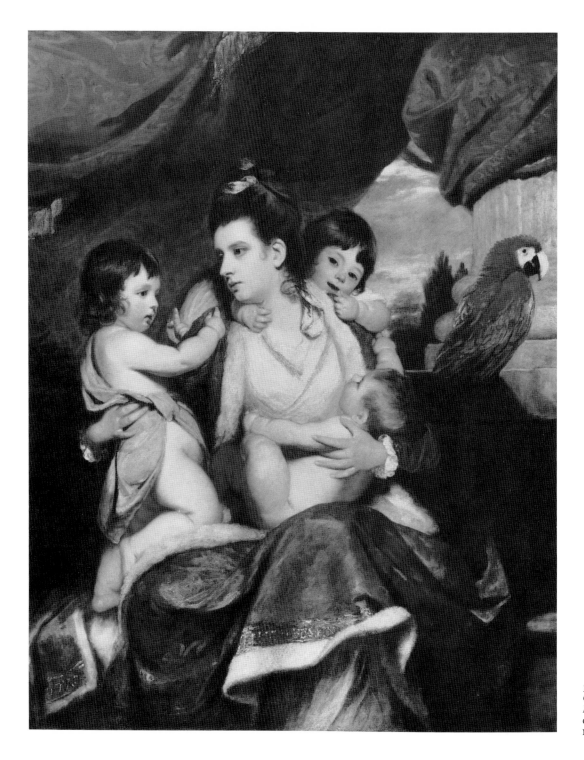

3. Joshua Reynolds, *Lady Cockburn and Her Three Eldest Sons*, 1773, oil on canvas
National Gallery, London

strive to represent the idea, the abstract ideal of his subject, in order to render this truth, which is at the same time nature in perfection. In art, antique sculpture had come closest to this ideal. During his time in Rome, West had been in close contact with Winckelmann, Mengs, and Hamilton, and thus had learned his lesson about classical art even before he came to London. Reynolds later outlined the core of this theory in his first four discourses delivered before 1772, the year of this exhibition.

The lack of attention to the exhibitions during their first few years means that con-

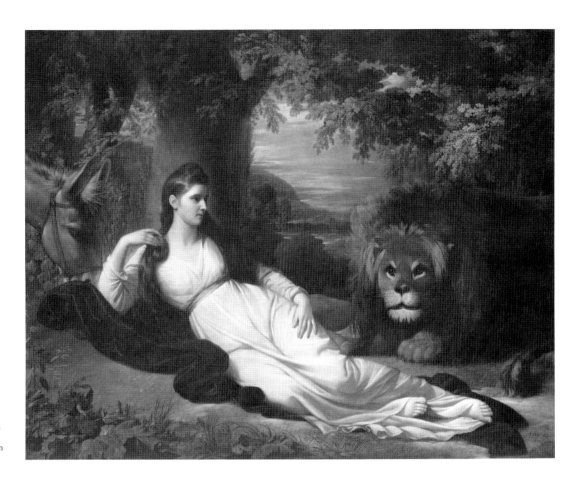

4. Benjamin West, *Una and the Lion*, 1771, oil on canvas
Wadsworth Atheneum, Hartford,
Ella Gallup Sumner and Mary Catlin
Sumner Collection

temporary critics said little about Reynolds' *Juno*. Still, this painting figured along with the two historical paintings by West[23] and a few other paintings among those "Pictures that have this season chiefly attracted the attention of the Connoisseurs at the Royal Academy in Pall Mall." Walpole simply noted in his catalogue, "very bad."[24]

West's picture gives the impression of correcting Reynolds' early version, as if to show just how manifold the subject could be. West does not employ the subject as a portrait disguise, but shifts it away from portraiture and back to mythology, thus avoiding the critical point, the conflict between the sitter and the portrait role. West not only "criticized" Reynolds' historical portraiture, he even competed with him by discovering a new literary source for painting: The introduction into painting of scenes from Spenser's works seems to be West's invention.

In 1772, West exhibited "Una. From Spenser's Faerie Queene, Book I, Canto 3,

Verses 4 and 5" (*Una and the Lion*, fig. 4).[25] The verses in question were given in full by the *Middlesex Journal*.[26] This again is a historical portrait. It was not exhibited as such, but there is some evidence that the sitter was a Miss Hall. The *Faerie Queene*, this "historical fiction," as Spenser himself called his poem, glorifies Elizabeth I as Queen Gloriana. Una symbolizes religious truth, that is, Protestantism. Her donkey stands for the vehicle of truth, the church.[27]

West's Una is a young woman, reclining in the shade of a tree. Her decent white dress signifies innocence, decorous for Una as well as for a young British lady. According to the text, her ". . . angels face/As the great eye of heaven, shyned bright,/And made a sunshine in the shady place,"[28] which explains the strong chiaroscuro. The lion on the right side is tamed by the sight of her beauty. Instead of devouring her, he licks her hand and feet, according to Spenser's text. In the painting, he lies quietly at Una's feet.

In classic art theory, truth and beauty are

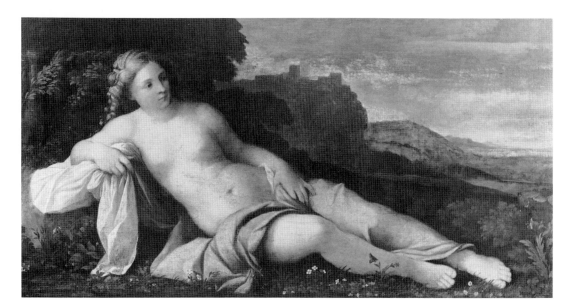

5. Palma Vecchio, *Venus in a Landscape*, c. 1520, oil on canvas
Courtauld Institute Galleries, London, Princes Gate Collection

synonymous. Una, as the personification of truth, must therefore be of ideal beauty. Consequently, when employed as a portrait disguise, this role turns into a metaphor of the beauty of the sitter. The Claudian landscape matches this classical ideal. But West goes even further than discovering a new role for female portraiture. The pose of his Una, who in Spenser's poem is a chaste virgin, shows here close parallels to an Italian Renaissance nymph or Venus reclining in a landscape or interior. The pose may even have been borrowed from Palma Vecchio's *Venus in a Landscape* (fig. 5). This erotic allusion transcends the literary model so far as almost to be a travesty. West does not rely on a single literary source, but combines opposite components: the chaste virgin Una and the antique goddess of love are united by the only characteristic they have in common, which is their beauty. West's Una is almost coquettish: she is the opposite of the rigorously moral Protestant allegory as intended by Spenser.

This picture might even be interpreted as a painted disproof of Reynolds' "Fourth Discourse" from December 1771, written and delivered five months before the exhibition, in which he stated that "such as suppose that the great stile might happily be blended with the ornamental, that the simple, grave and majestick dignity of Raffaelle could unite with the glow and bustle of a Paulo, or Tin-

toret, are totally mistaken. The principles by which each are attained are so contrary to each other, that they seem, in my opinion, incompatible, and as impossible to exist together, as that in the mind the most sublime ideas and the lowest sensuality should at the same time be united."[29] To do justice to Reynolds: He excluded Titian from his judgment, and he changed his opinion in later discourses. Even if Una is not a portrait, but simply an illustration of Spenser's poem, there is still the wit of borrowing and adapting a figure for new purposes, just as Reynolds had taught his students to do. This means that West beat Reynolds with his own weapons.

Reynolds' answer came in 1780, when he exhibited *Miss Beauclerk in the Character of Una* (fig. 6).[30] This Una is sitting on the ground, her hands folded in her lap, and her eyes cast down modestly.[31] She recalls rather a Madonna of the Humility than a Venetian nymph. Compared to West's version, this is a literal translation from literature into painting. It is *ut pictura poesis* as championed by Reynolds, applied to portraiture with the end of ennobling sitter, portrait, and painter all. The demure behavior is portrayed as a characteristic of the sitter, and it is also appropriate for Una as described by Spenser.

The newspaper reviews celebrated the picture as the incarnation of female beauty

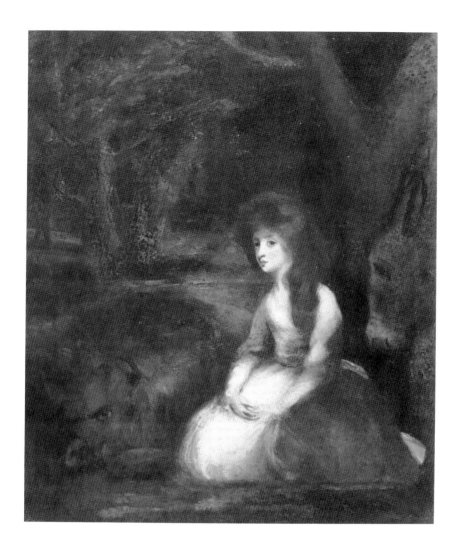

6. Joshua Reynolds, *Portrait of Miss Mary Beauclerk as Una*, 1777, oil on canvas
Harvard University Art Museums, Fogg Art Museum, Cambridge, Gift – Herbert Daniel Stone

formed her into a fairy in tender embrace with the lion. George Stubbs' portrait of Isabella Saltensell (1782) is a further example of Una as a portrait pattern.[35]

Another pattern made fashionable by Reynolds was that of the role of Hebe, the young cup-bearer of the gods. His first example, *Mrs. Pownall as Hebe* (fig. 7), dates back to 1762. It shows the sitter as a full-length figure standing on Olympus, holding the ewer and turning her face toward the beholder. This picture was followed by *Miss Mary Meyer as Hebe*, exhibited in 1772 (fig. 8), and *Mrs. Musters as Hebe*, exhibited in 1785.[36] Cotes exhibited his now lost version of Hebe at the Royal Academy in 1769.[37] Gavin Hamilton painted a Hebe in the late 1760s (fig. 9),[38] and George Romney joined the fashion in about 1776 with his portrait of Elizabeth Warren as Hebe.[39] West painted three women in this fashionable role in the late 1770s (fig. 10).[40]

The Hebe portraits by Hamilton and West seem to be more indebted to an allegorical formula used in eighteenth-century France – for example, Nattier's *Portrait of Madame de Caumartin as Hebe* (1753) – insofar as they are half-lengths, whereas Reynolds' versions are full-length portraits.[41] In comparison to the arabesque outline of the French prototype, Hamilton classicized the subject by changing the dress and hairstyle of the sitter to a kind of antiquish drapery, and he enlarged the eagle to heroic grandeur. West, in turn, tamed the subject to bring it into accordance with the rules of decorum for portraiture. His sitters are decently clad, and the eagle is reduced in size to make a proper domesticated attribute. From here, it was only a step to portraits like the idyllic scenes of ladies feeding poultry.[42]

The adaptation of the French representations of Hebe to British taste proved to be so successful that it made its way into literature. These portraits of Hebe are an instance of painting influencing literature, maybe of *ut pictura poesis*. In the *Vicar of Wakefield* (1766), Oliver Goldsmith compared a young girl to Hebe: "Olivia, now about eighteen, had that luxuriary of beauty with which painters generally draw Hebe; open, sprightly, and commanding."[43] Nicholas Penny tries to explain why the Hebe pattern was so fashionable: "Hebe, who

and virtue, which proves the congruence of the individual sitter and the ideal of a young girl in general: "a Lady in the Character of Spenser's Una, which is a perfect Picture of Beauty, Innocence and Simplicity."[32] This formula of a kneeling girl dressed in white under the shelter of a tree was one of Reynolds' standard patterns for girls, characterizing them as innocent, shy, and vulnerable. The most famous example is the *Age of Innocence* (1788).[33]

Una made a career as portrait pattern. After her first solo appearance as a Chelsea porcelain figure in the 1760s,[34] West introduced her into painting. John Hamilton Mortimer illustrated the scene in Bell's 1778 edition of the *Faerie Queene*. In 1780, Reynolds painted his Una. Henry Fuseli drew her (1780–1790); Richard Cosway trans-

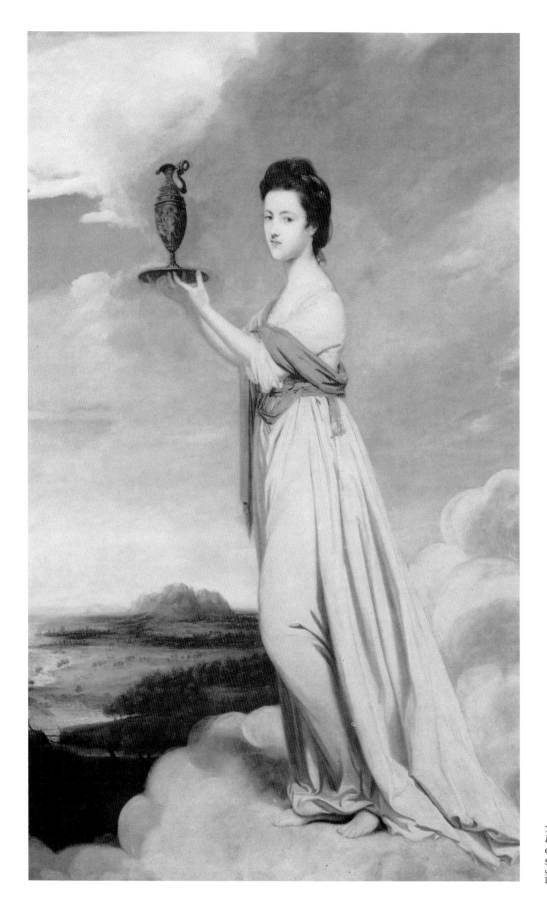

7. Joshua Reynolds, *Mrs. Pownall as Hebe*, 1762, oil on canvas
Sale, Sotheby's, London, 9 December 1981, lot 169

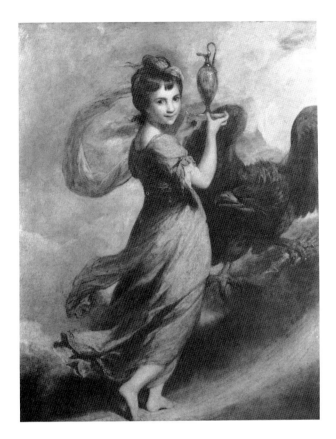

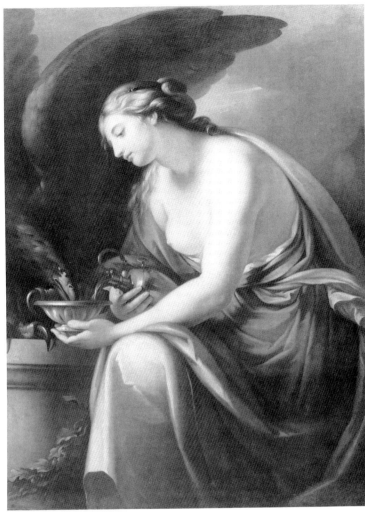

8. Joshua Reynolds,
Miss Mary Meyer as Hebe,
1771–1772, oil on canvas
National Trust, Ascott
Photograph: Courtauld Institute of
Art, London

9. Gavin Hamilton, *Hebe
Giving a Drink to the Eagle
of Jupiter*, c. 1767, oil on
canvas
Stanford University Museum of Art,
Gift of the Committee for Art at
Stanford

served nectar to Jupiter (represented here in the shape of an eagle), seems to have done nothing improper, so ladies were content to be associated with her, and their husbands and fathers were doubtless gratified by the theme of gracious and decorous service to male needs."[44]

British Innovations in Historical Painting

The exhibitions of 1772 and 1773 mark a peak in the pictorial discussion between Reynolds and West as portrait painters. In 1772, West exhibited his comment on Reynolds' *Juno and Venus* and initiated Una as a pattern for the historical portrait. Furthermore, in 1773, Reynolds began to intrude into West's field as a painter of historical subjects. It must have hurt Reynolds to see West gain royal patronage so soon after his arrival in London, whereas he himself had to struggle to obtain sittings from George III even after he had been finally appointed Portrait Painter to the King in 1784. While West received an annual stipend of one thousand pounds sterling from 1780 until 1810, Reynolds was furious that the king's rat-catcher earned more than he himself did.[45] Remarks in newspapers may also have been a thorn in his flesh, as in this example:

What can exceed our charming History Painter, Mr. West, in the correctness of his Composition, the Harmony of his Stile, or the Delicacy of his Colouring? Let it be remembered likewise to the Praise of this admirable Artist, that he has ventured to walk in a Path unmarked by the Traces of

any British Painter. Portrait-Painting has had its Day, and the Name of Sir Joshua Reynolds must be handed down with Honor to Posterity, for the great Share he took in reducing Painting to a Science at the same Time that he abolished by his Example the false Taste which Sir Godfrey Kneller's Pieces had everywhere authorised. But the Superiority of History-painting, over Works of every Kind, is now universally acknowledged.[46]

For Reynolds, 1773 was the first year to exhibit a historical painting in what he called the "grand style" – *Count Ugolino and His Sons in the Dungeon*, a scene from Dante's *Inferno* (Canto 33) (fig. 11).[47] In the same year, West exhibited *The Cave of Despair* from Spenser's *Faerie Queene* (Book 1, canto 9) (fig. 12).[48]

Spenser described the inhabitant of the cave as Despaire sitting on the ground, his clothes ragged, half-starved, with a "deadly-dull" look, surrounded by the weapons he has to offer for suicide and his victims in different phases of decay. Despaire has induced the Red Cross Knight to attempt suicide, but Una, running in from the left side of the picture, intervenes just in time. West translated this scene into the medium of paint, relying in his depiction on Salvator Rosa's *Dream of Aeneas* (fig. 13), with special reference to the setting of the figure, indicating "melancholy."[49]

Reynolds' painting treats a similar subject of despair: Count Ugolino and his sons in prison. The moment depicted is when Ugolino hears the prison door bolted even more firmly and realizes that they are to starve. Ugolino becomes petrified with grief, while his sons, who do not comprehend the situation, are terrified by their father's reaction.

At first sight, Reynolds' choice of this subject is surprising. There had been no previous Ugolino depictions in British art, and Dante was not widely known in Britain at that date. Therefore, the exhibition catalogue quoted the relevant lines from Dante, and Reynolds himself had inscribed them, albeit with slight inaccuracies, on the painting.[50] However, there was a growing interest in Dante. Giuseppe Baretti and Joseph Warton, both friends of Reynolds, had translated this Dante passage, and the *London*

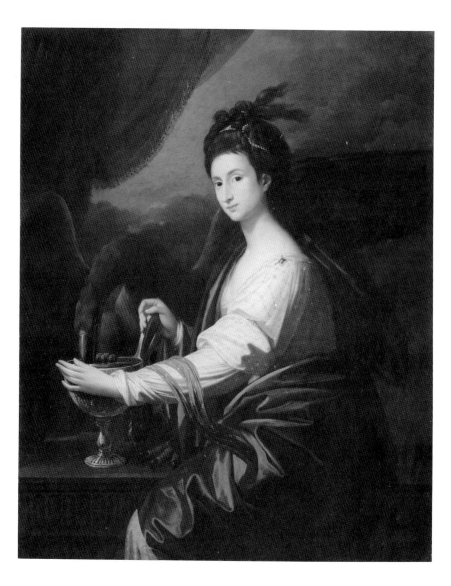

10. Benjamin West, *Mrs. Jonathan Worrell as Hebe*, c. 1775–1778, oil on canvas Tate Gallery, London

Chronicle proudly referred to its publication of Lord Carlisle's partial translation.[51] Jonathan Richardson had it translated into blank verse before this, when he referred to a relief of this subject, which he attributed to Michelangelo, but which is actually by Pierino da Vinci: "Michael Angelo was the fittest man that ever lived to cut, or paint, this story; . . . he was a Dante in his way, and read him perpetually."[52]

Richardson recommended this subject as one by which a sculptor or painter could prove his equivalence to a poet. Richardson indulged in a description of a hypothetical painting of this scene:

And could we see the same story painted by the same great master, it will easily be

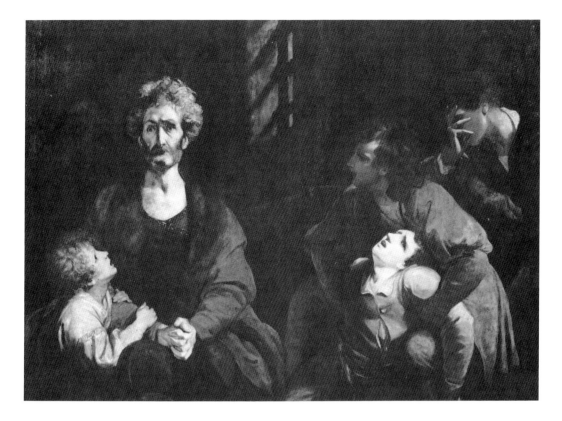

conceived that this must carry the matter still farther; there we might have had all the advantage of expression which the addition of colours would have given; . . . these would have shewn us the pale and livid flesh of the dead and dying figures; the redness of eyes and bluish lips of the count, the darkness and horror of the prison, and other circumstances besides the habits. . . . There are certain ideas which cannot be communicated by words, but by sculpture or painting only.[53]

This was exactly what Reynolds had been looking for. He chose this moment, which according to Richardson is beyond words, when Ugolino is petrified, when he can neither weep nor speak to his sons. By executing Richardson's unpainted model for the paragon of painting and poetry, Reynolds, who championed the equivalence of poetry and painting in his discourses, styled himself another Michelangelo for the sake of both British historical painting and his own. So Reynolds' *Ugolino* relies on the authorities of Dante, Michelangelo, and Richardson.

In addition, Reynolds borrowed from Michelangelo: not from the attributed relief, but from the Sistine ceiling. It is one of Christ's ancestors from the lunettes, which Reynolds probably knew by a print of Adamo Scultori.[54] Nathaniel Hone identified Reynolds' source in his violent attack on Reynolds' practice of borrowing, known as the *Conjuror*.[55]

The group of the fainting or dying son who is supported by his brother quotes in reverse the group of the two Marys from Annibale Carracci's *Pietà* (fig. 14). As Reynolds again and again explained in his discourses, the Carracci were the best examples to demonstrate what "grand style" should be like; their style is paradigmatic of what he called "the language of the painters." This refers to *ut pictura poesis*. As both words and colors function as a means of communication, "Stile in Painting is the same as in Writing." The style of a painting or poem decides whether the subject appears mean or dignified. These statements were written at the same time as the *Ugolino* was painted.[56]

For both Reynolds, the painter of historical portraits, and West, the painter of classical histories, these pictures were experiments in a new realm, the sublime. Richardson defined the sublime as the high-

est degree of the excellent.[57] In his discourses, Reynolds correspondingly coupled the sublime with his definition of the grand style, which was reserved for historical painting. Salvator Rosa was made an ancestor of this new notion of the sublime. The style of his works was regarded as the prototype of the irregular and picturesque. Richardson provided the link between the "irregularity" of Rosa's style and the sublime: "The sublime is consistent with great irregularity; nay that Irregularity may produce that Noble effect. . . . The Sublime therefore must be Marvellous, and Surprizing. It must strike vehemently upon the Mind, and fill, and Captivate it Irresistibly."[58] This is very close to Reynolds' definition of the grand style: "The sublime in Painting, as in Poetry, so overpowers, and takes such a possession of the whole mind, that no room is left for attention to minute criticism."[59]

In his treatise *A Philosophical Enquiry into the Origins of Our Ideas of the Sublime and the Beautiful* (1756), Edmund Burke had contrasted "beauty" and "sublime" because of their different, even opposite, effects on the mind. Beauty inspires love, but the sublime, whose source is among other things "terror," evokes fear.[60]

Warton had praised both Michelangelo and Dante as "great masters in the Terrible," and Reynolds himself cited Michelangelo constantly as the master of the grand style. Reynolds' and West's subject is utmost human pain, despair, and isolation — according to Burke another source of the sublime, for "turning upon pain may be a source of the sublime. . . . The total and perpetual exclusion from all society, is as great a positive pain as can almost be conceived." And again, "all *general* privations are great, because they are all terrible; *Vacuity, Darkness, Solitude,* and *Silence.*"[61]

Both pictures are painted in dark brown colors. These were regarded as "trademarks" of the sublime, contributing to the solemnity and awe of the subject. In Richardson's words, "Here are certain sentiments of Awe, and Devotion which ought to be rais'd by the first Sight of Pictures of that Subject, which that Solemn Colouring contributes very much to, but not the more Bright, though upon other Occasion pref-

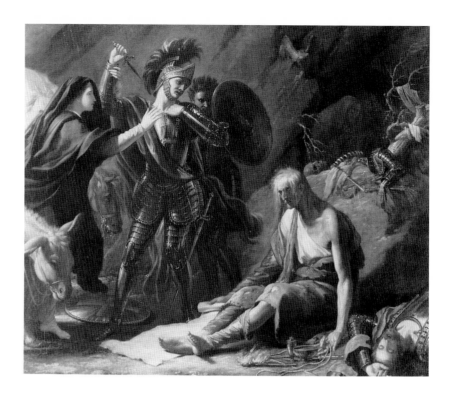

12. Benjamin West, *The Cave of Despair*, 1772, oil on canvas
Yale Center for British Art, New Haven, Paul Mellon Collection

erable."[62] These dark colors aimed at creating the sublime, as Burke explained, for example, in a paragraph on "COLOUR considered as productive of the SUBLIME": "Among colours, such as are soft, or cheerful, . . . are unfit to produce grand images . . . when the highest degree of the sublime is intended, the materials and ornaments ought neither to be white, nor green, nor yellow, nor blue, nor of a pale red, nor violet, nor spotted, but of sad and fuscous colours, as black, or brown, or deep purple, and the like."[63]

It is striking that Reynolds' *Ugolino* is not as "irregular" as the "sublime" was supposed to be. This is probably due to the origin of the painting. It is uncertain whether *Ugolino* was intended as such from the beginning. Originally, the picture seems to have been just a head of the model George White, who sat also for Reynolds' picture of Resignation, a character from Goldsmith's *Deserted Village*, exhibited in 1771,[64] and for the *Captain of Banditti*, exhibited in 1772[65] (fig. 15). According to the print made after this painting, this is in emulation of Salvator Rosa. At some time between 1766 and 1770 the canvas was extended to incorporate the additional figures

13. Salvator Rosa, *The Dream of Aeneas*, 1662, oil on canvas Metropolitan Museum of Art, New York, Rogers Fund, 1965

of the sons. The study of the head may have been painted as early as 1766; in 1770, however, Reynolds worked on the *Ugolino*.[66] The painting dates back to the beginning of Reynolds' presidency of the Royal Academy, whose declared aim was among other things the promotion of historical painting. Reynolds may have felt obliged to contribute to this goal not only in theory but also in practice. In his discourses, Reynolds described the theory of history painting in full, but when it came to painting historical pictures, he was less experienced.

West, the "American" painter, chose a British author for his production of a sublime history painting. His pictorial source was the Italian Salvator Rosa. Reynolds, the British painter, drew his subject from Italian literature and Italian painting, but his invention rested on the suggestions of a British painter and theorist. Both Reynolds and West endeavored not merely to illustrate a literary character but to create a pictorial equivalent. The notorious topos *ut pictura poesis* was so often employed to rank painting "as a sister of poetry"[67] that these constant efforts to create an equivalence clearly indicate its lack.

The congeniality in style of the two paintings was marked by a newspaper review, which stated, "This piece [*The Cave of Despair*] is much in the same stile with that of Count Hugulino [*sic*] and her [*sic*] sons, and would, if possible, be still more terrible, were it not that we are convinced it is founded upon a fable, whereas the other is built upon real history."[68] This slight criticism gives Reynolds' picture the preference. Many of the reviews praised both paintings in terms of "warmest admiration."[69] However, there were some less flattering opinions, and other contemporary critics were not altogether favorable to Reynolds' experiment in the sublime:

Sir, . . . let me advise you to keep to your Portrait Painting . . . the painting of history is new and strange to you, as appears too evidently from your unfledged picture last year of Venus and Cupid casting up accounts,[70] and the Ugolino and his family now in the present exhibition. Why, Sir, if these pictures were shewn even in France or Italy, where you ever may be so little known, every body would, at the first glance, judge them to be the rude disorderly abortions of an unstudied man, of a portrait painter, who quitting the confined track where he was calculated to move in safety, had ridiculously bewildered himself in unknown regions, unfurnished with either chart or compass. Be advised, Sir Joshua, keep to your portraits, which will do you and your country credit, and leave history painting (as you do watchmaking or navigation) to those who have studied it.[71]

No such comments were being made about West's *Cave of Despair*. Apparently, art critics more willingly accepted innovations from West than from Reynolds. Obviously, this is still the effect of the old identification of British painting with portraiture, whereas artists not born in Britain were supposed to be more gifted for historical painting.[72] West had been born in the colonies, in Pennsylvania. He kept a certain flair of Americanness, although he was born a British subject and remained British throughout his life. Having left the colonies at the age of twenty-two in 1760, he settled three

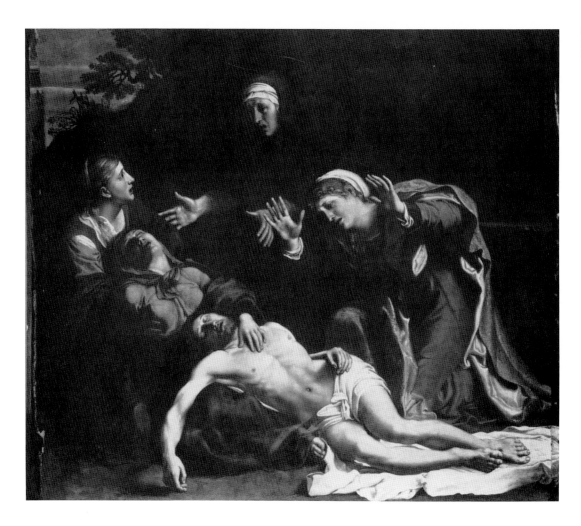

14. Annibale Carracci, *Pietà*, 1605, oil on canvas
National Gallery, London

years later in London and stayed there until his death in 1820. In 1772, he became Historical Painter to the British king, and in 1792 he succeeded Reynolds as president of the Royal Academy. Even though his working life was spent in Britain, American painters followed him across the Atlantic, and in many collections he figures as an American painter.

West had established himself as a history painter from his arrival in London. His steady output of history paintings in the neoclassical style had always been met with approval. In addition, he had enjoyed royal favor for about four years when he exhibited his *Cave of Despair*. His well-established reputation provided a much better starting point for innovations than Reynolds had. The *Death of General Wolfe* exhibited in 1771 had not changed this.[73] Reynolds, however, was just taking his first steps in history painting.

In spite of some criticism, both the *Ugolino* and the *Cave of Despair* found numerous imitators among artists. Mortimer's illustration for Bell's edition of the *Faerie Queene* in 1778 included the subject. In 1818, the *Cave of Despair* even became the subject of the painting prize at the Royal Academy.[74] The after-life of *Ugolino* has been explored by Busch and by Yates, who have traced it to Jean Baptiste Carpeaux.[75] The latter is an instance in which French artists took over a subject of painting that had become "British."

The frontality of Ugolino, combined with his stare, became a standard pattern for the flood of representations of Ugolino that followed, as Fuseli's[76] and Blake's[77] versions demonstrate.[78] Both new translations and new paintings helped to turn Ugolino into a synonym for Dante. The skeptical critics were proved wrong by the artists, who made Reynolds' first excursion into the sublime

a nearly perfect success. In fact, both pictures were a success, and it is difficult to decide whether this success depended most on the paintings themselves, their "sublime" subjects, their inventors, and/or the fashion for the sublime. In general, pictures of captives, prisons, and caves became fashionable during the second half of the eighteenth century.[79] Taken altogether, Reynolds' and West's pictures helped to establish or confirm the taste for such imagery, whether in painting or in literature. Literary imagery transformed into painted images supported Reynolds' beloved classical doctrine *ut pictura poesis*[80] as well as the rise of the new picturesque and romantic taste. Warton's wish for British subject matter had, at least in part, finally come true.

NOTES

This article is based on a public lecture I gave as a John Paul Getty Fellow. I would like to thank Elizabeth Cropper, Ronald Paulson, and Walter Melion for reading the manuscript, correcting my sometimes strange English, and making valuable suggestions.

1. The memorandum is dated 28 November 1768 (Minutes of the General Assemblies of the Academicians of the Royal Academy of Arts, 1768, Royal Academy of Arts, London).

2. Ellis K. Waterhouse, *Painting in Britain, 1530–1790* (Harmondsworth, 1953); Johannes Dobai, *Die Kunstliteratur des Klassizismus und der Romantik in England*, 3 vols. (Bern, 1974–1977), 2:1102–1132.

3. Since the union with Scotland in 1707, the term *Britain* should be used. But because England played the leading part in this union, *English* is often used instead of *British*.

4. Horace Walpole, *Anecdotes of Painting in England; with some Account of the Principal Artists, and incidental Notes on other Arts . . . Collected by the Late George Vertue, digested and published from his original Mss* (Strawberry Hill, 1762–1771).

5. Their history has been told best in Dobai, 1974–1977, 2:1101–1152.

6. An example is Robert Baker, *Observations on Pictures Now in Exhibition* (London, 1771).

7. These were *Angelica and Medoro* (University Art Gallery, State University of New York at Binghamton), Helmut von Erffa and Allen Staley, *The Paintings of Benjamin West* (New Haven, 1986) von Erffa and Staley

1986, nos. 188–191; *Cymon and Iphigenia* (location unknown), nos. 195–197; and *A Gentleman, Whole Length* (General Robert Monckton) (Trustees of Lady Galway's Settlement): von Erffa and Staley 1986, no. 665.

8. Joseph Warton, *An Essay on the Genius and Writings of Pope*, 2 vols. (London, 1764), 5th rev. ed. (London, 1806), 2:29.

9. Laurel Bradley, "Eighteenth-Century Paintings and Illustrations of Spenser's *Faerie Queene*: A Study in Taste," *Marsyas* 20 (1979–1980), 31–51, esp. 32–33.

10. Warton 1764, 1:219; Warton 1806, 1:272.

11. John Sunderland, "Mortimer, Pine and Some Political Aspects of English Historical Painting," *Burlington Magazine* 116 (1974), 317–326, n. 34.

12. Joseph Addison and Richard Steele, *The Spectator*, ed. with introduction and notes by Donald F. Bond (Oxford, 1965), issue of 6 December 1712. The original was issued in 635 numbers from 1 March 1711 to 6 December 1712, and from 18 June 1714 to 20 December 1714.

13. Jonathan Richardson, *An Essay on the Theory of Painting* (London, 1715), 223–224.

14. Joshua Reynolds, *Discourses on Art*, ed. with introduction by Robert Wark (San Marino, Calif., 1959), 60 (Discourse IV).

15. Anthony Ashley Cooper, Earl of Shaftesbury, *Characteristics of Men, Manners, Opinions, Times*, 3 vols. (London, 1713), Treatise VII, "A Notion of the Historical Draught, or Tablature of the Judgment of Her-

cules, According to Prodicus, Lib. II. Xen de mem Socr."
He explained the case using the subject of "Hercules
at the Crossroads" as the example. Reynolds delivered
his version of the subject in 1761 in the form of a
parody known as *Garrick Between Comedy and Trag-
edy* (private collection). For a summary of the discus-
sions of this painting and for bibliography, see Nicho-
las Penny, *Reynolds* [exh. cat., Royal Academy of Arts,
London] (London 1986), no. 42. West did not lose time
and painted his *Choice of Hercules* (Victoria and Albert
Museum, London) in 1764, shortly after his arrival in
London, but he did not exhibit it in public. See von
Erffa and Staley 1986, no. 143.

16. Reynolds' portrait of Lady Stanhope in the Balti-
more Museum of Art is a rare exception, showing her
as a woman of letters and a connoisseur.

17. Blakeslee sale (New York, 1915), present where-
abouts unknown.

18. Von Erffa and Staley 1986, no. 169. The review
appeared in *The Middlesex Journal* (28–30 April 1772):
"The whole affair of the *Cestus* is related at great
length by Homer in the 14th Book of the Iliad. That
particular part of it which forms the subject of the
present piece, is thus described:

*She said. With awe divine the Queen of Love
Obey'd the sister and the wife of Jove:
And from the fragrant breast the zone embrac'd
With various skill and high embroidery grac'd.
In this was ev'ry art and ev'ry charm,
To win the wisest, and the coldest warm:
Fond love, the gentle row, the gay desire,
The kind deceit, and still reviving fire,
Persuasive speech, and more persuasive sighs,
Silence that spoke, and eloquence of eyes.
This on her hand the Cyprian Goddess Laid;
Take this, and with it all they wish, she said.
With smiles she took the charms, and smiling prest
The powerful Cestus to her snowy breast.*

Poets and Painters mutually borrow their subjects from
one another and both of them, in their turn, may im-
prove on what they borrow. Poets are unlimited in
point of time, but at one time they can only introduce
one circumstance. Painters, on the contrary, are con-
fined to one point of time, but in that one point they
can introduce many circumstances. Mr. West has availed
himself of this privilege of his art. Neither Cupid nor
the Graces are mentioned by Homer in the above quoted
passage. Both of them are represented by Mr. West in
this picture. Venus delivers and Juno receives the Ces-
tus, as if fully convinced of its wonderful efficacy, but
as if at the same time they entertained a doubt of its
proving as powerful in the hands of the latter as in
those of the former. Cupid, by his look confirms their
suspicion. He seems to say with eyes, 'Indeed, Juno,
you may take the Cesture, but with that and every
other ornament of dress, you will never be so lovely
as my mother.' "
I am grateful to John Sunderland for permission to
quote from the Witt Index of Royal Academy Exhi-
bitions.

19. Edgar Wind, "Charity: The Case History of a Pat-
tern," *The Journal of the Warburg and Courtauld In-
stitutes* 1 (1937–1938), 322–330; Hans Kauffmann,
*Giovanni Lorenzo Bernini: Die figürlichen Komposi-
tionen* (Berlin, 1970), 122.

20. Wind 1937–1938, 322–325.

21. One is owned by the National Trust, Petworth
(c. 1780, Collection of the Earl of Egremont); the other,
the design for a window at New College, Oxford (pri-
vate collection, England), was exhibited at the Royal
Academy, 1779.

22. *The Middlesex Journal* (28–30 April 1772) (see note
18 above); Walpole's copy of the exhibition catalogue,
quoted by Algernon Graves, *The Royal Academy of
Arts: A Complete Dictionary of Contributors and Their
Work from Its Foundation in 1769 to 1904*, 8 vols.
(London, 1906), 8:213; Reynolds 1959, 39–53 (Dis-
course 3, 1770).

23. *The Departure of Regulus from Rome* (1769, Royal
Collection, London), von Erffa and Staley 1986, nos.
10–12; *Venus Lamenting the Death of Adonis* (1768,
retouched 1819, Museum of Art, Carnegie Institute,
Pittsburgh), von Erffa and Staley 1986, nos. 116–117.

24. *Lloyd's Evening Post, And British Chronicle* (1–3
May 1769); *The St. James's Chronicle, Or, British Eve-
ning Post* (2–4 May 1769); *The Whitehall Evening Post:
Or, London Intelligencer* (2–4 May 1769); *The Gaz-
etteer and New Daily Advertiser* (5 May 1769; Walpole
quoted in Graves 1906, 6:270.

25. Von Erffa and Staley 1986, no. 218.

26. *The Middlesex Journal* (25–28 April 1772):

*IV One day, nigh waerie of the yrkesome way,
From her unhastie beast she did alight;
And on the grasse her dainty limbs did lay
In the secrete shadow, far from all mens sight:
From her fayre head her fillet she undight,
And layd her stole aside. Her angels face,
As the great eye of heaven, shyned bright,
And made a sunshine in the shady place;
Did ever mortal eye behold such heavenly grace.*

*V It fortuned, out of the thickest wood
A ramping Lyon rushed suddeinly,
Hunting full greedy after salvage blood—
Soone as the royall virgin he did spy,
With gaping mouth at her ran greedily,
To have at once devourd her tender corse;
But to the pray when as he drew more ny,
His bloody rage aswaged with remorse,
And, with the sight amazd, forgat his furious forse.*

*VI In stead thereof he kist her wearie feet,
And lickt her lilly hands with fawning tong.*

Quoted by von Erffa and Staley 1986, 277, no. 218,
with slight alterations from the Witt Index of Royal
Academy Exhibitions.

27. Von Erffa and Staley 1986, no. 218. According to
the files of the Wadsworth Atheneum, quoted by the
Witt Index of Royal Academy Exhibitions, West's wife
"was presumed to be the model for Una." For the
symbol of the ass, see John M. Steadman, "Una and
the Clergy: The Ass Symbol in *The Faerie Queene*,"

Journal of the Warburg and Courtauld Institutes 21 (1958), 134–137.

28. See note 26, stanza IV.

29. Reynolds 1959, 64–65 (Discourse 4).

30. A reduced version in a private collection, England. It is unclear which version was exhibited.

31. The print by Watson, published 15 April 1782, bore the lines: "Nought is there under heaven's wide hollowness, / That moves more deare compassion of mind, / Than beautie brought t'unworthie Wretchednesse, / Thro' envie's snares, or fortune's freakes unkind! — / Vide Spencer's Fairy Queene, Canto III."

32. The quotation is from *The Public Advertiser* (2 May 1780), "A Candid Review": "This is one of the sweetest Portraits we ever saw — it is the likeness of Miss Beauclerc. The story is finely told; the landscape beautiful and altogether it forms an admirable picture."
The Morning Chronicle, and London Advertiser (20 May 1780), signed "Candid": "the character of Una, by the President, is a design of such real merit, and greatness of stile, that I think I am warranted in saying he has made Virtue more lovely by it, and has shown us the human face divine. The execution of this piece . . . excite[s] fresh astonishment at the magic power of the pencil of this artist."
The St. James's Chronicle, or, British Evening Post (6–9 May 1780): "This, we are told, is designed for a Portrait of Miss Beauclerc. The upper Part of the Figure is enchanting; but the lower is offensive, from a Fault which Sir Joshua has more than once committed; that of placing his Figures in an equivocal Attitude, as if they were stiffened in the Art of curtseying."
The Morning Post, and Daily Advertiser (2 May 1780): "'Spencer's Una', is a most beautiful portrait, and characteristically descriptive of

— 'the fairest Una *found*,
'Strange Lady in so strange *habiliment*,
'Teaching the Satyrs which her sat around,
'Trew sacred love, which from her sweet lips
 redound.'"

Walpole commented on West's version: "Una too old, her right leg ill drawn. Lion has no dignity, a poor picture," whereas he commented on Reynolds' Una: "wants chiaroscuro Miss Mary Beauclerk eldest daughter of Mr. Topham Beauclerk and Lady Diana Beauclerk, very sweet." Quoted in Graves 1906, 6:273–274.

33. Tate Gallery, London (copy in the City Museum and Art Gallery, Plymouth). For the copy see Penny 1986, no. 145. According to family tradition, the sitter was Reynolds' grand-niece Theophila Palmer, born in 1782.

34. See Bradley 1979–1980, 41 n. 83, fig. 14.

35. For Fuseli, see Gert Schiff, *Johann Heinrich Füssli* (Zürich, 1973), no. 811 (Kupferstichkabinett, Staatliche Museen Berlin). Cosway's portrayal, engraved by Maria Cosway, is illustrated in Bradley 1979–1980, fig. 18; Stubbs' version is *Isabella Saltensell as Spenser's Una* (Fitzwilliam Museum, Cambridge).

36. The Iveagh Bequest, Kenwood.

37. Edward Mead Johnson, *Francis Cotes: Complete Edition with a Critical Essay and a Catalogue* (Oxford, 1976), 100: "Exhibited in 1769: A lost portrait in pastel. A Lady as Hebe; Present whereabouts unknown. Pastel on Paper, measurements unknown. Possibly signed and dated. . . . The catalogue description reads: 'A young lady ditto (in crayons) in the Character of Hebe.' Walpole noted in his copy of the catalogue 'very pretty.'"

38. The original is in the collection of the Marquess of Exeter. See Françoise Forster-Hahn, "After Guercino or After the Greeks? Gavin Hamilton's 'Hebe': Tradition and Change in the 1760's," *Burlington Magazine* 117 (1975), 365–371.

39. Private collection, on loan to the National Museum of Wales, Cardiff.

40. *Mrs. Jonathan Worrell* (c. 1775–1777, Tate Gallery, London), von Erffa and Staley 1986, no. 721; *Grizzel Dundas* (c. 1777, private collection), no. 613; *An Anonymous Lady* (1778, E. Deane Turner), no. 733.

41. See Robert Rosenblum, "Reynolds in an International Milieu," in Penny 1986, 43–54. Forster-Hahn 1975 gives the credit of creating the Hebe fashion in Great Britain to Hamilton, but the existence of Reynolds' earlier portrait of Mrs. Pownall as Hebe has escaped her attention. Nattier's portrait of 1753 is in the National Gallery of Art, Washington, D.C.; Rosenblum 1986 examines the influence of French painting on British painting.

42. *Mrs. Pelham Feeding Poultry* (exhibited Royal Academy 1774, the earl of Yarborough, Brocklesby Park); *Mrs. and Miss Macklin and Miss Potts (The Cottagers)* (1788, the earl of Radnor, Longford Castle).

43. Oliver Goldsmith, *The Vicar of Wakefield*, ed. with introduction by Arthur Friedman (London, 1974), 11.

44. Penny 1986, nos. 81, 251.

45. Joshua Reynolds, *Letters*, coll. and ed. Frederick W. Hilles (Cambridge, 1929), 112–113.

46. *The Public Advertiser* (26 May 1773). *The Middlesex Journal* (1–4 May 1773) had a similar opinion: "From the specimens Mr. West has already given the public in history painting, he is now justly considered as one of the first in this country; his pieces now in this exhibition still add to his character."

47. Penny 1986, no. 82.

48. Von Erffa and Staley 1986, nos. 220–221.

49. Before West, two other artists had treated the subject. Henry Fuseli's drawing of c. 1769 (pen and brown ink, brown wash, black chalk, and brown and red-purple watercolor; Schiff 1973, no. 338) had been preceded by William Kent's version for the first extensively illustrated edition of the *Faerie Queene* by Bell in 1751. Rosa had served as a model for Reynolds' character of *Resignation* and the *Captain of Banditti*, exhibited at the Royal Academy in 1771 and 1772 respectively.

50. Quoted in Graves 1906, 6:271: "Io non piangeva, sì dentro impetrai: / Piangevan Elli; ed Anselmuccio

mio / Disse: Tu guardi sì, Padre! Che hai? / Pero non lagrimai nè risposo'io / Tutto quel giorno nè la notte appresso."

51. *The London Chronicle* (15–18 May 1773); Frederick Howard, fourth Earl of Carlisle, *Poems* (London, 1772 [privately printed]), 2d ed., 1773. Published as well in the *Annual Register* (1773), 230–232. See Frances A. Yates, "Transformations of Dante's Ugolino," *Journal of the Warburg and Courtauld Institutes* 14 (1951), 92–117, for detailed information about the various translations.

52. Jonathan Richardson, *A Discourse on the Dignity, Certainty, Pleasure and Advantage, of the Science of a Connoisseur* (London, 1719), rpt. in *The Works of Mr. Jonathan Richardson* (London, 1773), 241–346. The quotation is in Richardson 1773, 262.

53. Richardson 1719, 26–35; Richardson 1773, 262.

54. See Penny 1986, no. 83a; and John Newman, "Reynolds and Hone: 'The Conjuror Unmasked'," in Penny 1986, 344–354.

55. Exhibited at the Royal Academy, 1775, withdrawn (National Gallery of Ireland, Dublin). See Penny 1986, no. 173, for further information and bibliography.

56. Reynolds 1959, 64 (Discourse 4), 32 (Discourse 2), 236–237 (Discourse 13).

57. Jonathan Richardson, *An Essay on the Theory of Painting* (London, 1715), 226–255.

58. Richardson 1719, 35. This refers to writing, but Richardson championed *ut pictura poesis*, so that this remark can be applied to painting as well.

59. Reynolds 1959, 65 (Discourse 4), and 276 (quotation from Discourse 15).

60. Edmund Burke, *A Philosophical Enquiry into the Origins of Our Ideas of the Sublime and the Beautiful* (London, 1756), ed. with introduction and annotations by James T. Boulton (London, 1958); Walter Jackson Bate, *From Classic to Romantic: Premises of Taste in Eighteenth-Century England* (Cambridge, Mass., 1946); Edgar Wind, "Humanitätsidee und heroisiertes Porträt in der englischen Kultur des 18. Jahrhunderts," *Vorträge der Bibliothek Warburg* 9 (1930–1931), 156–229, esp. 175. For Reynolds and Burke, see Carl B. Cone, "Edmund Burke's Art Collection," *Art Bulletin* 24 (1947), 126–131; Dixon Wecter, "Sir Joshua Reynolds and the Burkes," *Philological Quarterly* 18 (1939), 301–305.

61. Warton 1806, 1:253 n.; Reynolds 1959, 263–282 (Discourse 15); Burke 1958, 44, 71.

62. Richardson 1715, 88–89.

63. Burke 1958, 81–82 (Section 16); also 124 (Section 27, "The Sublime and Beautiful compared"): "the great ought to be dark and gloomy."

64. Sedelmayer sale (Paris, 1907), present whereabouts unknown.

65. Private collection.

66. Penny 1986, no. 82.

67. Reynolds 1959, 50 (Discourse 3).

68. *The London Chronicle* (20–22 May 1773). The preference of "real history" seems to stem from Warton 1806, 1:250: "If we briefly cast our eyes over the most interesting and affecting stories, ancient or modern, we shall find that they are such, as, however adorned, and a little diversified, are yet grounded on true history, and on real matters of fact. . . . The series of events contained in these stories, seem far to surpass the utmost powers of human imagination. In the best conducted fiction, some mark of improbability and incoherence will still appear."

69. *The Middlesex Journal* (1–4 May 1773), for West.

70. The Iveagh Bequest, Kenwood, Royal Academy 1771.

71. *The Morning Chronicle, and London Advertiser* (30 April 1773). Later in the month, the same newspaper (10 May 1773) published an answer to this attack, signed "an Artist," calling the author of the first "some perturbed spirit." *The Middlesex Journal* (29 April 1773) put it more delicately: "No. 243, no doubt, is a picture that very much arrests our attention, and if we consider it in the light of a faithful and animated transcript from that passage in Dante, we must look up to it with admiration; but, with great submission to so eminent a painter's judgement as Sir Joshua Reynolds, we think such subjects unworthy a great pencil; and we are the more justified in this opinion by the following precept of the great Fresnoy:

–'Vitare memento
'Barbara, crude oculis, sordidaque
'Et miseres, et vel acuta, vel aspera tectu.'"

72. William Hogarth became a victim of this prejudice, when he painted his *Sigismunda* (1759, Tate Gallery, London); Waterhouse 1953, 123.

73. The National Gallery of Canada, Ottawa: von Erffa and Staley 1986, nos. 93–100; Edgar Wind, "The Revolution of History Painting," *Journal of the Warburg and Courtauld Institutes* 2 (1938–1939), 116–117; Charles Mitchell, "Benjamin West's 'Death of General Wolfe' and the Popular History Piece," *Journal of the Warburg and Courtauld Institutes* 7 (1944), 20–33. Both Wind and Mitchell point out that the introduction of contemporary costume into history painting was not innovative. John Galt told the story about Reynolds, who first objected to the introduction of military uniforms into historical paintings, but after having examined the finished painting, retracted his doubts and even announced: "I foresee that this picture will not only become one of the most popular, but occasion a revolution in the art." John Galt, *The Life, Studies, and Works of Benjamin West*, 2 vols. (London, 1820), facsimile rpt. ed. Nathalia Wright (Gainesville, Fla., 1960), 2:49–50. This is entirely contradictory to Reynolds' Third Discourse, delivered just five months before the exhibition of West's picture: "He [the Painter] must divest himself of all prejudices in favour of his age or country, he must disregard all local and temporary ornaments, and look only on those general habits which are everywhere and always the same. He addresses his works to the people of every country and

every age; he calls upon posterity to be his spectators, and says with Zeuxis, 'in aeternitatem pingo'" (Reynolds 1959, 40–41). Therefore, this anecdote seems to me to be an invention by Galt.

74. Von Erffa and Staley 1986, no. 220, list more examples.

75. Werner Busch, *Die notwendige Arabeske: Wirklichkeitsaneignung und Stilisierung in der deutschen Kunst des 19. Jahrhunderts* (Berlin, 1985), 212; Yates 1951, 110–117; Jean Baptiste Carpeaux, *Ugolino* (bronze, Salon 1863, Louvre, Paris).

76. The whereabouts of Fuseli's picture is unknown; Schiff 1973, no. 1200; engraving by Moses Haughton, 1811.

77. William Blake, *Gates of Paradise* (1793), "Does Thy God O Priest take such vengeance as this? Publish'd 17 May 1793 by W. Blake Lambeth." About 1826 or 1827, Blake drew illustrations to Dante, two of which illustrate the story of Ugolino (British Museum, London). These later illustrations have nothing in common with Reynolds' representation except Ugolino's frontality.

78. This formula has been described as follows: "Die extreme Stilisierung lässt die Figur des Ugolino selbst zum Symbol werden. Ugolinos Versteinerung, sein starrer Wahnsinn ist zu einer überzeugenden Paraphe des höchsten Schmerzes und der totalen Vereinzelung und Vereinsamung geronnen" (Busch 1985, 212).

79. Lorenz Eitner, "Cages, Prisons and Captives in Eighteenth-Century Art," in *Images of Romanticism: Verbal and Visual Affinities,* ed. Karl Kroeber and William Walling (New Haven, 1978), 13–38. In particular, Laurence Sterne, *A Sentimental Journey Through France and Italy* (London, 1768), in the chapter entitled "The Captive," provided the artists with a description that gave rise to numerous translations into the medium of paint: "he was sitting on the ground, upon a little straw, in the furthest corner of his dungeon, which was alternatively his chair and his bed: a little calendar of small sticks were laid at the head, notched all over with the dismal days and nights he had passed there; he had one of these little sticks in his hand, and with a rusty nail he was etching another day of misery to add to the heap." Joseph Wright of Derby painted two versions of a "Captive" (one in 1774, which is now lost, a copy in the Derby Museum and Art Gallery). A drawing for the original is in the Wadsworth Atheneum, Hartford, Conn. (pen and black wash). John Hamilton Mortimer exhibited a now lost pen and ink drawing at the Society of Artists in 1774 (etched by Robert Blyth in 1781). This was preceded by a pen, ink, and wash drawing (Oppé Collection) in 1773. Benedict Nicolson, *Joseph Wright of Derby: Painter of Light* (London, 1968), 60–61, figs. 74–76, pl. 162, and cat. no. 217.

80. At the same time, this contributed to the end of the doctrine, because the paintings developed into mere illustrations of a text. The paintings for Boydell's Shakespeare-Gallery are an example of this.

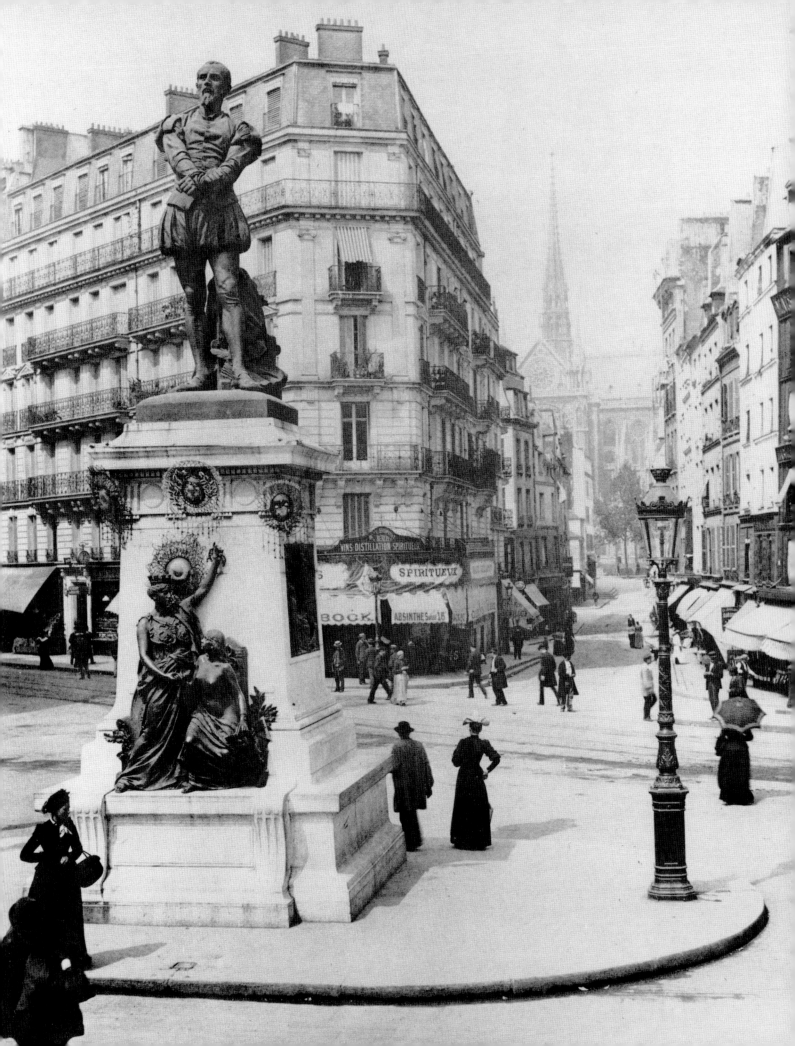

JUNE HARGROVE
University of Maryland

Shaping the National Image:

The Cult of Statues to Great Men in the Third Republic

The Third Republic was forced to invent itself, so to speak, after the unexpected collapse of the Second Empire during the Franco-Prussian War in 1870. The provisional government wobbled under rivalry among three factions: republicans, monarchists, and Bonapartists. To be governed by democratic vote necessitated a politics of the masses, of which the French had barely gotten a taste in their two brief prior republics. New tactics to establish "bonds of loyalty" had to be quickly improvised.[1] Even after the republic stabilized with the elections of 1877, shifting coalitions attempted to impose their stamp on the new state. During the power struggles that ensued, statues commemorating famous persons became weapons of advocacy.

Since the eighteenth century, a growing appreciation for the didactic potential of statues to persons of merit encouraged the practice of erecting their portraits in public spaces.[2] The concept of recognizing individuals for accomplishment rather than birth sprang from the same egalitarian philosophy of the Age of Enlightenment that had fostered the revolution. Such statues as Jean-Baptiste Pigalle's *Voltaire* (1776) established the precedent for expressing homage to a secular hero in the form of a public likeness. While celebrating the individual's achievement, the sculpted effigy singles him or her out as a paradigm worthy of emulation. The Constituent Assembly recognized the usefulness of monuments for propaganda, ordering one to honor Rousseau in 1790, although it was never realized.[3]

The tradition of statues to great men[4] had been more advocated than practiced in the hundred years before the establishment of the Third Republic, but it was a concept ripe for implementation in the more liberal atmosphere of the later nineteenth century. Sculpture in France had already adopted a more serious, nationalistic tone after the French defeat by the Prussians.[5] Commemorative statues could not only make tangible a given ideology, they also could provide an ideologically appropriate platform for voicing opinions at inaugurations and demonstrations. The heated debates between left and right echoed across the public spaces of Paris, where one hundred fifty statues of persons of merit were erected between 1870 and 1914.

The provisional government was anxious to restore confidence to the nation. As a balm for the humiliation of defeat, the equestrian statue of *Joan of Arc* (fig. 1), by Emmanuel Fremiet, was erected in 1874 on the Place des Pyramides, near where she had been wounded in battle. The Maid of Orléans was a symbol that offered something for everyone, which helps to explain her unabated popularity in the last decades of the century. Above all she signified, in the words of a contemporary, "que la France peut se ressaisir, qu'elle doit se reprendre."[6] Like James Pradier's personification of the city of Strasbourg, Fremiet's *Joan of Arc* be-

came an ex-voto to remind the French of
the loss of Alsace and Lorraine; the statue
more often than not stood covered with
wreaths and bouquets.

The Maid of Orléans was one of the few
figures that held appeal for the French
regardless of their individual political con-
victions. Most of the subjects carried an ide-
ological bias that factions were eager to ex-
ploit, but the republicans were able to do
so with greater ease than their opponents.
The very premise of commemorating men
(and eventually women) for their merits was
consonant with the fundamental principles
of the republic. Unlike the monarchists and
Bonapartists, the republicans had the dis-
tinct advantage of appropriating the mem-
ory of countless citizens to their political
persuasion. They were torn, however, by
differing visions of the nature of the republic.

The Paris Commune had left deep scars
on the national psyche. The animosities of
Parisians toward the Second Empire and the
administration were visibly acted out in such
incidents as the burning of the Hôtel de
Ville and the destruction of the Vendôme
Column. The civil war was a class war that
compounded the divisions within the re-
publican camp. In the aftermath of the com-
mune, the radical socialists dominated the
municipal council of Paris, whereas the
bourgeois conservatives controlled the
parliament.

The premature death of Léon Gambetta
gave the conservatives their first opportu-
nity to glorify federal hegemony. They
banded together in a group known as the
Democratic Alliance, the purpose of which
was to erect a monument to Gambetta (fig.
2) that touted the founding of the Third
Republic. After a much publicized compe-
tition, the work was confided to Louis-
Charles Boileau, architect, and Jean-Paul
Aubé, sculptor.

The verbose rhetoric of Gambetta's prose,
carved on the pyramid of the monument,
was matched by florid visual allegories, in-
cluding the crowning Trimph of Democ-
racy on a winged lion. The central sculp-
tural group emphasized Gambetta's role in
the national defense by borrowing its com-
position from François Rude's famous group,
La Marseillaise (The Departure of the Vol-
unteers, 1792), on the Arch of Triumph at

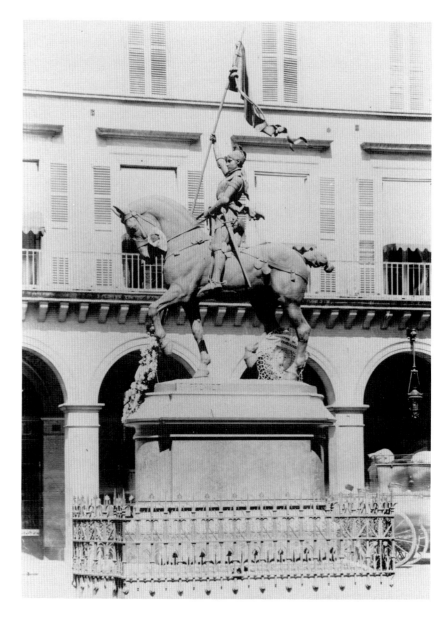

1. Emmanuel Fremiet, *Joan of
Arc*, Place des Pyramides, 22
February 1874, gilt bronze
Photograph: Collection France
Debuisson

the opposite end of the Champs-Elysées. As
extravagant as the Gambetta monument
might appear to us, the main criticism lev-
eled at the time was that the huge pyramid
disrupted the architectural harmony of its
historic environment, an argument familiar
today for its use against I. M. Pei's glass
pyramid for the Louvre, which occupies the
same site.

While the Gambetta monument com-
memorated a founder of the republic, the
municipal council chose to celebrate Etienne
Marcel, a martyr in the cause of municipal
governance. The new Hôtel de Ville, rising
out of the ashes of the old, included an ex-

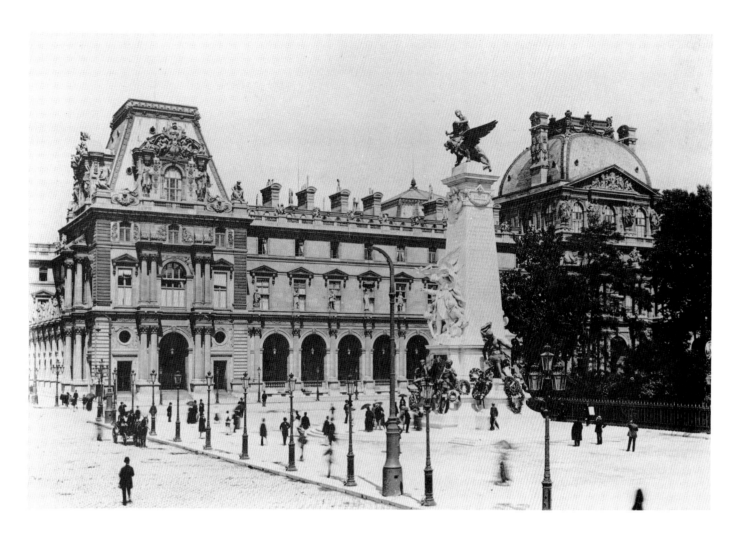

panded decorative program. Statues of historically illustrious Parisians ornamented the four facades of the building. The place of honor in the garden, facing the quay along the Seine, was assigned to the equestrian bronze of Marcel. Marcel, a medieval *prévôt des marchands* (roughly the equivalent of mayor), was assassinated during a rebellion in 1358, when he placed civic freedom above royal authority. The city held a competition in 1882, which was won by Jean-Antoine Idrac, whose model was completed after his death by Laurent Marqueste.

These two monuments were not initially intended to counter one another, but their inaugurations were deliberately juxtaposed during the festivities of Bastille Day in 1888. If a picture is worth a thousand words, and one did not preclude the other, these images squared off municipal autonomy against state sovereignty. The radicals harbored an animosity to a government that crushed the commune, and the conservatives feared a rebellious capital. This indicates the degree to which monuments became an arena for political maneuvers.

The crowned sovereign had previously held a monopoly over public homages that was abolished with the advent of a more democratic government. Henceforth the erection of statues was open to public demand. If the monument was to stand on city property, a request had to be approved by the municipal council. It then passed to the minister of the interior for approval, before the president of the republic signed a decree. Consequently, the monuments finally erected were not the result of a coherent government program, but the haphazard fruits of random committees with differing degrees of success.

About 80 percent of the one hundred fifty

3. Joseph-Michel Caillé, *François Voltaire* (shown here before installation), Quai Malaquais, 14 July 1885, bronze (destroyed c. 1942)
Photograph: Archives de Paris

4. Paul Berthet, *Jean-Jacques Rousseau* (shown here before installation), Place du Panthéon, 3 February 1889, bronze (destroyed 1942)
Photograph: Archives de Paris

statues were sponsored by private committees. Theoretically any citizen could form a committee to honor any deserving candidate. In reality, many committees were motivated by political action groups in concert with members of the municipal council. Some statues were entirely sponsored by the council.

The statues of great men project a collective vision of the French nation in the process of defining itself. At the very least, they illustrate the common values and aspirations of the French in the latter part of the nineteenth century and the beginning of the twentieth, and in many instances they were consciously intended as propaganda to advance a partisan opinion. These monuments may be divided into three broad categories, representing the republican legacy, the consensus of values, and the conflict of issues.

The Republican Legacy

The commemoration of the founders of the successive republics legitimized the status of the present system. In glorifying their historical precedents, the republicans gave credibility to their bid for power.

Voltaire and Rousseau were canonized in the nineteenth century as the spiritual fathers of the revolution. For the centenaries of their deaths in 1878, it was proposed to construct their statues (figs. 3, 4) in conjunction with the festivities, under the aegis of the municipal council.[7] These projects unleashed a bitter controversy. The atheism of Voltaire and the intolerance of Rousseau aroused an opposition that delayed these monuments for years.

If Voltaire and Rousseau proved volatile subjects, Georges Danton provoked an outrage that shook the vaults of the senate as the 1889 centennial approached. The heroes of the revolution of 1789 triggered internecine debates that revealed deep schisms. The radicals insisted that the revolution be embraced in its entirety, whereas the conservatives preferred to whitewash the less palatable episodes of the revolution. They attributed the September massacres to Danton, and the violence of the Terror was precisely what the present senate feared might erupt again if revolutionary fervor were to

BAUDIN
REPRESENTANT DU PEUPLE
1811 - 3 DECEMBRE 1851

spread too far. The monument to Danton, by Auguste Paris, is inscribed 1889, although resistance to it delayed its installation until 1891. The municipal council funded outright eight statues extolling luminaries of the revolution: Pierre-Augustin de Beaumarchais, the marquis de Condorcet, Danton, Denis Diderot (by Léon Lecointe), Jean-Paul Marat, Rousseau, Michel-Jean Sedaine, and Voltaire.[8] The state, although embroiled in the disputes over monuments like that of Danton, rarely initiated them.

The heroes of the Second Republic, the *quarante-huitards*, were likewise elevated onto pedestals as the forebears of the present republic. Although the brevity of their political ascendancy did not diminish their usefulness as role models, the stipulation that monuments for political motives were forbidden gave rise to hybrid commemorations. Individuals were frequently selected for their involvement with the 1848 revolution, while their subsequent careers were cited as the justification for the homage. For example, the Academy of Sciences organized a subscription for a monument to François Arago, who was genuinely revered for his achievements as a physicist and astronomer. At the same time, the name of Arago was inseparable from the short-lived Second Republic. Key politicans championed the statue by Alexandre Oliva, which was dedicated in 1893. Meanwhile, the marble of Urbain Le Verrier by Henri Chapu was refused on the dubious argument that he was not as great a scientist as Arago. It seems more likely that Chapu's statue was relegated to the grounds of the observatory as a penance for Le Verrier's affiliation with the Second Empire.

Ferdinand Raspail was hailed as a brilliant chemist. Fair enough, but no one was deceived. How could they be, when Raspail's name was likewise synonymous with the Second Republic? His monument, by the brothers Charles and Léopold Morice, shows Raspail as an activist and orator. One relief shows him proclaiming the republic at the Hôtel de Ville in 1848. The connection was the more pointed given the date of the monument's inauguration, in July 1889, thereby reinforcing the parallel.

Although he was a physician as well as a deputy, one of the few political heroes openly honored was Alphonse Baudin (fig. 5), who died in 1851 fighting Napoleon III on the barricades. The city purchased the model by Eugène Boverie from the Salon of 1901 to erect a bronze monument to this celebrated martyr, but the council was deprived of its just prerogative. After the elections of 1900, the left and the right had switched places, temporarily reversing the balance of power. The radicals usurped from the city the privilege of presiding at the inauguration. After a month of squabbling over protocol, the state declared that there would be no dedication; however, the president, Emile Loubet, would honor the fiftieth anniversary of Baudin's death with a ceremony at the monument. When the event occurred, a furious municipal delegation was hooted off the platform as it tried to represent the council.

Slower to emerge as candidates for commemoration, for obvious reasons, were the personalities of the Third Republic. And by the time that they did, after 1900, their significance had shifted. Whereas the monument to Gambetta asserted the supremacy of the state, those honoring Jules Ferry and Pierre Waldeck-Rousseau were singled out

to shape the profile of that authority. Both of these statesmen were moderates. While they furthered a secular republic, they were aligned with the conservative forces of property and capitalism. The committees sponsoring their statues were granted the extraordinary privilege of sites in the Tuileries, near the Gambetta monument. Since the land belonged to the state, the committees thereby circumvented the city's veto on other potential sites.

Regardless of the conflicting opinions surrounding the memories of Ferry and Waldeck-Rousseau, their monuments signified the triumph of values on which most republicans finally agreed. Ferry had consistently advanced the principle of secular education, which nurtured a devotion to the nation. To underscore this, schoolchildren paraded in their regional costumes at the inauguration on 20 November 1910 of the monument by Gustave Michel. On the back of the marble ensemble, a young patriot spreads his idealism around the world through colonial expansion, another policy that was only popularly accepted in the early years of the twentieth century.

Waldeck-Rousseau had sponsored the law of 1884 that acknowledged – and limited – the power of labor unions. Never forgiven by opponents at both ends of the political spectrum, he was considered by many to be an opportunist. In the marble monument honoring him, completed by Laurent Marqueste in 1910, a personification of the republic indicates his bust to two working-class Apollos, politely removed from the common man distrusted by the comfortable bourgeoisie. A gilt-bronze Fame once flew in the arch above his portrait.

The Consensus of Values

François Caron in *La France des patriotes* contends that the divisive conflicts of the Third Republic have obscured the collective values that unified the French.[9] Faith in progress, the rise of democracy, and national patriotism ensured the continued existence of the republic, despite the strife surrounding clericalism, socialism, and the Dreyfus affair. The issues of consensus and conflict are nowhere more conspicuous than in contemporary statues.

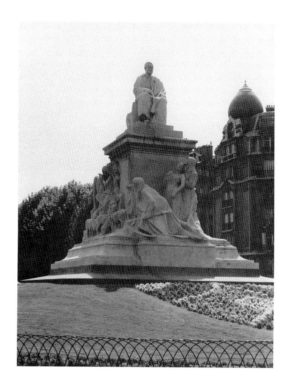

6. Alexandre Falguière, *Louis Pasteur*, Place de Breteuil, 16 July 1904, stone
Photograph by Alain Yen

The philosophy of positivism, founded by Auguste Comte, fueled the faith in progress. Committed to this notion, his contemporaries believed that pursuit of the sciences and the arts would result in a better world, and specifically in a better France. Placing Comte's monument in front of the Sorbonne in 1902 confirmed the responsibility assigned to education in enlightening the individual, represented by the worker on the base, opposite a grateful Humanity. Such egalitarian aspirations for the proletariat did not sit well with all republicans. Of the similar homage to the educator-poet Eugène Manuel, the *Gazette des beaux-arts* remarked, "Le bel ouvrier, tel qu'on le doit à l'influence universitaire!"[10] Improving the lot of the working class was nonetheless part of a growing humanitarianism.

Predictably, men of medicine held a high place in the positivist pantheon, where the emphasis on science and progress was combined with a humanitarian impulse. Louis Pasteur, whose name is literally a household word even today, was honored with no fewer than a dozen monuments in France, including one by Alexandre Falguière near the Invalides in Paris. Below Falguière's seated portrait of Pasteur (fig. 6), a mother looks to the famous scientist to save her

daughter, while the thwarted specter of death cannot disturb the bucolic scenes that flow around the base. These vignettes illustrate the benefits of Pasteur's discoveries. Positivism had an impact on style; not only was empirical observation an influential factor in the prevailing taste for realistic portraits, it also encouraged the trend toward accessible iconography. The Pasteur allegories, drawn from the language of everyday experience, are inherently more democratic than images dependent on an esoteric iconography.

The notion of "men of progress" was expanded to include the benefactors of society, whose philanthropy was aimed at the common weal. Three of the five women (besides Joan of Arc) who were honored with statues before 1914 belong to this category (the other two were authors).

Not only in theme but also in format, the monument to Madame Boucicaut and the Baroness de Hirsch evidences the egalitarian trend in public sculpture. The two ladies, personifying goodness and charity, come down from their pedestal to share their wealth with an urchin. As observers, we are further linked to these secular saints by the intermediary of the indigent mother and child huddled on the monument steps, implying that we are all potential recipients — and eventual benefactors, too. In its original placement at ground level, the platform opened directly into the observers' space, so that nothing prevented us from joining these philanthropists. The ensemble, by Paul Moreau-Vauthier, was inaugurated in 1914.

Cultural heroes contributed significantly to the collective self-image that the French held dear. Pride in the accomplishments of native sons affirmed their sense of national patrimony. Authors such as Alexandre Dumas were praised for furthering the purity of the French language. And to an increasingly literate public, they were popular heroes.

Gustave Doré, better known today as a printmaker, suggested the novelist's universal appeal by ornamenting the base of the monument to Dumas *père* with three readers: a worker, a housewife, and a student. On the back, a swashbuckling d'Artagnan from *Les Trois mousquetaires* dangles over the edge. Doré popularized here

the use of figures that represent the "creations" and "recipients" of an author's genius. The sculptor died in 1883, shortly before the monument was inaugurated, which explains the unusually large signature on the face of the pedestal, added to honor his contribution.

Artists and composers were likewise given their due. The monument to Eugène Delacroix and the one to Charles Gounod glorified the talents of two epic creators and, by association, the French nation itself. Two thirds of the monuments erected in Paris between 1870 and 1914 honor men of the sciences, letters, and arts. While this could be explained simply by the prevalent attitudes of the time, to accept the statistic at face value would be somewhat misleading.

Of the twenty-five statues of artists erected in Paris, half of them were historical figures that were direct government purchases, such as the statue of Bernard Palissy. They are more or less decorative sculptures that have been assimilated into the tradition of statues of famous men. Of the eleven contemporaries honored by a public effigy, only the statue of Delacroix seems to have no compromising motive behind the initiative.

Five of these monuments, such as those to Nicolas Charlet (fig. 7) and Ernest Meissonier (fig. 8), honored artists whose work glorified the French army. Monuments to military leaders are noticeably absent in these years, perhaps in comment on the ever-present humiliation of defeat, but more probably due to the looming fear of a coup, the threat of another General Georges Boulanger. Bellicose inclinations were sublimated into homages that indirectly extolled *la Revanche*. Inaugural speeches, however, were anything but discreet. The long poem written for the dedication ceremony of the Meissonier monument claims that his paintings inspired the French with renewed courage:

Et l'effort renaîtra dans notre âme abattue.
Voilà pourquoi, devant cet artiste vainqueur,
La France, consacrant sa gloire et sa statue,
Lève trois fois l'épée en saluant du coeur.[11]

The Conflict of Issues

Without denigrating the sincerity of the homage to the icons of culture, tribute was

not exempt from ulterior motives. The implicit messages of many statues touched upon the most sensitive issues dividing the nation. It became a standard ploy for sponsoring committees to capitalize on an individual's apolitical fame as a vehicle through which to advance their particular cause.

The sixteenth-century doctor Théophraste Renaudot founded the *Gazette de France*, which used for its masthead the cock, crowing to the rising sun. Renaudot's efforts to improve living standards for the poor brought him to theories that anticipated socialism. Should the affluent bourgeoisie miss the point, the inscriptions on the pedestal quote Renaudot's text on distributing wealth to aid the less fortunate.

The statue of Paul Broca (fig. 9), erected by the Society of Anthropology, was a deliberate assertion of the theory of evolution against the teachings of the church. Paul Choppin sculpted Broca measuring a skull with a craniometer, which he invented. The controversy between Catholicism and Darwinism was only part of the bitter struggle between the Church and the anticlericals. The long-suffering Madame Broca, panic-stricken at the thought of a demonstration, insisted that the inauguration of the monument in 1887 be held on a Sunday morning, while her husband's detractors were at Mass.

In the monument to Jean Macé, the Ligue Française de l'Enseignement extolled its goals for a secular system of education. The case of Macé exemplifies the complex allegiances between factions. The league's motto, "Pour la Patrie, par le livre et par l'épée," appealed to the military, traditionally partisans of the clerical right, who violently protested the league. But the French were convinced that the Prussians had won the war because of their superior system of public instruction. The secularization of education was a major component of the struggle to separate Church and State. The battle between the faithful and the anticlericals consumed enormous energy in the three decades before the two institutions were officially sundered in 1905.

Education was only one aspect of the acrimonious disputes over the separation of Church and State. Paid for by the city, the monument to Etienne Dolet (fig. 10) was

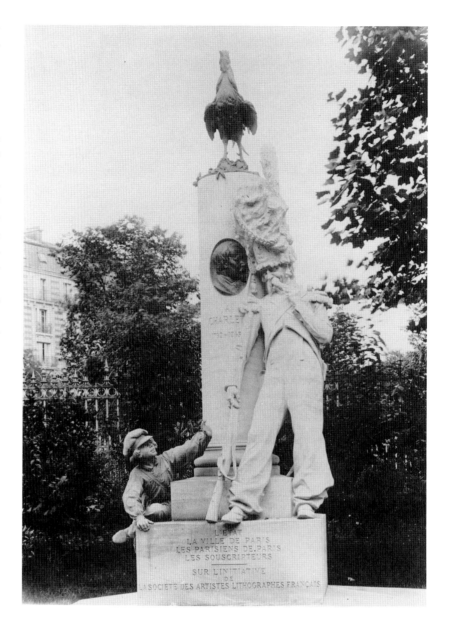

7. Alexandre Charpentier, *Nicolas Charlet*, Jardins Denfert-Rochereau, 2 May 1897, bronze (figures destroyed c. 1942)
Photograph: Collection France Debuisson

masterminded by the freethinkers as an affront to the believers. The statue stood on the Place Maubert, where Dolet had been burned for heresy in 1546. The fact that this monument was erected in 1889 during the centennial of the revolution is consistent with the radical socialism of the majority in the municipal council. For decades, the Dolet monument served as the focus of rallies organized by the freethinkers.

As the move to separate Church and State accelerated, the strife intensified. Incensed by the building of the church of Sacré-Coeur, dubbed the "clerical mastodon," the freethinkers of the Libre-pensée organization

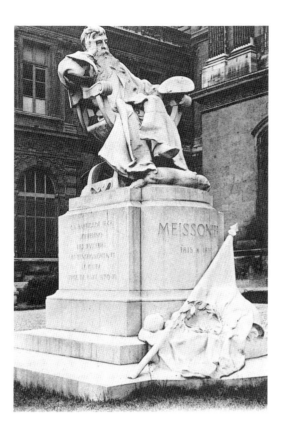

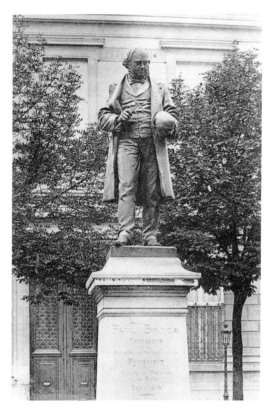

8. Antonin Mercié, *Ernest Meissonier*, Jardin de l'Infante, 26 October 1895, marble (moved to Poissy, 1966)
Postcard: Collection Debuisson

9. Paul Choppin, *Paul Broca*, Boulevard Saint-Germain, 20 July 1887, bronze (destroyed c. 1942)
Postcard: Private collection

retaliated with a monument to the Chevalier de la Barre. The nineteen-year-old chevalier had been tortured and executed in 1766 for failure to salute a religious procession. Armand Bloch, the sculptor, aligned his effigy directly on the axis of Sacré-Coeur. The inauguration of the bronze highlighted the 1906 International Congress of Freethinkers. The freethinkers got as much publicity as they could out of the occasion, but as one lamented, the statue was to that ostentatious dome what a rowboat was to a battleship.[12]

Through a committee called Les Amis de la Liberté de Conscience, Catholics struck back with a statue of Michel Servet, a Spanish theologian and doctor, burned at the stake in 1553 by Protestants. At least the Catholics were not alone in their bigotry! This was their best coup, particularly since many Protestants were active members of Librepensée. The committee's petition to place the Servet statue near that of Etienne Dolet was categorically refused by the municipal council, as were the inflammatory inscriptions they had chosen.[13] The central cartouche was nonetheless inscribed, "brulé

vif par ordre de Calvin." The wording on the dedication became a cause célèbre, and the last four words were effaced after the statue was dedicated in 1908. Ironically, the sculptor, Jean Baffier, was noted for his extreme radicalism.

Certainly the ugliest conflict of the Third Republic was the Dreyfus affair. Lawyer and statesman Ludovic Trarieux was among the earliest to protest the irregularities of the Dreyfus trial. As minister of justice in 1895, he supported the partisans of the revision. During Zola's trial in 1898 for his article "J'accuse," Trarieux founded the Ligue des Droits de l'Homme, to ensure that "toute personne dont la liberté serait menacée ou dont le droit serait violé est assurée de trouver près de nous aide et assistance."[14] When the league opened a subscription for a monument to Trarieux in 1904, the family of Alfred Dreyfus contributed substantially.[15] The monumental ensemble was by Jean Boucher. The bust of Trarieux was melted down in 1942, so only the marble figures on the pedestal remain. Two large figures flank the proclamation of the Rights of Man: Justice, tormented by doubts over convict-

ing an innocent man, is contrasted to a worker, who exudes a new self-confidence with the recognition of his rights.[16] At the base of the platform, a poor widow guides an orphan to lay flowers on the monument of a man who protected the defenseless. The sculptor has created the illusion of a sculpture within a sculpture in order to enlist our sympathies. The critics, however, were less than sympathetic, and one deplored the figures as big dolls worthy of the Campo Santo at Genoa.[17]

The Ligue des Droits de l'Homme had begun the monument to Zola (fig. 11) in 1902, before Trarieux's death, but it was not inaugurated until 1924. The committee faced two intractable obstacles. The first, which was never resolved, involved the subject matter of the monument. The sculptor, Constantin Meunier, renounced the figure of Truth that was to accompany the author's portrait because a nude allegory, "empruntée à la fable antique, aurait formé un anachronisme choquant avec les personnages tout modernes."[18] The committee was adamant that some reference to the Dreyfus affair play a conspicious part. The tug-of-war ended abruptly when Meunier died. Alexandre Charpentier was then commissioned to create a realistic scene of Zola's trial over "J'accuse," but his death left the relief unfinished. The league had to reconcile itself to the absence of reference to Zola's courageous stance in Dreyfus' defense.

But Zola's ghost needed no attributes to conjure up memories of the affair. Animosities were still raging when the proposal for the monument was introduced in the municipal council, less than a year after Dreyfus was finally declared innocent in 1906. Voting against the homage, the ultra-clerical Poirier de Narçay fulminated, "Malgré la décision de justice, plutôt à cause d'elle, mon opinion sur l'affaire Dreyfus n'a pas varié."[19]

The second obstacle concerned the selection of a site. Four sites were seriously considered before 1914, but, as one councilor noted, "tout le monde réclame une statue pour Zola et personne n'en veut dans son quartier."[20] The sponsoring committee lobbied for the Place Dauphine, opposite the Palais de Justice. But the local councilor objected violently to the political message

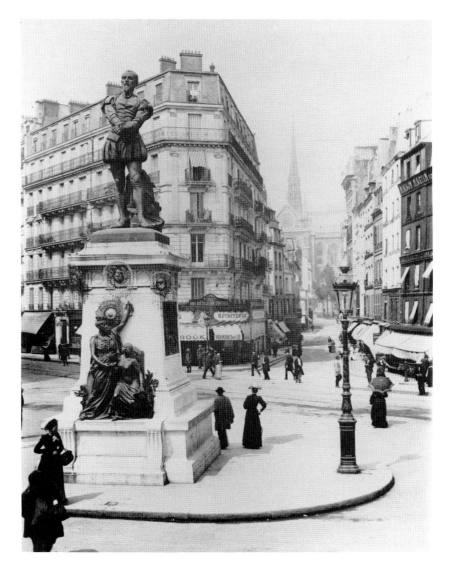

10. Ernest Charles Guilbert, *Etienne Dolet*, Place Maubert, 19 May 1889, bronze (destroyed c. 1942) Photograph: Collection France Debuisson

that would be sent by the statue's proximity to the heart of the French judiciary system. When the committee persisted, the conservative representative of the sixth arrondissement exclaimed, "Il faut savoir quel est le quartier de Paris qui sera sali par ce monument."[21] To which a voice in the back of the chamber responded, "Saint-Sulpice!" (the most elegant parish in the sixth arrondissement, and electoral seat of the deputy opposing the Zola monument). Eventually the committee badgered the administration into conceding a meridian on the Boulevard Clichy, but unfortunately this was in July of 1914, and another decade would pass before Zola came to roost.

In light of such charged subjects, could any monument be politically innocent? Even

11. Constantin Meunier, *Emile Zola*, Avenue Emile-Zola, 15 June 1924, bronze (destroyed c. 1942)
Photograph: Private collection

Latin."[22] It is hard to believe that a little bronze portrait entwined with roses could be seen as so vicious, but to a public that had learned to read monuments for their pedagogical message, few subjects indeed escaped calumny from one faction or another.

One might argue that the subtlest statement is to be gleaned from monuments to men whose lives were devoid of momentous import. Adolphe Alphand, for example, was the director of public works, responsible for the refreshing patches of green that still distinguish Paris. The marble monument places him on a high pedestal, surrounded by four figures, in the center of a curved exedra that sits on a stepped platform. Grateful as we are to Alphand, a monument of such magnificence is more indicative of the diffusion of public commemoration than of the brilliance of his achievement. It is not Alphand's genius—he did not actually design the parks—but his efficiency that is cause for this marble accolade. He is the good bureaucrat rewarded posthumously for doing his job well, honored by a monument fit for a king—it is inconceivable that Le Nôtre could have been so honored under Louis XIV. In the nineteenth century, the criteria of merit evolved from genius to diligence. Artist Jules Dalou replaced the superannuated allegories of the past with the pragmatic staff of the busy executive. Alphand confers with his four colleagues, a group that includes the sculptor himself. We are invited up the steps to admire the reliefs, where industrious gardeners recall Dalou's frustrated design for a monument to Labor. A lesson in civic virtue, the Alphand monument conveys that such recognition is within everyone's grasp. Its meaning is significantly reiterated by the formal structure of the monument that reaches out to embrace us in its space.

The very diffusion of the monument undermined its effectiveness. If Balzac needs no introduction, most of us remember *La Bohème* as a Puccini opera and not as a novel by Murger. The more common the monument was, the more imperative a form of homage it seemed. Public statues became "la Légion d'honneur des morts."[23] Paris was fast becoming a national necropolis.

seemingly innocuous subjects provoked acerbic exchanges. The bust of Henri Murger, vaguely remembered today as the author of *Scènes de la vie de bohème*, raised more than eyebrows. The young artist Henri Bouillon was devastated when the Ligue Française de la Moralité Publique insisted that the example of Murger "ne peut que dépraver en dépeignant tranquillement le dévergondage . . . lâche." To put this monument in the Luxembourg Gardens would be to advertise "la licence du libertinage" among "la jeunesse qui agite le Quartier-

As the impact of the monument was di-

12. Louis-Ernest Barrias, *Victor Hugo*, Place Victor Hugo, 26 February 1902, bronze (destroyed c. 1942) Postcard: Collection Debuisson

263. PARIS — Monument de Victor Hugo

13, 14. Ernest Damé, *Claude Chappe*, boulevards Saint-Germain and Raspail, 13 July 1893, bronze (destroyed c. 1942)
Postcards: Collection Debuisson

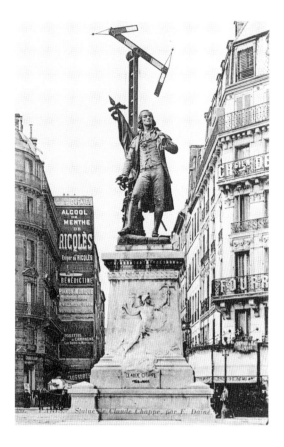

(fig. 12) necessitated a colossal megamonument to elevate him beyond a mere Ferdinand Fabre, the author of picturesque tales of rural France. The Hugo ensemble, by Louis-Ernest Barrias, was one of the most expensive monuments commemorating an individual hero in Paris, costing over three hundred thousand francs by the time it was dedicated in 1902.[24] But even the more modest monument to Fabre, a collaboration between Laurent Marqueste and the painter Jean-Paul Laurens, was hardly cheap. The bust of Murger was a bargain at two thousand francs but the committee first refused an additional two thousand francs for bronze roses on the pedestal.

By the twentieth century, the sheer number of monuments posed a dilemma. Paris suffered from urban congestion. Statues competed with crowds, vendors, and traffic, all jostling for space. To all intents, the monument to Claude Chappe (figs. 13, 14) was accused of murder.[25] It occupied most of the pedestrian island on the intersection of the boulevards Saint-Germain and Raspail, so that passengers descending from the trams were forced into the path of oncoming vehicles. After one passenger was struck by a car, the statue was blamed—but no action was taken.

Faced with a population explosion in

luted by its diffusion, artists and committees alike were driven to greater extremes to connote the magnitude of their subject's accomplishments. The statue of Victor Hugo

bronze and marble, the municipal council found itself hoist by its own petard. Early on, it had encouraged public homage out of expediency, without the foresight to establish constraints. After 1900, drastic measures were proposed to curtail "statuomania." These stopgap efforts would have come to naught but for the coincidence of other historical realities. When the secular republic became fact, the nationalist crisis was spent, thereby diminishing the urgency of the monument as a vehicle for political propaganda. The artistic vogue for realistic statues had passed long before its popular appeal peaked. World War I broke the momentum, and after 1918, the monument responded to different and more sober circumstances.

The statues erected in Paris between 1870 and 1914 are a phenomenon of the time. While they document the ideological aspirations and antagonisms that characterized the Third Republic, they are more than illustrations of personalities. The ideals that generated them were fundamental to the procedures that governed them. The monuments, which were *not* the products of a systematic policy, proliferated in tandem with egalitarian attitudes. The choices of subject, style, iconography, and format reflected the didactic demands placed on public art in an increasingly democratic society. The evolution of these public homages incarnates the history of a nation forging its identity, wedding the past to the present in bronze and marble.

NOTES

1. Eric Hobsbawm, ''Mass-Producing Traditions: Europe, 1870–1914,'' in *The Invention of Tradition*, ed. Eric Hobsbawm and Terence Ranger (Cambridge, 1983), 263–307.

2. See my history of the statues to famous men: June Hargrove, *Paris: An Open-Air Pantheon* (Antwerp, 1989).

3. Paul Vitry, ''Les Monuments à J.-J. Rousseau,'' *Gazette des beaux-arts* (1912), 97–117.

4. In French, the traditional phrases, common since the eighteenth century, are *grands hommes* or *hommes célèbres*. This use of *hommes* or *men* seems ultimately more accurate than *persons* because their number includes so few women.

5. Ruth Butler, ''Nationalism, a New Seriousness, and Rodin: Some Thoughts about French Sculpture in the 1870s,'' in *Nineteenth-Century Sculpture*, Acts of the Twenty-fourth International Congress of Art History (Bologna, 1979), 161–167.

6. Jacques Biez, *Emmanuel Fremiet* (Paris, 1910), 161.

7. See Georges Benrekassa, Eric Walter, et al., ''Le Premier centenaire de la mort de Rousseau et de Voltaire: Significations d'une commémoration,'' *Revue d'histoire littéraire de la France* (March–June 1979), 265–295. The list of names of the men commemorated during the Third Republic begins to have a slightly incestuous ring as key initiators of one monument are subsequently themselves honored with another. For example, both Louis Blanc and Clovis Hugues, active in erecting a statue to Rousseau, were themselves commemorated later.

8. This count is based on the archives of the Bureau des Monuments.

9. François Caron, *La France des patriotes* (Paris, 1985).

10. André Beaunier, ''Les Salons de 1908,'' *Gazette des beaux-arts* (1908), 44–77, 48.

11. Jean Aicard, *Hommage à Meissonier*, F21 4853, Archives Nationales, Paris.

12. *L'Action* (7 August 1904), Dossier Armand Bloch, Musée d'Orsay, Paris. See further Eric Walter, ''L'affaire La Barre et le concept d'opinion publique,'' in *Le Journalism d'Ancien Régime* (Lyon, 1982).

13. Dossier Servet, Bureau des Monuments, Paris.

14. The quotation is taken from a modern reprint of the *Manifesto de la Ligue française de l'enseignement* (Paris, 1866).

15. *Bulletin officiel de la Ligue des Droits de l'Homme* (1904), 385.

16. As I was working on this paper, I realized that labor is consistently represented in the nineteenth century as a blacksmith. Is this related to the demise of the occupation? Was it simply a custom, or is there some code that it signifies? At present, these questions remain unanswered.

17. André Beaunier, ''Les Salons de 1908,'' *Gazette des beaux-arts* (1908), 44–77, especially 47.

18. Mathias Morhardt, ''Le Monument Emile Zola,'' *Les Cahiers des droits de l'homme* (1924), 292–294, especially 293.

19. *Bulletin municipal officiel* (19 July 1907), 3200.

20. *Bulletin municipal officiel* (19 July 1907), 3200.

21. Extract from deliberations of municipal council (3 April 1908), Dossier Zola, Bureau des Monuments, Paris.

22. *Le Relèvement social* (1 May 1895), F21 4856, Archives Nationales, Paris. The newspaper was published by the Ligue Française de la Moralité Publique.

23. *Le Gaulois du dimanche* (9 July 1911), 10.

24. Dossier Barrias, Musée Victor Hugo, Paris.

25. *Bulletin municipal officiel* (16 July 1910), 2758.

NANCY J. TROY
Northwestern University

Le Corbusier, Nationalism, and the Decorative Arts in France, 1900–1918

Long before the 1920s, when he became famous as Le Corbusier, purist architect, polemicist, and denigrator of all things decorative, Charles-Edouard Jeanneret was himself a decorative artist and interior designer.[1] Whereas Le Corbusier was committed to internationalism, Charles-Edouard Jeanneret made a reputation for himself in the years just before and during World War I as a staunch supporter of the French neoclassical tradition. Indeed, he took advantage of the nationalist climate of France at the time to establish his professional credentials in the Paris art world as an expert on decorative art.

To understand Jeanneret's development throughout this period, it is necessary not only to take his involvement in the decorative arts seriously but also to approach the decorative arts and nationalism in France from a perspective that recognizes their conjunction in those years. In the early twentieth century, French decorative artists faced a profound crisis as a result of the impact of both industrialization and foreign competition. Jeanneret himself played a significant role in articulating the circumstances of this crisis; its implications in turn conditioned the development of his work and ideas throughout the 1910s. An examination of Jeanneret's activities in the realm of decorative art thus provides an opportunity to recuperate a neglected aspect of his career and, at the same time, to consider the shifting meanings and values that

were attached to the French national tradition by Jeanneret, as well as by other artists and designers active in France during this period.

The field of decorative art is especially well suited to an examination of the discourse on the French national tradition because decorative art occupied a substantial place in the French economy. Competition from abroad therefore generated an explicitly political response, which decorative artists were compelled to address. The decorative arts can be studied as a model of the varied, often conflicting ways in which "Frenchness" was defined by modernist artists faced with the necessity of responding to foreign initiatives while at the same time maintaining the substantial degree of attachment to the French national heritage that their audiences seem to have required.

Concern about foreign encroachments into the territory of the decorative arts, which for centuries had been controlled by France, was not new in the early twentieth century. One of the first to comment on the problem was Comte Léon de Laborde. On the occasion of the 1851 Great Exhibition of the Works of Industry of All Nations held in the Crystal Palace, Laborde reported on the growing English challenge to French dominance in a two-volume work that received widespread attention.[2] Official reports about subsequent international exhibitions reiterated Laborde's themes, as did Prosper Mérimée in 1862, when he reminded French

decorators that "a defeat is possible, that indeed one is foreseeable, if they don't from this moment forward make every effort to preserve their supremacy."[3] After France's humiliating defeat in the Franco-Prussian War, the defensive French eye shifted away from England to focus on Germany. The issue of foreign competition became so heated that it could be — and indeed often was — discussed in the revanchist language of war. Witness Marius Vachon in his 1882 book, *Nos industries d'art en péril*: "the competition has developed rapidly so as to become a powerful and audacious giant who is not at all content to divide the prize with us but instead attempts to tear it violently away. The battle has been engaged for several years; it is a terrible struggle in which our adversary employs arms against us that we, in our presumption, have given up. He is already gaining ground; we are in retreat: the moment is critical; we must energetically take up the offensive again if we don't want to be defeated, wiped out."[4] As proof of the danger at hand, numerous French critics recited the chillingly bellicose words pronounced by the German emperor at the inauguration of the Kunstgewerbemuseum in Berlin in 1881: "We defeated France on the field of battle in 1870; now we want to defeat her in the fields of commerce and industry."[5]

Debora Silverman has argued persuasively that economic considerations, particularly the need to balance France's weakness relative to other nations in heavy industry, contributed significantly to the emphasis that the French placed on luxurious craft objects as "the presumed source of French market preeminence" at the end of the nineteenth century.[6] Silverman views the creation of the art nouveau style from this perspective; although she plays down the internationalism and eclecticism characteristic of early art nouveau enterprises, she correctly emphasizes the nationalist sentiments that helped to inspire the recuperation of elegant, eighteenth-century rococo forms and the spirit — if not the actual methods — of traditional French craftsmanship in art nouveau objects produced around 1900. In that year, French critics were unanimous in praising the art nouveau pavilion that Siegfried Bing erected at the

1. Georges de Feure, *Boudoir*, L'Art Nouveau Bing, Exposition Universelle, Paris, 1900
Photograph: Collection Bibliothèque des Arts Décoratifs, Paris

Exposition Universelle in Paris (fig. 1) as the embodiment of the national self-image of aristocratic delicacy, refinement, and good taste. At the same time, the same critics expressed considerable disdain for what they described as the German national traits of "logic, solidity, and even rudeness" that supposedly characterized the display in the German pavilion by manufacturers and designers working in the most advanced Jugendstil craft tradition, including members of the recently established Vereinigten Werkstätten, the Dresdener Werkstätten, and the artists' colony at Darmstadt.[7] Distancing themselves from the German example, the French argued that German art "responds to an ideal that is different from our own."[8] Only reluctantly did they admit their admiration for one thing the Germans had, which they themselves lacked: "a working method that is unknown to us: professionals associating themselves with designers, painters, sculptors, even writers, in order to complete an ensemble." According to a contemporary observer, "exquisite works are born of such intellectual associations."[9]

The ambivalence that characterized the French response to contemporary German design from this moment forward was clearly motivated by insecurity and self-doubt in

the face of the Germans' enthusiastic embrace of modern manufacturing methods and their willingness to design practical objects for everyday use. By 1900, German decorators, collaborating with artisans in efficient workshops outfitted with sophisticated equipment, had created the foundations of a production and marketing system through which well-designed, functional objects could be sold at an affordable price to a relatively large number of middle-class clients.[10] In contrast to the Germans, indeed in defense against their success, the French tended to cling to an elitist conception of design, defined in terms of aristocratic traditions of style and individual craftsmanship, that was diametrically opposed to the practical orientation and collaborative arrangement of the various German *Werkstätten*. In effect, the French tried to turn their weakness as industrial producers into a last bastion of strength by falling back on what G. M. Jacques described as "that indefinable quality that makes whatever she [France] produces fascinate, seduce, and intoxicate other peoples . . . that faculty of radiance, of seduction that France alone possesses."[11]

French decorators maintained their isolation from one another and especially from large-scale manufacturers because they believed it was necessary to preserve their reputations as artists, creators of individualized objects of exceptional quality upon which their nation's dominance of decorative art markets had always been based. This conservative tendency was reinforced in the early 1900s, as industrial production of art nouveau designs by "a legion of maladroit *pasticheurs*"[12] rapidly resulted in the proliferation of what were described at the time as exaggerated forms and "pseudo-artistic efforts of the most baroque sort."[13] The most respected French designers — for example, those who joined the Société des Artistes Décorateurs in 1901 — generally regarded mass production as a threat to good design. They were reluctant to collaborate with manufacturers, whom they regarded as unscrupulous exploiters who either plagiarized contemporary models or reproduced period furniture — managing in either case to avoid paying copyright expenses. The profoundly antipathetic relationship between decorative artists and manufacturers that prevailed in France contrasts markedly with the situation in Germany, where after 1907 the Werkbund achieved considerable success in fostering collaboration between precisely these two groups.

French decorative artists were thus caught in a particularly difficult dilemma: dedicated to resisting the encroachment of industry on what had traditionally been exclusive *métiers* devoted to the manufacture of luxury items for an elite clientele, they were compelled by the German union of art and industry to recognize the necessity of reforming their own professional practices and institutions without betraying the French national heritage to the Germans. This, broadly speaking, was the goal of the Union Provinciale des Arts Décoratifs, which was formed in 1907 by a number of French designers, artisans, and representatives of related organizations to foster the decentralization of the French decorative arts movement along the lines of the German model.[14] In 1908 the Union Provinciale was invited to Munich, where the organization's first official congress coincided with Die Ausstellung München 1908, an enormous exhibition intended to establish Munich's competitive position as a center of modern German design comparable to Darmstadt, Dresden, and Berlin. Mounted in a group of new exhibition buildings located in a public park, the show gave pride of place to local designers, while nevertheless "comprehending within its scope everything of moment to a social aggregate like Munich: art, commerce, trade, manufacture, education, public works, sports of all kinds, and so forth."[15] In this impressive context, the members of the Union Provinciale had an opportunity to assess what its president described as the "methodical, rational, and powerful regeneration of Bavarian decorative art."[16] Every item in the exhibition seemed to the French visitors to have been endowed with simplicity, practicality, and sound technical execution. The detailed arrangement and harmonious presentation of dozens of domestic settings was especially striking.

Through a variety of publications, including a series of articles in *Le Figaro*, the Munich exhibition had a profound impact

on the French.[17] In the context of growing anti-German sentiment, aroused not only by recent confrontations between France and Germany over control of Morocco, but also by what was viewed with considerable dismay as a "veritable 'invasion'" of German companies establishing branches in France, the high quality of the Munich designers' work was immediately perceived as a dangerous challenge to France's design industry.[18] Indeed, Rupert Carabin, a sculptor and furniture maker who prepared an official report for the Conseil Générale du Département de la Seine, drew a comparison with the catastrophic battle of Sedan in which the French had been defeated by the Prussians in 1870: "The Sedan of commerce, with which we have been threatened for so many years, is now no longer to be feared, it is a fait accompli and we must play our part."[19] Faced with a difficult struggle for both domestic and foreign markets, the French reluctantly acknowledged the necessity of learning yet another bitter lesson from their German rivals.

In addition to acting as a catalyst in a profound and enduring reevaluation of France's decorative arts system relative to that of Germany, the Munich exhibition also inspired the architect Frantz Jourdain, president of the Salon d'Automne, to invite the Munich decorators to exhibit their work in the French capital in 1910. In a series of rooms on the ground floor of the Salon d'Automne, they presented the same kind of exhibition that had been such a success in Munich two years earlier: an ensemble of related interiors designed and meticulously appointed so as to suggest the lived-in environment of a cultivated, upper-middle-class family (figs. 2, 3).[20] Not only were all the details of each interior, including the appropriate furniture, paintings, and other decorative objects, integrated in a unified design, but the color schemes were also coordinated so that adjacent rooms would not clash with one another. Although dozens of designers and craftsmen were involved and all the objects had to be transported from Munich, the installation was ready by the time of the official opening—an organizational feat that the Parisian decorators, for all their proximity to the Grand Palais, were rarely able to accomplish.[21]

The total effect of this particular German "invasion" was powerful enough to overwhelm French critics, who responded in unabashedly nationalist terms. Several commentators concluded that a "question of race" was ultimately responsible for the distinctions between French and German designs at the Salon d'Automne—the former emphasizing "suppleness, restraint,

2. Karl Bertsch, *Bedroom for a Woman*, Salon d'Automne, Paris, 1910
Photograph: *Art et décoration* 28 (November 1910), 139

3. Richard Berndl, *Large Salon*, Salon d'Automne, Paris, 1910
Photograph: *Art et décoration* 28 (November 1910), 140

harmony, and grace," and the latter composed of what was described, with some hostile exaggeration, as large, heavy forms in conjunction with dark, lugubrious colors or strident contrasts of acidic tones. But while the French cited innate differences of taste or social customs peculiar to each nation as reasons for rejecting the German designs on aesthetic grounds, they could not fail to acknowledge and praise the Munich decorators' demonstration of the supposedly typical German characteristics "of work, perseverance, and organization." As M.-P. Verneuil was forced to admit, "In this Bavarian exhibition we have a lesson to learn: that of discipline. The *munichois* demonstrate the beneficial effects of common effort, as opposed to the individual effort that prevails among us, where truly, anarchy reigns."[22]

The attention that the Munich designers helped to focus on the arrangement of interiors into a series of coordinated ensembles helped ensure that French designers would also adopt this approach when showing their work. In the wake of the 1910 Salon d'Automne, there emerged a group of designers, typified by André Groult (fig. 4) and André Mare (fig. 5), who had not been trained as craftsmen and lacked experience in the craft *métiers*. These designers tended to concentrate relatively little attention on the construction of individual objects and to focus instead on the presentation of ensembles in which bright colors played a prominent role. For this reason they came to be known as *coloristes*. In 1912, Mare described their aims in terms that reveal the importance that the *coloristes* attached to the French national tradition: "First of all, make something very *French*, stay within the tradition. . . . Return to simple, pure, logical, and even slightly harsh lines, whereas the period that preceded us was horribly tormented [in its forms]. . . . Return to very bold, very pure, very daring colors, whereas that same preceding period always delighted in washed-out, anemic tones. . . . For the decoration, take up once again the motif[s] which, from the Renaissance until Louis-Philippe, did not change. Give them renewed life. . . . In sum, make things that are a little severe in outline, the harshness of which will be mitigated by a pleasant

decor, boldly colored, and the whole in a tradition that is very French."[23]

The *coloristes* insisted on the specifically French character of their work. But by articulating Frenchness in opposition to the delicacy and refinement typical of the best art nouveau designs, they shifted the interpretation of the national heritage to new ground where it was in danger of being confused with a nefarious Germanic influence. In appealing to the Louis-Philippe style, rather than the rococo that had inspired art nouveau decorators, the *coloristes* seemed— despite their claims to the contrary—to be inviting comparison to the Germans, who had also been inspired by French furniture of the same era, or by its German variant, the Biedermeier style. Moreover, the *coloristes'* involvement with cubist painters in the Puteaux circle that included the Duchamp-Villon brothers, Albert Gleizes, and Jean Metzinger—demonstrated most clearly in the Maison Cubiste at the Salon d'Automne of 1912 (fig. 6)—was a damning association in the opinion of cultural conservatives, who viewed modernist art as a foreign import that threatened the cultural integrity of France.[24] This attitude was even articulated in the Chamber of Deputies, where, on 3 December 1912, an attempt was made to prohibit official support of the supposedly foreign-dominated Salon d'Automne (an important forum for both the Puteaux cubists and the *coloriste* designers) by excluding its annual exhibition from the Grand Palais. The chauvinist motivation of the attack on modernist art is evident in the words of a deputy who declared to his colleagues, "Gentlemen, it is in fact absolutely unacceptable that our national palaces are permitted to be used for exhibitions of a character that is clearly anti-artistic and antinational."[25]

The history of the decorative arts in prewar France, briefly outlined above, demonstrates that the issue of nationalism was not only pervasive but also subject to multiple, often conflicting claims. These circumstances provide a context that is crucial to understanding the young Charles-Edouard Jeanneret's activities during the 1910s. Jeanneret managed to introduce himself into the ongoing debate about the decorative arts in France in 1912, by orchestrating the cir-

4. André Groult, *Bedroom*, Salon d'Automne, Paris, 1911
Photograph: *L'Art décoratif* 26 (November 1911), 275

culation in Paris of his book, *Etude sur le mouvement d'art décoratif en Allemagne* (commissioned and published by the board of the Ecole d'Art in his hometown, La Chaux-de-Fonds, Switzerland).[26] In this text, Jeanneret provided a detailed account of German institutions and exhibitions devoted to the industrial and applied arts. He had gathered the material for the book in 1910–1911, when, as a student of architecture and design, he was staying in Germany and, among other activities, working for four months in the architectural office of Peter Behrens. The *Etude* is, on one hand, a summary and cogent analysis of the conditions in Germany that the French perceived as a threat to their control of the international and even the domestic markets for decorative art; on the other hand, it is a document of the theoretical position Jeanneret himself occupied in 1912, at the beginning of a six-year period during which his development as a designer (and architect) was bound up with the problematic circumstances of the decorative arts in France.

The factual portion of Jeanneret's report

on German design is sandwiched between remarks of a broad nature in which he set out his view that a complex and intimate relationship had existed between the social, political, economic, and artistic developments in France and Germany since the end of the eighteenth century. In many respects his fascinating, though brief, analysis closely parallels the thinking of the French *coloriste* designers. Opening his book with the words, "Here is what today's innovators claim," Jeanneret proceeded to articulate a *coloriste* vision of France's cultural tradition, which proceeded from the notion that the French Revolution had had a destructive effect on the decorative arts and particularly on craftsmanship. Continuing to voice the opinion of progressive French artists, he explained that the strength of the French tradition had enabled it to survive the revolution and produce the Empire style, which "remains perhaps the most aristocratic, the most sober, the most 'serious.' This, say today's innovators, is the style that is surely the closest to us. They say further, 'It is, logically, the style that we

5. André Mare, *Study*, Salon
d'Automne, Paris, 1911
Collection Michel Mare, Paris
Photograph: *L'Art décoratif* 26
(November 1911), 272

should take up and continue.'" In thus as-
sessing contemporary practice in the dec-
orative arts, Jeanneret differed to a certain
degree from André Mare and other *colo-
ristes* who were willing to embrace the styles
of the Restoration and Louis-Philippe pe-
riods. According to Jeanneret's reading of
the most progressive French attitude to the
decorative arts, the Restoration style was
regarded as tainted by an increasingly bour-
geois spirit that was later embodied in the
"anemic forms of the Louis-Philippe style,"
with which "the applied arts uttered their
last word."[27] Whereas the *coloristes* sought
to exploit the bourgeois spirit that they too
regarded as characteristic of the decorative
arts after the fall of the empire, Jeanneret

considered the triumph of bourgeois taste
to be responsible for the precipitous decline
of French decorative art after the middle of
the nineteenth century. In his opinion, the
neoclassical orientation embodied in a rein-
terpretation and renewal of the Empire style
constituted the most progressive current in
contemporary French decorative art. To the
extent that the *coloristes* were working in
this direction, Jeanneret applauded their re-
form project.

Having established a French perspective
in the first pages of his book, Jeanneret turned
to Germany, which he described as an
"unformed" nation, lacking a great artistic
tradition of its own and therefore better
prepared than was France to "accept *le
bourgeoisisme.*" Not only had Germany
"copied France for centuries," she had re-
cently begun to usurp France's hegemony
in the arts by attempting to appropriate those
French artists (he mentioned Courbet,
Manet, Cézanne, van Gogh, Matisse, and
Maillol) who were consistently denied rec-
ognition at home: "Germany poses as a
champion of modernism, creating nothing
in the domain of the fine arts to substantiate
this position, but revealing her new tastes
by the systematic absorption (purchase) of
works by Parisian painters and sculptors . . .
and, on the other hand, revealing herself
almost all of a sudden to be colossal in terms
of power, determination, and profit-making
in the realm of the applied arts." This sit-
uation, Jeanneret argued, was "an acci-
dent," "a passing event," that Germany
would not be able to sustain in the long run
precisely because it lacked a native aes-
thetic tradition which, like that of France,
was governed by a "normal, progressive ev-
olution of the thought and the spirit of this
nation." It was only a matter of time before
"l'Allemagne révolutionnée" would be
overtaken by "la France évoluée." The Ger-
mans' conquest of the applied arts, he con-
tinued, was simply the transposition into
that realm of the energy and organizational
proficiency that had enabled them to build
their powerful machinery of state and, as
proved in 1870, also of war. What it
amounted to was "a revolution that was
economic, therefore practical"; in the deep-
est sense it had nothing to do with art, where
Jeanneret, like so many Frenchmen, be-

6. André Mare et al., *Salon Bourgeois, Maison Cubiste*, Salon d'Automne, Paris, 1912
Photograph: Collection Michel Mare, Paris

lieved the French would always retain their supremacy.[28]

Bringing his text to a close, Jeanneret acknowledged that "it might be said that I make too much here of national rivalries," but he had been struck by them both in France and in Germany. He believed such rivalries to be "a precious stimulant to both nations" and argued, moreover, that a great deal could be learned from the Germans: "If Paris is the center of art, Germany remains the great center of production. Experiments are carried out there, and battles there become meaningful; the building has risen and the rooms, with their historiated walls, tell of the triumph of order and tenacity."[29] Here it is obvious that Jeanneret admired the large ambitions and industrious spirit of the Germans, the characteristics that enabled them to create the powerful network of design institutions that Jeanneret described in his book. It hardly needs to be said that these were precisely the characteristics that aroused the defensiveness of the French. Moreover, the or-

ganization of Jeanneret's book into three distinct parts — the two central chapters devoted to German initiatives are bracketed by the introduction and conclusion dealing primarily with their implications for the French — mirrors Jeanneret's own ambivalence about the German achievement that was his subject.

The Swiss Romande cultural context in which Jeanneret matured was oriented toward France. This helps to explain why the École d'Art would sponsor Jeanneret's study of the decorative arts in Germany, which was less familiar territory to the industrialists of La Chaux-de-Fonds, for whom the book was ostensibly intended. It is clear, however, that Jeanneret hoped his *Etude* would reach a much broader audience, particularly in France. Of the 500 copies that were printed in 1912, 450 were distributed free of charge in La Chaux-de-Fonds, where the study provoked scarcely any response. According to Jeanneret, however, "several copies crossed the Swiss border"; and, "something I certainly did not anticipate,"

he wrote with false naïveté, for he was surely responsible, "little by little they made their way."[30] Almost immediately after the book appeared, Jeanneret's friend William Ritter praised and quoted from it in one of his regular columns in the French journal *L'Art et les artistes*.[31] By October 1912, Jeanneret was already attempting to have a second edition published in France, and with this in mind he wrote a form letter to people whose influence he thought might prove helpful. Noting that in the spring (that is, immediately after the *Etude* was published) he had already sent a copy to the addressee, he went on to boast that the book had received "numerous expressions of interest from people particularly well suited [*autorisées*] to judge art and its integration into social life—from France, Germany and Belgium." "If I had to locate the reason for this," he remarked, "I would find it in the fact that those interested in the relationship of industrial art to economic prosperity and commercial expansion found in it [the *Etude*] a clear and useful synthesis of German intentions and results." In seeking to republish the book in France, where his ideas would "reach their real milieu," Jeanneret wrote that the aim of his text was to encourage the manifestation of "the Latin spirit in works of a more social sensibility."[32]

In mounting his literary foray into France, Jeanneret was supported by none other than Rupert Carabin, whose defensive report about the 1908 Munich exhibition Jeanneret may well have known.[33] That Jeanneret shared something of Carabin's nationalist spirit, or at least understood its importance for his own career ambitions, was evident in 1914, when portions of his *Etude* were reprinted in the French journal *L'Art de France*.[34] Jeanneret was anxious to control the presentation so that, as he wrote to the editor, he would not appear "to have become almost a Teutonic enthusiast," which, he wanted to be clear, "is far from the truth!" "I tell you this, Monsieur, simply to indicate very clearly my 'Latin' nationality," by birth as well as in matters of taste.[35] How timely this remark appears, in retrospect, to have been. In May 1914, Jeanneret was duly identified in *L'Art de France* as "a Frenchman from Switzerland," and thus his sympathy for the French nation was proclaimed on the eve of World War I.[36]

At this point, Jeanneret's study of the decorative arts in Germany assumed even greater importance for the French. As Jeanneret wrote on May 27, 1914, to Paul Cornu, librarian of the Union Centrale des Arts Décoratifs in Paris, his book had been "commented on more or less everywhere," and he was "bombarded by orders from booksellers and people like you, Monsieur, committed to new ideas."[37] Excerpts were published during the spring and summer of 1914 not only in *L'Art de France* but also in *Les Tendences nouvelles*.[38] In 1915, Jeanneret sent a copy to a French architect named Maurice Storez, for whom the *Etude* was a powerful revelation. Storez used it as the basis of an article in which he called on the French not to succumb to disorganization and lack of discipline but instead to start planning for postwar reconstruction as the Germans were already doing. Arguing that discipline and organization were originally French traits, part of a national tradition characterized by "good sense, logic, and the ideal," Storez urged the French to reclaim this heritage from the Germans. In the process, he quoted at length from Jeanneret's first chapter, cited points Jeanneret made elsewhere in the text and in correspondence, and acknowledged his reliance on Jeanneret's study for the formulation of his own essay.[39]

Clearly, Jeanneret was quite successful in his attempt to insert his book—and himself along with it—into French debates about the decorative arts in the period just before and during World War I. But his efforts were not confined to the *Etude*, or to other publications of the period that he also sought to make known in France; professional activities he pursued as a designer for clients in La Chaux-de-Fonds also gave him access to what he viewed as the much more stimulating atmosphere of Paris, the artistic center in which he desperately wanted to work. Between 1912 and 1917, when Jeanneret built only three houses and a movie theater, he was employed as an interior designer by members of several wealthy families prominent in the La Chaux-de-Fonds watch-making industry (figs. 7, 8). These clients called upon him to redesign and decorate rooms in their homes; in such com-

missions Jeanneret was responsible for virtually every aspect of the interiors. As one might expect on the basis of the views he outlined in his *Etude*, Jeanneret drew inspiration from the French Directoire, Empire, and Restoration styles. His interiors were conceived as harmonious ensembles, and in carrying them out Jeanneret looked to Paris, not only for the purchase of specific objects, but also to study the most progressive ensembles — designs by the *coloristes* that were shown each year at the Salon d'Automne.

Jeanneret went to Paris for three days in December 1913 in order to study the interiors displayed in the Salon d'Automne. He described his state of mind at the time: "Very troubled by the problem of interior deco-

ration, I would have liked to dispel my uneasiness, to find in the diverse manifestations of Parisian artists a direction, or at least to sort things out, to submit to enchantments, which would be conversions. I expected a lot and I was delighted at first, then rather worn out and disconcerted; my uneasiness remains the same."[40] The copious notes he took at the Salon d'Automne reveal that he paid particular attention to prominent *coloriste* designers, including André Groult, Paul Huillard, Gustave-Louis Jaulmes, Maurice Lucet and his partner Pierre Lahalle, Rob Mallet-Stevens, André Mare, and Louis Süe working with Jacques Palyart (fig. 9).[41] Most of them pursued an additive approach to design and, in seeking to align their work with the French tradition, as we

8. Charles-Edouard Jeanneret,
Library, Raphael Schwob
House, La Chaux-de-Fonds,
Switzerland, 1917
Photograph: Fondation Le Corbusier,
Paris
Copyright © 1991 ARS N.Y./
SPADEM

9. Gustave-Louis Jaulmes,
Dining Room, Salon
d'Automne, Paris, 1913
Photograph: *Art et décoration* 35
(January 1914), 5

have seen, they generally looked to a variety of styles dating from the end of Louis XVI's reign through the Restoration and Louis-Philippe periods, when geometry and symmetry had been emphasized, resulting in increasingly simplified forms. It should be remembered that, for a variety of reasons, critics tended to see Germanic influences in the work of these designers, as they did also in the products of Paul Poiret's decorative arts outlet, the Maison Martine, which Jeanneret visited on two occasions in 1913. Jeanneret was attracted to their work because it was similar to his own, in which he was bringing together actual antique pieces, mostly from the Louis XVI and Directoire periods, and juxtaposing them with furniture he designed himself, inspired by these and similarly classicizing historical styles.

Scattered throughout Jeanneret's sketchbooks from the early and mid-1910s are rapidly executed drawings of such objects as chairs, canapés, desks, armoires, and lamps that he came across either in Paris or in Swiss cities such as Geneva and Lausanne.

Many of the drawings are annotated with brief remarks concerning the dimensions, condition, and price of the pieces. One shows an armchair with a rush seat and a simple wood frame whose squared-off back is articulated by plain, rectilinear splats.[42] Jeanneret bought this chair, or one very much like it, for the salon of the house he built for his parents in 1912. There he placed it alongside an upholstered canapé of his own design — inspired by the geometry of the Empire style — which was remarkable for its bold juxtaposition of simple, rectangular forms (fig. 10). The neoclassical flavor of this piece corresponds to the architectural style of the house, which is often described as exhibiting the influence of Peter Behrens.[43] Indeed, Behrens and other German architects may well have been partially responsible for introducing Jeanneret to the formal vocabulary of neoclassicism. In Germany, Jeanneret had also been attracted to the work of Bruno Paul, and some of his furniture bears comparison with Paul's. Nevertheless, Jeanneret's correspondence and private notes clearly show that when

10. Charles-Edouard Jeanneret, *Salon*, Jeanneret-Perret House, La Chaux-de-Fonds, Switzerland, c. 1913
Photograph: Fondation Le Corbusier, Paris
Copyright © 1991 ARS N.Y./ SPADEM

he did not buy from (relatively inexpensive) Swiss sources, the furniture he purchased came from Paris, not Munich or Berlin.

Jeanneret's "style" furniture has been discussed in detail by Arthur Rüegg, who notes that on occasion Jeanneret selected Louis XIII furniture, but in that case only rush-bottom chairs for such informal settings as the salon in his parents' house, and not for the interiors of well-to-do clients for whom the elegant, tapering lines of Directoire-inspired furniture would have been considered more appropriate.[44] Given the relative refinement of Jeanneret's idiom and its affinities with the historicizing designs of the French *coloristes*, it comes as something of a surprise to find that in a letter written

only about a week after his visit to the 1913 Salon d'Automne, he expressed enormous enthusiasm for two interiors he had seen there by Francis Jourdain, whose approach was very different. Jourdain, son of Frantz Jourdain, had been trained as a painter, but after the early 1900s, when he first turned his attention to interior design and was working in the art nouveau style, he had begun to make increasingly plain, simply constructed furniture, mostly for his own use. In 1911 Jourdain received a gold medal for his contribution to the decorative arts section of the International Exposition in Turin, and the following year he established a commercial workshop in Esbly (Seine-et-Marne) called Les Ateliers Modernes.

11. Francis Jourdain, *Bedroom*,
Salon d'Automne, Paris, 1913
Photograph: *Art et décoration* 35
(January 1914), 18

12. Francis Jourdain, *Salon–
Dining Room*, Salon
d'Automne, Paris, 1913
Photograph: *Art et décoration* 35
(January 1914), 19

13. *Francis* Jourdain, *Sketch for a Bedroom*
Bibliothèque Forney, Paris
Photograph: L. Werth, *Meubles modernes* [1913]

In his furniture and in his attitude to design generally, Jourdain was indebted to the ideas of the Austrian architect Adolf Loos, as advertisements for Les Ateliers Modernes in *Les Cahiers d'aujourd'hui* clearly stated.[45] It was in the pages of this journal that translations of two essays by Loos, "L'Architecture et le style moderne," and "Ornement et crime," appeared in 1912 and 1913. Jeanneret was familiar with *Les Cahiers d'aujourd'hui* at least as early as the autumn of 1913,[46] but he does not appear to have paid much attention to Jourdain's work until December, when he saw Jourdain's bedroom and salon–dining room ensembles in the Salon d'Automne (figs. 11, 12). The wood furniture in both interiors was extremely simple, even severe, in form as well as coloration.

Although Jeanneret did not mention Jourdain's ensembles in the notes he made at the Salon d'Automne, in a letter to the designer one week later he said that the only durable impression he had received at the exhibition was made by Jourdain's work. Indeed, it would seem that this high regard for Jourdain's designs had completely displaced the interest he had so recently expressed in the *coloriste* ensembles. His own reaction astonished Jeanneret because he associated Jourdain's work with the com-

plex, aggregate features characteristic of art nouveau designs: "I did not expect that the emotion which carried me away would come from that direction," he wrote. He explained that in a promotional booklet for Les Ateliers Modernes, which Jourdain had sent him, he had seen Jourdain's drawings of interior ensembles (fig. 13): "There your ensembles appeared to be animated by that mentality which ten years ago built up complexes so abnormal that they had to fall [from grace] several years later. What I am referring to are those pieces of furniture for multiple uses which were no more than architecture-furniture [*immeubles-meubles*]."[47] Jeanneret evidently felt that the designs in Jourdain's brochure showed affinities with art nouveau insofar as they involved pieces of furniture intended for multiple uses, forms that, he said, "could be called the opposite of my ideas." In other words, while siding with the *coloristes* against the complexity and unadaptability of art nouveau designs, Jeanneret discovered in Jourdain's furniture, notwithstanding any features that might be reminiscent of art nouveau, a viable alternative to something—still ill defined—that continued to trouble him in the work of the *coloristes*.

The significance to Jeanneret of this discovery becomes clear in the subsequent passage of his letter to Jourdain: "The conception of the piece of furniture in itself, the piece of furniture as a work of art, the obsession with the admirable Louis XVI or Empire armchair, or with one from Compiègne or the Trianon, or with imitations of them, appear to me to be just as artificial as the obsession with the decoration of a facade or a painted frieze in a room."[48] Here Jeanneret was obviously thinking of works by the *coloristes*, or his own designs that showed their influence. They all rejected art nouveau *immeubles-meubles* in favor of the "piece of furniture in itself." In doing so, both Jeanneret and the *coloristes* sought inspiration in classicizing forms of earlier French styles. However, in Jeanneret's estimation, their high regard for the styles of the past made them vulnerable to the risk of turning their designs for useful objects into works of art that, despite formal differences, were really not unlike art nouveau designs. He now realized that theirs was a

superficial, decorative response to the problems of contemporary design. The interiors Jourdain showed in the Salon d'Automne, on the other hand, contained simply constructed furniture, composed almost exclusively of rectangular elements devoid of applied ornament; their utter plainness took the *coloristes'* simplification of form to an extreme in which no overt reference was made to national traditions or past styles. Jourdain's work exposed the artificiality of everything else exhibited alongside it and so forced Jeanneret to reassess his understanding of what constituted the best of modern design.

At this point in his letter to Jourdain, Jeanneret referred to Loos' essay, "Ornament and Crime," in which, he wrote, Loos "crystallized, in solid form, vague impressions, feelings that are nascent or already well developed but which are hardly ever acknowledged at this time when the fury of 'decorative art', the folly of the *Beautiful*, overwhelms and stupefies the simple, instinctive, necessary, and only true sentiment of the *Good* — the Good or *Well Made Thing* being Beautiful in and of itself."[49] Jeanneret now recognized that Jourdain's work was founded on a conception of design similar to Loos' in which French national traditions obviously played no part, and he understood that it called into question all that he had previously considered to be the best furniture available in Paris: "Your work," he told Jourdain, "is a sword planted in the middle of the road which surveys from on high . . . [illegible word] the puppets of the *Beautiful*. Poiret, in spite of himself, must be very disturbed by it. It courageously poses the question again, furnishing *principles*. And a whole part of my being is drawn instinctively to that, a whole part of my spirit as well."[50]

In Loos' essay condemning ornament Jeanneret discovered an alternative to the *coloriste* vision of design, a means of recuperating the classical tradition without recourse to specific forms of the past. By drawing a distinction between style and ornament, Loos made it possible to conceive of a modern style devoid of the vocabulary of decorative forms that the *coloristes* still considered to be the constitutive elements of style. Loos argued that recognition and acceptance of the conditions of the present in and of themselves yield a modern style, which cannot in fact be created in any other way. Through denial of the past, this style in effect affirms the past, because it is linked to it by a cultural evolution that entails continual rejection of that same past, enabling it to assume its legitimate place in history.

Jourdain's interiors impressed Jeanneret because they gave form to some of these ideas. By insisting on what Jourdain described as "the beauty of a simple, rational form, well adapted to its function, and on the sumptuousness of a beautiful, unadorned material,"[51] he indicated a course for design that avoided the impasse of decoration, whether based on the English arts-and-crafts model in which Jeanneret had been trained or the French neoclassical styles to which Poiret and the *coloristes* resorted as a means of overcoming the limitations of art nouveau. It thus appears that working through the problem of decoration led Jeanneret to the threshold of an international, or nonnational, style. Because the rejection of ornament entailed the abolition of all those decorative motifs that both constituted and signified the French national tradition, it opened up the possibility of transcending the nationalist implications of the decorative arts.

Given the conservative atmosphere of La Chaux-de-Fonds, it was impossible for Jeanneret to put his new understanding to work in designs he was called upon to realize for private patrons there. But in a report he wrote in December 1914 about the teaching of drawing, he was able to articulate some of these ideas.[52] In many of its details as well as its more general premises concerning the fundamental distinction between art and the design of functional objects, Jeanneret's text reveals a profound debt to Loos. He quoted one of Loos' most powerful statements on the inverse relation between ornament and culture, and echoed Loos' proposition that craft traditions survived only in those *métiers* too humble to attract the attention of artists; he even subscribed to Loos' view that one of the extremely rare instances of an appropriate modern style was to be found in contemporary men's clothing.

Arguing that contemporary designers

should not draw inspiration from a decorative tradition embodied in the recognized historical styles — the approach taken by the French *coloristes* — Jeanneret took his cue from Loos when he declared that the model should instead be located in "average production [*production normale*]," which is determined by "the general influence of the contemporary spirit" on one hand, and by "the qualities of skill and good manufacture" on the other. Yet Jeanneret did not deny the high quality achieved by the great craftsmen-designers of the past. On the contrary, he singled out the work of André Charles Boulle, Philippe Caffieri, and Jean Henri Riesener as evidence of a tremendously valuable classical tradition that had characterized French design throughout the eighteenth century. He located these designers at the apex of a pyramid, the foundation of which was formed by average production, which is to say the work of those who might have been less gifted designers but who were nonetheless trained artisans capable of producing objects of reasonable quality adequate to the purposes for which they were intended. Jeanneret maintained that the hierarchical structure of design production was essential for the articulation of a contemporary style. Without the sound basis provided by average production, it was impossible for even the greatest artist to develop a consistent vocabulary of forms: no amount of artistic training could replace basic knowledge of the *métiers*. Design education had embarked upon a false route by attempting to "create out of the blue a Riesener or a Boulle when the whole foundation is nonexistent." This, he believed, was "the reason for the failure of the so-called 'modern' styles."[53]

The most important innovation in the corrective program Jeanneret proposed in his report involved his conception of knowledge of the *métiers*, because in it the machine played a central role. In this respect he was indebted not to Loos — whose discussions of average production address handicraft and never mention the machine — but to the Germans whose spectacular success in working with modern industry Jeanneret had described so powerfully in his 1912 book. When he declared that those who produce designs must be trained in the most modern industrial techniques as well as in traditional modes of handicraft, Jeanneret was in effect fusing Loos' paean to vernacular, pre-industrial culture with the Germans' embrace of the machine. Jeanneret argued that the purpose of learning the production methods of the past was not to repeat them for the rest of one's career but precisely the opposite, to enable a student "to appreciate the benefits of modern machines and their intelligent utilization." Once the machine was accepted as the fundamental premise of design production, it would inevitably become the basis for a modern style. And when designers would finally abandon the domain of art, in which their search for a solution to the problem of style could only produce superficial, decorative results, they would be free to ally themselves with the most advanced technical innovators of their day, "those who make machines, precision tools, the makers of automobiles, steamships, the engineers" — in short, all those who strove "for the honor and glory of their epoch, by creating instruments of the greatest utility and of a form as self-evident as it is symptomatic."[54]

In his 1914 report on drawing, Jeanneret articulated a view of design according to which the great French neoclassical tradition was carried into the present by the principles that governed mechanical production outside the realm of art, rather than by an artistic approach directed toward a revival of those decorative forms that had governed the conception of French tradition in the past. Given his refusal to submit to the nationalist implications of the French attachment to tradition, and his willingness to embrace in its stead a respect for modern industry that was widely identified with Germany, one would be justified in expecting Jeanneret to distance himself from the *coloristes* even more completely than he had done at the end of 1913 in his letter to Jourdain. This was, however, far from the case. In fact, Jeanneret planned to include objects designed by André Groult in at least one interior that he was decorating for a client in La Chaux-de-Fonds in February 1915. At that time, he wrote Groult that he found his things to be "exquisite" and that it was "a joy to use them in realizing certain

works." The manner in which he went on to describe his aims as a designer bears scarcely any resemblance to either Loos' ideas or the model of modern industry to which he had subscribed only two months earlier: "An interior that we are creating is (or should become, if the client would actually consent) a spiritual state, [or] at least a work of the soul. Everything holds together, is related, and sings softly in symphony."[55] Here there is no suggestion of machine-made forms or reference to industrial designs inspired by modern, functional equipment. Rather, Jeanneret appealed to the far more conventional conception of the interior as a state of mind corresponding to a musical composition of totally harmonious elements.

How can one make sense of the apparent contradictions in Jeanneret's approach to modern design at this time? In order to account for his recuperation of the *coloriste* attitude, which Groult represented and which Jeanneret seemed to have rejected more than a year earlier, it is vital to consider the atmosphere of wartime France, where hostility to Germany was obviously intense.[56] That Jeanneret was affected by this atmosphere is borne out by notes he made during the summer of 1915, when he spent six weeks in Paris. In a sketchbook from that period, he recorded a visit to the department store Le Printemps where, in the products of L'Atelier Primavera, he discovered a laudable tendency in contemporary French design: "There's a big department with the most beautiful products that can be demanded of the present age, handmade and very cheap." These were commercial products of high quality that, Jeanneret observed, marked a distinct triumph over the Germans. In addition, and more to my point, he commented approvingly on things he had noticed elsewhere in Paris: "magazines, boutiques, clothing, objects of pleasure – then: Groult and his competitors. It's more than enough to completely offset the Hun."[57] Jeanneret's coupling here of Groult and the *coloristes* with an explicit anti-German attitude suggests that once again, French nationalism played an important role in determining his approach to decorative art and interior design.

In fact Jeanneret did not have to go to

Paris in order to experience the effects of the war on French perceptions of modern design. In June 1915, before his trip to Paris, Jeanneret visited Auguste Perret in the south of France. At that time he must have learned of an attack that Léon Daudet had recently made in the French press against Perret's Théâtre des Champs-Elysées (fig. 14). Perret himself seems to have known few details about it, for in a letter of June 30, Jeanneret informed him that Daudet's article "appeared in the first week of March in the Lyon *Nouvelliste*; its title: 'L'ART BOUCHE' (or so I'm told)."[58] At this point, neither Jeanneret nor Perret had read the article, but it is clear that Jeanneret was already committed to helping Perret mount a defense against Daudet's charges that Perret's theater was indebted to German ideas. In fact, Daudet's accusation was not new; soon after the Théâtre des Champs-Elysées was inaugurated in April 1913, the simplified yet massive forms of Perret's neoclassically inspired, reinforced concrete structure had already been associated with the *style munichois*, a pejorative epithet encompassing all of German art and design that had entered the French critical vocabulary when the Munich decorators had shown in the 1910 Salon d'Automne.[59]

Jeanneret's strategy called for Perret to amass and then publish evidence of German borrowings from French designs, apparently in order to demonstrate that progressive French architects and designers, like their German counterparts, all drew upon traditional French neoclassical sources. He wrote Perret that he had acquired several examples of wallpapers designed by German artists and advised Perret to obtain examples of comparable French designs: "You will find all of this in Paris, to make striking contrasts – at André Groult's, at L'Atelier Français [founded by Louis Süe in 1912], for the modern, at Salaguad for the old." A similar comparison between French and German designs could be made with examples of furniture, "to defend experiments like those of Groult."[60]

In thus formulating Perret's defense, Jeanneret not only thought in terms of both architecture and design, he also identified Perret's position as an architect with that of Groult as a designer. In light of the fact

14. Auguste Perret (with Gustave Perret), *Théâtre des Champs-Elysées*, Paris, 1911–1913
Phtograph: J. Feuillie
Copyright © 1991 ARS N.Y./ SPADEM

that both men were dedicated to the use of an analogous vocabulary of French neoclassical forms, their parallelism in Jeanneret's view is not as surprising as it might at first appear. Perret had for some years been involved in the same intellectual circles as a number of the *coloristes* with whom Groult was associated, and they were all affected by the anti-German attitude that, even before the war, had led French critics to associate the neoclassical reaction to art nouveau with foreign, antinational, and specifically German influences.

This episode illustrates that during the war, the nationalist views that had previously helped to shape Jeanneret's conception of modern decorative art were articulated in more emphatic terms. Despite

Loos' importance for the ideas Jeanneret would espouse in subsequent years, after 1914 Loos did not figure prominently in any of his wartime formulations on the subject of design, presumably because Loos' work had little bearing on the specifically French values that Jeanneret, like so many of his contemporaries in Paris, was seeking to isolate and promote. This is evident in yet another project Jeanneret initiated during the summer of 1915: a book, entitled *France ou Allemagne*, in which he intended to address salient issues in architecture and design in terms of the confrontation between French and German attitudes that had conditioned his understanding of these fields at least since 1910. By juxtaposing examples of French and German work (much as Jeanneret suggested Perret should do), *France ou Allemagne* would pose the questions, "Where does French art stand? Where does German art stand?" The purpose was to prod the reader into an awareness of the high quality that Jeanneret perceived in the most recent developments in Paris; his goal was to provide "a necessary piece of rehabilitation."[61]

While conducting research for this book, Jeanneret wrote to his old supporter, Rupert Carabin, for basic information concerning the history of French decorative art; he appealed to his other principal mentor in France, Auguste Perret, for background material on the architectural aspects of his project. In the fall of 1916, he also asked Perret to help him find a publisher in France. Perret responded that he had several alternatives in mind, one of which was to prove particularly significant for Jeanneret's future development: "My friend Ozenfant of *L'Elan* . . . could take charge of the printing at a low cost," Perret wrote; "in this way we would be completely free."[62]

It is well known that Jeanneret was introduced to Amédée Ozenfant by Perret at a meeting in Paris of a group called Art et Liberté. However, the fact that their first encounter came about because Jeanneret had begun to write a book focusing primarily on the decorative arts has not been remarked upon, nor has the nationalist context of that encounter been explored. Malcolm Gee and Kenneth Silver were the first scholars to call attention to Art et Liberté, an association

of progressive artists, architects, musicians, and writers that was established in 1916 in response to attacks made on Perret and Poiret concerning purported German influences on their work.[63] The purpose of the group, initially headed by Perret's brother-in-law, Sébastien Voirol, was to defend "artists of merit [who are] perfectly French" against such "false traditionalists" as Léon Daudet, who argued that their work was "anti-French."[64] On 17 December 1916, Perret became vice president of Art et Liberté's governing board, of which Poiret was also a member.[65] Once again we find nationalism and the related issue of French tradition at the heart of the modernist enterprise, this time in an organization devoted to precisely those principles Jeanneret had articulated in outlining a defense of Perret the previous year. Particularly striking in this instance, but also true of the others discussed above, is the fact that vanguard artists felt compelled to claim allegiance to tradition and to describe their aims in the same nationalist terms used by opponents of modern art.

The appropriation of nationalist rhetoric as a defense for modernist art was a project shared during the war by Ozenfant. In the spring of 1915, he founded *L'Elan*, a journal whose purpose, stated in the first number, was to further "propaganda for French Art, French independence, in sum, the true French spirit."[66] While conservative critics were equating cubism with *art boche*, *L'Elan* promoted it as the embodiment of French neoclassical modernism. Given the parallel with the ideas that informed Jeanneret's *France ou Allemagne* project, and the fact that *L'Elan* was soliciting manuscripts for publication in book form, it is logical that Perret would propose Ozenfant as a possible

publisher of Jeanneret's book. Although *France ou Allemagne* never appeared, Jeanneret and Ozenfant nonetheless developed a close bond, collaborating on the formulation of the purist aesthetic in the pages of their journal, *L'Esprit nouveau*, where the name Le Corbusier gained prominence in the 1920s.

It has been said that when they first met, Ozenfant was "more sophisticated" than Jeanneret, and that he, not Jeanneret, "was largely responsible for giving Purism its neoclassical flavor."[67] As the foregoing discussion has shown, however, through his involvement in the decorative arts, Jeanneret had already articulated an equally strong commitment to neoclassicism, which, at least initially, he regarded as a fundamental component of the French national tradition. Thus, while Jeanneret undoubtedly learned a great deal about painting from Ozenfant, the neoclassical aspect of purism was not something Ozenfant had to teach him, nor did Jeanneret become committed to neoclassicism only through his architectural training and experience. Rather, his neoclassical attitude assumed a definitive form in the nationalist climate of the decorative arts before and during World War I. Although the nationalist, decorative-arts dimension of Jeanneret's neoclassicism would later be masked by the internationalism of Le Corbusier's antidecorative work of the 1920s,[68] it deserves recognition and study for a variety of reasons. Not least of these is what it reveals about the historical circumstances that conditioned Jeanneret's appropriation of a nationalist discourse in the context of which modernism was being defined — by its enemies as well as its friends — in early twentieth-century France.

NOTES

1. A version of this essay was originally presented as a lecture in 1987. The material has since been incorporated in a book: Nancy J. Troy, *Modernism and the Decorative Arts in France: Art Nouveau to Le Corbusier* (New Haven, 1991).

Jeanneret's early training in the Ruskinian decorative arts tradition, his student work as an art nouveau designer of decorative motifs for watchcases as well as architectural surfaces, and his youthful involvement in the Swiss Romande decorative arts movement have received considerable attention. See Mary Patricia May Sekler, *The Early Drawings of Charles-Edouard Jeanneret (Le Corbusier), 1902–1908* (New York, 1977); Eleanor Gregh, "The Domino Idea," *Oppositions* 15/16 (Winter–Spring, 1979), 61–87; Luisa Martina Colli, *Arte artigianato e tecnica nella poetica di Le Corbusier* (Rome, 1982); H. Allen Brooks, "Le Corbusier's Formative Years at La Chaux-de-Fonds," in *Le Cor-*

busier: *Early Buildings and Projects, 1912–1923*, ed. H. Allen Brooks, vol. 1 of *The Le Corbusier Archive* (New York, 1982), xv–xxv; *La Chaux-de-Fonds et Jeanneret (avant Le Corbusier)* [exh. cat., Musée des Beaux-Arts and Musée d'Histoire] (La Chaux-de-Fonds, 1983) (this catalogue is an enlarged, special edition of *Architese* 13 [April 1983]).

The present essay concentrates not on the earliest period of decorative arts training that is the principal focus of the studies cited above, but rather on Jeanneret's involvement in the decorative arts during the early and mid-1910s. This relatively neglected subject has been examined in three articles by Arthur Rüegg, "Anmerkungen zum *Equipement de l'habitation* und zur *Polychromie intérieur* bei Le Corbusier," in *Le Corbusier: La ricerca paziente* [exh. cat., Villa Malpensata] (Lugano, 1980), 152–162; "Charles-Edouard Jeanneret, architecte-conseil pour toutes les questions de décoration intérieur . . . ," in La Chaux-de-Fonds 1983, 39–43; and "Equipement: Les contributions de Le Corbusier à l'art d'habiter, 1912–1937: De la décoration intérieur à l'équipement," in *Le Corbusier: Une encyclopédie* [exh. cat., Centre Georges Pompidou] (Paris, 1987), 124–135.

2. Léon de Laborde, *De l'union des arts et de l'industrie*, 2 vols. (Paris, 1856).

3. Prosper Mérimée, quoted in Victor Champier, "Le Pavillon de la commission française organisée par l'Union Centrale à l'Exposition d'Amsterdam," *Revue des arts décoratifs* 1 (1883–1884), 70.

4. Marius Vachon, *Nos industries d'art en péril: Un musée municipal d'études d'art industriel* (Paris, 1882), 8.

5. Quoted in Edmond Plauchut, "La Rivalité des industries d'art en Europe," *Revue des deux mondes* 40 (May–June 1891), 643. This statement serves as the epigraph for Vachon's book, *Nos industries d'art en péril*, in which it is quoted on the title page.

6. Debora L. Silverman, *Art Nouveau in Fin-de-Siècle France: Politics, Psychology, Style* (Berkeley, 1989), 11.

7. Charles Genuys, "Exposition Universelle de 1900: Les Essais d'art moderne dans la décoration intérieure," *Revue des arts décoratifs* 20 (1900), 288.

8. Genuys 1900, 288.

9. Frantz Jourdain, "L'Architecture à l'Exposition Universelle: Promenade à batons rompus," *Revue des arts décoratifs* 20 (1900), 331.

10. See John Heskett, *German Design 1870–1918* (New York, 1986).

11. G. M. Jacques, "Epilogue," *L'Art décoratif* 5 (December 1900), 134.

12. Henri Clouzot, "Le Mobilier moderne au 6e Salon des Artistes Décorateurs," *La Revue de l'art ancien et moderne* 29 (April 1911), 262.

13. Charles du Bosquet, "Le Salon des arts décoratifs français à l'Exposition de Bruxelles," *L'Art décoratif* 23 (April 1910), 121. For a similar point of view, see Maurice-Pillard Verneuil, "Un Intérieur moderne," *Art et décoration* 17 (February 1913), 54: "In the heroic

years of art nouveau, when one could still look confidently to the future ahead, an evil blow was dealt by too rapid diffusion [of the style] and the adaptation of the new ideas by some who were insufficiently prepared. To this we owe the 'Modern Style' of horrible and sad memory. All the department stores inundated us with 'modern style' furniture that was, in brief, baroque, awkward, ridiculous, and grotesque. It was a movement backward, and everything was put into question again." The rapid dissemination of art nouveau is discussed by Rosalind H. Williams, *Dream Worlds: Mass Consumption in Late Nineteenth-Century France* (Berkeley, 1982), 173–174: "As commerce adopted the style, it became even less simple and more symbolic, ornate and outlandish."

14. The activities and concerns of this organization are recorded in its journal, *L'Art et les métiers*, the first issue of which appeared in November 1908. See also Nancy Troy, "Toward a Redefinition of Tradition in French Design, 1895 to 1914," *Design Issues* 1 (Fall 1984), 53–69, and especially 62–65, on which I have drawn for the discussion that follows here.

15. L. Deubner, "Decorative Art at the Munich Exhibition," *The International Studio* 141 (November 1908), 42. See also Wilhelm Michel, "Die Ausstellung München 1908: Wohnungskunst und Kunstgewerbe," *Die Kunst* 20 (1909), 9–15, followed by forty pages of photographs of designs displayed at the exhibition.

16. Victor Prouvé, "Art et métiers," *L'Art et les métiers* 1 (November 1908), 7.

17. See Jules Huret, "En Allemagne: Munich; Les Arts décoratifs à l'exposition," *Le Figaro* (19 January 1909), 5. Huret's- discussion of the exhibition was part of a larger series on Germany. Two years after it appeared in *Le Figaro*, it was included as a chapter in his book, *En Allemagne: La Bavière et la Saxe* (Paris, 1911), 143–171. Huret wrote three other books on Germany, and together the four volumes reached a wide audience. See Claude Digeon, *La Crise allemande de la pensée française (1870–1918)* (Paris, 1959), 480 n. 1.

18. Raymond Poidevin and Jacques Bariéty, *Les Relations franco-allemandes 1815–1975*, 2d ed. (Paris, 1977), 177.

19. Rupert Carabin, quoted in Victor Rolly, "La Crise des arts décoratifs en France: Le Congrès de Munich: Rapport de M. Rupert-Carabin," *Mon chez moi* (10 February 1909), 42.

20. See *Exposition des arts décoratifs de Munich*, preface by Baron de Pechmann [special exh. cat., Salon d'Automne] (Paris, 1910).

21. Witness the complaint of the critic Gustave Kahn: "Why are the [French] decorators never ready? Why don't they begin to work on their ensembles in time to show the surprises in their works to an enthralled opening audience? . . . For several years now the masters of decorative art have been the last to arrive" ("Art: Le Salon d'Automne," *Mercure de France* 99 [16 October 1912], 879).

22. The citations in this paragraph are from Maurice-Pillard Verneuil, "Le Salon d'Automne," *Art et décoration* 28 (November 1910), 130, 136, 160.

23. André Mare, letter of 20 February 1912 to Maurice Marinot, Collection Michel Mare, Paris. I am grateful to the late Anne-Françoise Mare-Vène for granting me access to Mare's papers on numerous occasions. This particular letter is transcribed in Margaret Mary Malone, "André Mare and the Maison Cubiste," M.A. thesis, University of Texas at Austin, 1980, app. B, 146. I am grateful to Ms. Malone for sharing her work with me.

24. See Kenneth E. Silver, *Esprit de Corps: The Art of the Parisian Avant-Garde and the First World War, 1914-1925* (Princeton, 1989), 12; Troy 1991, 79.

25. *Journal officiel de la Chambre des Députés* (3 December 1913, 1ère séance), 2924. I am grateful to Linda Dalrymple Henderson for making a copy of this publication available to me. A brief excerpt from this debate is translated in Patricia Leighten, "Picasso's Collages and the Threat of War, 1912–1913," *The Art Bulletin* 67 (December 1985), app., 672.

26. Charles-Edouard Jeanneret, *Etude sur le mouvement d'art décoratif en Allemagne* (1912; rpt. New York, 1968).

27. Jeanneret 1912, 9, 10.

28. Jeanneret 1912, 11, 13.

29. Jeanneret 1912, 73–74.

30. "Quelques exemplaires cependant, avait franchi les frontières suisses et, chose à laquelle je ne m'attendais certes pas, ils ont fait petit à petit leur chemin" (Charles-Edouard Jeanneret, letter of 14 October 1912 addressed "Très honoré Monsieur," Collection Fondation Le Corbusier, Paris [hereafter FLC], Box R3(18), 151–152). It should be noted that in the late 1980s the FLC assigned new inventory numbers to much of the archival material in its collection. The numbers cited here were correct in June 1989.

31. William Ritter, "Le Mouvement artistique à l'étranger: Allemagne," *L'Art et les artistes* 15 (April–September 1912), 188.

32. "J'ai reçu vers la fin de cette année, de nombreux temoignages d'intérêt de personnes particulièrement autorisées à juger de l'Art et de son immixtion dans la vie sociale, –de France, d'Allemagne, de Belgique. . . .
"Si j'en dois chercher la raison, je la devinerais dans le fait que ceux qu'intéressent les rapports de l'art industriel avec la prospérité économique et l'expansion commerciale, y ont trouvé une Synthèse limpide et utile des intentions et des résultats allemands.
"J'envisage donc la possibilité d'une réédition de mon Étude.
"Ces notes écrites avec le désir absolu de voir se manifester en oeuvres d'un esthétisme plus social le génie latin, je les désirerais réimprimées en France, pour qu'elles atteignent leur milieu réel" (Jeanneret, letter of 14 October 1912 addressed "Très honoré Monsieur").

33. Jeanneret reported in a postcard of 2 January 1913 to William Ritter that his proposal for a new edition of the *Etude* had been rejected by the French publisher Floury, whom he had approached on the advice of "courageous Monsieur Carabin, a sculptor who loves form and has an enthusiastic respect for German energy" (photocopy FLC, Box R3(18), 176–177). The original copies of Jeanneret's letters to Ritter are in the Bibliothèque Nationale Suisse, Berne.

34. Charles-Edouard Jeanneret, "En Allemagne," *L'Art de France* 2 (April 1914), 347–395; (May 1914), 457–473.

35. "Il me semble presque être devenu un enthousiaste Teuton. Ce qui est bien loin d'être vrai!" "Je vous dis ceci Monsieur, oh, simplement pour me très nettement nationaliser *'latin'*" (Charles-Edouard Jeanneret, letter of 29 May 1914 to Emmanuel de Thubert, Collection Bibliothèque de la Ville, La Chaux-de-Fonds [hereafter BV/LCdF], LCms89, 67–69).

36. Jeanneret, "En Allemagne" (May 1914), 457.

37. "Commentée un peu partout, j'étais bombardé des demandes de libraires et de personnes telles que vous, Monsieur, attachées aux idées nouvelles" (Charles-Edouard Jeanneret, letter of 27 May 1914 to Paul Cornu, Collection BV/LCdF, LCms89 [each page annotated in pencil: "page supplémentaire"]).

38. Charles-Edouard Jeanneret, "Etude sur le mouvement d'art décoratif en Allemagne," *Les Tendences nouvelles* 62 (May 1914), 1538–1542; 63 (August 1914), 1573–1578.

39. Maurice Storez, "Que seront l'architecture et l'art décoratif après la guerre?" *La Grande revue* 87 (October 1915), 492–521.

40. "Très tracassé par le problème de la décoration d'intérieur j'aurais aimé dissiper un peu mon inquiétude, trouver dans les diverses manifestations des artistes parisiens une piste ou du moins faire un tri, subir des enchantements qui seraient des conversions. J'attendais beaucoup; j'ai été enchanté aux premiers pas, puis bien lassé et déconcerté; mon inquiétude reste la même" (Charles-Edouard Jeanneret, letter of 21 December 1913 to Francis Jourdain, Collection BV/LCdF, LCms89, 19–22 [subsequent citations of Jeanneret's letter to Jourdain refer to this document]).

41. See Charles-Edouard Jeanneret, "Carnet I" (Paris, Autumn 1913), Collection BV/LCdF, LCms88.

42. In additon to "Carnet I" (Collection BV/LCdF), see Sketchbook Al, published in André Wogenscky, ed., *Le Corbusier Sketchbooks, Volume I, 1914-1948* (New York, 1981), 13–26, especially 23.

43. See for example Stanislaus von Moos, *Le Corbusier: Elements of a Synthesis* (Cambridge, Mass., 1982), 17; and William J.R. Curtis, *Le Corbusier: Ideas and Forms* (New York, 1986), 37.

44. Rüegg 1983, 39–43.

45. See the text of the advertisement, "Intérieurs modernes," *Les Cahiers d'aujourd'hui* 5 (June 1913).

46. Charles-Edouard Jeanneret, undated letter postmarked 3 November 1913 to William Ritter, photocopy FLC, Box R3(18), 217.

47. "Je n'attendais pas que vint de là l'émotion qui me ravissait. . . . Vos ensembles y apparaissaient animés

de cette mentalité qui fit s'échafauder il y a dix ans ces complexes si anormaux qu'ils devaient tomber quelques années après. Je veux parler de ces meubles à multiples fins qui n'étaient que des immeubles-meubles." The brochure to which Jeanneret referred is Léon Werth, *Meubles modernes* (n.p., n.d.).

48. "La conception du meuble pour lui-même, du meuble oeuvre d'art, le hantise de l'admirable fauteuil Louis XVI, ou empire, celui de Compiègne ou de Trianon ou ceux à son instar, m'apparaissent aussi artificielles que l'obsession de décor d'une façade ou de la frise peinte d'une chambre."

49. "Il a cristallisé en matière invulnérable, des impressions vagues, des sentiments naissants ou déjà bien développés mais qui n'avaient point trop s'avouer à cette heure où la furie de 'l'art décoratif,' la folie du *Beau*, anéantit et stupéfie, le simple, l'instinctif, le nécessaire, et l'unique vrai sentiment du *Bon*, – Le Bon ou *Bien* étant Beau par essence meme."

50. "Votre oeuvre est un glaive planté au milieu de la route et qui regarde du haut de son . . . [illegible word], les fantoches du *Beau*. Poiret en doit être, malgré lui, bien inquiet. Elle repose courageusement la question, lui fournissant des *racines*. Et toute une partie de l'être instinctivement va à ça, toute une partie de l'esprit aussi."

51. Francis Jourdain, quoted in Louis Vauxcelles, "Les Arts décoratifs au Salon d'Automne," *Le Gil Blas* (28 November 1913), 4.

52. The report was not published until four years later in *Bulletin du Comité Central Technique des Arts Appliqués et des Comités Régionaux* [published as a supplement to *Les Arts français*] 24 (1918), 87–92; 25 (1919), 1–8; 26 (1919), 9–12; 27 (1919), 13–14. Francesco Passanti generously shared with me a copy of the twenty-nine-page typescript of the report (annotated in pen by Jeanneret in 1918) entitled L'OEUVRE: RAPPORT de la Sous-Commission de l'Enseignement présenté au Conseil de Direction," Collection FLC, Paris, Box B1(15), 40–68. All quotations are from the published version of the text. For Jeanneret's role as author, see Sekler 1977, 310.

53. Charles-Edouard Jeanneret, "L'Oeuvre 'Association Suisse Romande de l'Art et de l'Industrie'," in *Bulletin du Comité Central Technique*, supplement to *Les Arts français* 25 (1919), 3, 4.

54. Jeanneret 1919, 4, 2.

55. "Un intérieur que nous créons est (ou devrait être si le client voulait bien le permettre) un état d'âme, au moins, une oeuvre de coeur. Tout se tient, se lie, et chant doucement en symphonie" (Charles-Edouard Jeanneret, letter of 15 February 1915 to André Groult, Collection BV/LCdF, LCms89, 160–161).

56. On the anti-German climate of Paris during the war and its impact on painters in particular, see Silver 1989.

57. Jeanneret, Sketchbook A2, in Wogenscky 1981, 96–97 (Eng. trans., 8).

58. "L'article de Léon Daudet, contre le théâtre a paru dans la première semaine de mars, dans le 'Nouvelliste' de Lyon; pour titre: 'L'ART BOCHE' (paraît-il)" (Charles-Edouard Jeanneret, letter of 30 June 1915 to Auguste Perret, Collection BV/LCdF, LCms89, 230–232). I have not been able to locate the newspaper article mentioned by Jeanneret.

59. The nationalist element in the critical reaction to Perret's theater is discussed in Troy 1991, 98–100.

60. "Vous trouverez tout cela à Paris, pour établir des contrastes saisissants, – chez André Groult, à l'Atelier français, pour le moderne, chez Salaguad pour l'ancien." "La démonstration parallèle à celle des papiers peints, pourrait être faite avec le mobilier, pour défendre des tentatives comme celles de Groult" (Jeanneret, letter of 30 June 1915 to Perret).

61. Jeanneret, Sketchbook A2, in Wogenscky 1981, 99 (Eng. trans., 8).

62. "Mon ami Ozenfant de 'l'Elan' . . . pourrait se charger de l'impression à moins de frais, de cette façon nous serions complètement libre" (Auguste Perret, letter of 29 September 1916 to Charles-Edouard Jeanneret, Collection FLC, Box B1(20), 94).

63. Malcolm Gee, *Dealers, Critics, and Collectors of Modern Painting: Aspects of the Parisian Art Market Between 1910 and 1930* (New York, 1981), 218–221; Silver 1981, 199–200.

64. Quoted from the manifesto of Art et Liberté published in *La Renaissance politique, économique, littéraire et artistique* 5 (15 September 1917), 24.

65. "A travers les groupements artistiques: Art et Liberté," *Le Petit messager des arts et des artistes, et des industries d'art* 44 (20 May–10 June 1917), 15.

66. *L'Elan* 1 (1915), 2.

67. John Golding, *Ozenfant* (New York, 1973), 9.

68. A number of scholars, among them Richard Etlin, have recognized that the French neoclassical tradition persisted in many aspects of Jeanneret's work of the 1920s. See Etlin's articles, "A Paradoxical Avant-Garde: Le Corbusier's Villas of the 1920s," *The Architectural Review* 181 (January 1987), 21–32; "Le Corbusier, Choisy, and French Hellenism: The Search for a New Architecture," *The Art Bulletin* 69 (June 1987), 264–278.

RICHARD A. ETLIN
University of Maryland

Nationalism in Modern Italian Architecture,

1900–1940

The issue of national identity was fundamental to the search for a modern architecture throughout the West after the major shift in cultural attitudes beginning in the 1820s that has been known since that time as romanticism. The subject of modern Italian architecture from 1900 to 1940 offers a particularly rich field of inquiry with respect to nationalism on two accounts. First, it affords the opportunity to consider the interplay between an earlier cultural nationalism of the romantic era with the later political nationalism of fascism. Second, it represents an evolving and a pluralistic notion of modernism in architecture and the decorative arts. Here, I will discuss several examples: Turinese art nouveau, the Roman vernacular, the Milanese Novecento, Italian rationalism, and the fascist *stile Littorio.*

The new appreciation of cultural diversity associated with romanticism caused a crisis in Western architecture. It was now commonly accepted that every major historical civilization had its own architectural style characteristic of its culture, so it seemed incumbent on the present age to create its own original style. The potential conflicts between modernism and nationalism in satisfying this task were complex and to a great degree insoluble. Could an architecture be truly modern if it had to be given a recognizable national identity rooted in past traditions? Could a new architecture be truly national if its signs of modern civilization were shared by other countries?

These inherent difficulties came into focus in 1902 at the Prima Esposizione Internazionale d'Arte Decorativa Moderna, an exhibition largely initiated by the Sezione di Architettura of the Circolo degli Artisti di Torino (figs. 1, 2). In Italy, art nouveau or *arte nuova* literally burst into the public's consciousness with this event. The First International Exposition of Modern Decorative Art was also, in the words of the contemporary Italian architect and critic Alfredo Melani, "the first festival of the New Style."[1] To foreign observers, the Turinese initiative came as a welcome surprise in light of what was universally noted as Italy's indifference or even hostility to modern design at the Exposition Universelle of 1900 in Paris.

As the first international exposition to admit, as its program stipulated, "only original products that show a decisive tendency toward the aesthetic renewal of form" with all "mere imitations of past styles" excluded, this Turinese exposition offered an international display of art nouveau decorative arts from major artists throughout the West: Joseph Maria Olbrich and Peter Behrens from Germany, Victor Horta from Belgium, Charles Rennie Mackintosh and Margaret Mackintosh Macdonald from Scotland, Louis Tiffany from the United States, Walter Crane from England. Art nouveau exhibition buildings designed expressly for this event by Raimondo

D'Aronco and Annibale Rigotti, set within the magnificent verdure of Valentino Park by the Po River, provided a unified stylistic setting for the objects on display.

The year 1902 was a time of reckoning for art nouveau throughout the West. Enough had been accomplished in several countries since the inception of the style in the mid-1890s to prompt reflection about its significance. Was art nouveau, as *The Architectural Record* wondered, "only one of many expressions of 'fin de siècle' sensationalism,

which tries to whip jaded sensibility into new life by violent stimulation"?[2] Or was it, as the progressive French architect Frantz Jourdain argued, "the style of the twentieth century"? For the Turinese organizers of the First International Exposition of Modern Decorative Art, art nouveau was evidence of the artistic expression of modern life. Responding to what it considered the shallow criticism of the Turin exposition, the *Architektonische Rundschau* of Stuttgart explained, "The Turin Exposition, in spite of all its faults and deficiencies, is and remains an achievement whose significance will only be revealed later. It is only incredible that such an obvious idea had not materialized long ago somewhere else. Did nobody see the necessity or had nobody the courage of the Turinese when they gave life to this exhibit? Why has Berlin been so completely passive until this time? Why Munich?"[3]

Whereas the idea of hosting an international exposition of modern decorative art was widely praised, the architecture was beset by domestic and foreign criticism for its seeming lack of national identity. Nearly all critics commented that the architecture was modeled on the example of the Austrian Secession and its Wagner-Schule, which was seen as "the most future oriented group of artists," and in particular on Olbrich, who was considered "the most distinct representative" of the Wagner School.[4] The overall similarities between D'Aronco's architecture at Turin in 1902 and that of Olbrich's 1901 Darmstadt Artists' Colony, and especially between the entrance pavilions of both the exhibitions, prompted repeated comment.

The French critic Gustave Soulier expressed a widely shared sentiment when he objected, "There is no real sincerity in adopting these pre-existing forms, brought in from German lands and which do not at all correspond to the traditions and nature of Italy."[5] Even the ardent champion of innovative modernism, Alfredo Melani, objected to D'Aronco's architecture at the Turin exposition. "I . . . will become an enemy of *Arte Nuova* if in Italy it ties itself to models that come from England, Belgium, France, or Germany. Art made this way is not worthy of the name. The stigma

of plagiarism will reveal a fatal impotence." Italian artists could only create true works of art by drawing sustenance from "our own tendencies and our own national needs."[6] Melani, then, could not accept D'Aronco's new architecture: "I accuse the Palazzo dell'Esposizione of reflecting the art of the Viennese Secessionists and say that this is not an art worthy of D'Aronco. Driven by an influence alien to the spirit of its author, this building, for us modernists, has the value of pseudo-ancient art."[7]

In contrast, defenders of the exposition's architecture praised what they saw as D'Aronco making a vital, contemporary style truly Italian. A critic in the widely circulated *L'illustrazione italiana*, for example, congratulated D'Aronco for having demonstrated in his exposition buildings that "if Italy learns something from abroad, it nevertheless has the creative energy soon to equal the masters." In an article on D'Aronco's coming architecture for the 1902 Turin exposition published in January 1902, the vice president of the exposition's executive committee had stressed the balance between national and international characteristics that could be found in the new European architecture: "As in the other fields of the decorative arts, even in architecture ethnic differences have impressed a particular physiognomy on the various tendencies. Between the *Castel Béranger* by the French Guimard and the *Maison du Peuple* by the Belgian Horta; between the *Handelsbank* by Schilling of Dresden and the *Secession's Gebude* by the Viennese Olbrich, there are profound differences. But all are tied together again by certain common characteristics that constitute the physiognomy of the new style." Whereas D'Aronco adapted the overall aspect of the Viennese school as well as its ornamental details, he "brought a special elegance, a eurythmy of parts that reveal the precious quality of harmony of the Latin intelligence."[8]

The debate prompted by the art nouveau architecture at the 1902 Turin exposition established the parameters by which the conflict between nationalism and internationalism in the subsequent radically new modern Italian movement, the Italian rationalism of the late 1920s and 1930s, would

be argued. This occurred even in spite of the rationalists' claim that they were following the legacy established by the pioneering futurist architecture of Antonio Sant'Elia. Before that time, though, Italy experienced two other modern movements that sought to balance the opposing factors of tradition and modernity, but this time with a tilt toward tradition as the means to securing national identity. The first arose in Rome through the creation in 1890 of the Associazione Artistica fra i Cultori di Architettura. By the second decade of the twentieth century, its principal spokesmen were Gustavo Giovannoni and Marcello Piacentini, who also edited the group's major periodical, *Architettura e arti decorative*, first published in 1921. The second movement was centered in Milan with the rise of what has come to be known as post–World War I Novecento architecture. Its leaders were Giovanni Muzio and Gio Ponti; the latter would become director in 1928 of *Domus*, a new magazine whose Latin name epitomized the traditional basis of the renewal that the Novecento movement was promoting.

The Roman Associazione Artistica combined an enthusiasm for the popular Sittesque school of urban design with a commitment to renewing Italian architecture through the adaptation of traditional vernacular forms. Both interests were united through a fascination with the reasoned picturesque. When Camillo Sitte's epoch-making *Der Städte-Bau nach seinen künstlerischen Grundsätzen* (City Design According to Its Artistic Principles, 1889) reached Italy, it found fertile ground in the minds of the Roman members of the Associazione Artistica. They responded eagerly to the progressive, anti-academic approach to urban design grounded in a love for the charm of old cities whose picturesque aesthetic effects were enunciated as principles to be followed in new building, whether in old centers or beyond. The Italians were especially fond of Sitte's approach for it seemed to them to be thoroughly grounded in their heritage. As Marcello Piacentini observed, "Sitte profoundly studied the medieval environment and recorded innumerable groupings of buildings in the centers of our dearest and most beautiful cities, innumerable scenes with a picturesque and suggestive sense. On these models, he fashioned his theories for the layout of cities."[9]

Vernacular architecture, seen as the repository of a timeless way of building, marrying practicality and economy with unselfconscious artistic effect, using local materials and responsive to local needs and climate, became at the turn of the twentieth century an important alternative to what were considered artificial stylistic revivals. The architects of the Roman Associazione Artistica welcomed the renewal of a traditional Italian vernacular architecture as a natural complement to Sittesque planning principles. Both urbanism and architecture were further joined in the minds of these Roman architects by the notion of contextualism. *L'ambientismo* or contextualism was, as Gustavo Giovannoni explained, "the correlation between a work and its surroundings; the artistic harmony between individual works and the whole."[10]

In 1910, Giovannoni issued a report for the combined artistic associations of Rome in which he denounced the current approach to urbanism that sought to enhance the importance of major monuments by "creating around them a new setting." Not only was it wrong to isolate the monument in "the vastest and most regular setting possible," it was also a mistake to "neglect completely the minor buildings" that constituted their setting.[11] This was especially important in a city like Rome, which, as Piacentini explained in 1916, was a "picturesque," not a "grandiose" city: "To conserve a city, it is not enough to 'save' its monuments and its beautiful palaces, by isolating them and creating around them an entirely new setting; it is also necessary to save the ancient setting [*ambiente*], with which they were so intimately connected."[12] To consider the beauty of a building by itself, argued Piacentini, was a "purely academic" exercise. Piacentini repeatedly reminded his readers of Monneret de Villard's dictum that a city's beauty comes from its "ensemble, to which even the smallest constructions contribute."[13] "Sometimes," explained Giovannoni, "one can say that the monument is the entire setting."[14]

One of the most telling examples of this

principle was provided by Giorgio Wenter-Marini in a pair of drawings depicting the Castello del Buon Consiglio of Trento in its actual condition with a mass of minor buildings concealing its base and the proposal to liberate the monument from these structures. Wenter-Marini, whom *Architettura italiana* praised for his "important studies on contextualism," explained the lesson as follows: "against the coldness of the new arrangement one can contrast the picturesque play of the small masses that give scale to the castle." This castle, continued Wenter-Marini, "owed its dominating effect as an emerging mass to the small buildings that hide its base." The small buildings themselves had value not as works of art, but rather as a foil to the architectural monument.[15]

Neither Giovannoni nor Piacentini were advocating stylistic revivals. To maintain the diversity of the old city, it was important, explained Piacentini in 1913, to avoid the "clownlike variety of historical styles, this ineffable succession of Borrominiesque effects and pre-sixteenth-century parodies! Variety should derive from the movement of the masses; the lively and capricious nature of the building's profile; the alternation of porticoes, loggias, balconies, and gardens; from showing to advantage ancient monuments or public buildings and from harmonizing with them."[16] Piacentini termed this type of self-effacing background buildings *la prosa architettonica*.[17] In his project for the restoration of the center of Bologna, Piacentini proposed a contextual design of background buildings that were praised both for the variety of their massing and for "a sober simplicity of line and decoration that harmonize naturally with the existing construction."[18]

Giovannoni enunciated an analogous position:

Even in the stylistic sense there must remain a harmony between the old and the new; but I do not want to be misunderstood with this call for architectural tradition. This does not mean that new facades should be cold copies of pre-existing works. . . . There is nothing, for example, further from the true sense of architecture than those albums of ideal projects "im sinne der Alten" presented at the exposition of German cities of 1903 in Dresden to serve as models to apply for buildings in cities of a historic character. Every city, though, has its own artistic "atmosphere," that is, a sense of proportion, color, and form that has endured as a permanent element through the evolution of various styles, and that must not be abandoned. This should give the tone to the new works, even in the newest and most audacious creations.[19]

Just as Piacentini promoted the idea of the "prose of architecture," Giovannoni advocated the principle of *diradamento*. *Diradamento*, or "thinning out," connotes a selective pruning. Giovannoni's definition of *diradamento* took its cue from Alfonso Rubbiani's counsel to "improve circulation with the minimum of demolition and the maximum of expedients with the conviction that the more the streets are varied through the height of buildings, with movements that seem unpremeditated, by small visual releases that entice and entertain the eye, the better it is." Responding to Rubbiani's call for the adaptation of old city centers to modern life as a "subtle art," Giovannoni posited his theory of *diradamento*, which entailed "not the uniformity of new streets, but rather irregular widenings: demolition here and there of a house or of a group of houses and creating in their stead a small piazza with a garden, a small lung, in an old quarter; then the street narrows in order to widen again soon after, adding variety of movement, associating effects of contrast with the original setting, such that everything will be infused with a character of art and of [harmonious] setting."[20] One can see the application of this philosophy in Giovannoni's proposal for the hotly contested Via dei Coronari (fig. 3). Here Giovannoni treated not just the street but rather the entire zone as an "organic" ensemble in which ameliorations to the traffic are considered in conjunction with the preservation of important monuments in their characteristic setting.[21]

Whereas in "thinning out" the building mass of a neighborhood by selectively widening streets in an irregular manner preserved what Giovannoni called the "fiber" of the old quarter, the "pruning" that *diradamento* might entail was intended to enhance the artistic quality of the scene by

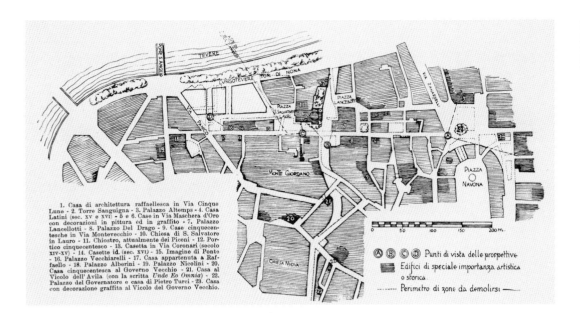

3. Gustavo Giovannoni,
Project for Via dei Coronari,
Rome, 1913
Nuova antologia
Photograph: Library of Congress

1. Casa di architettura raffaellesca in Via Cinque
Lune - 2. Torre Sanguigna - 3. Palazzo Altemps - 4. Casa
Latini (sec. XV e XVI) - 5 e 6. Case in Via Maschera d'Oro
con decorazioni in pittura ed in graffito - 7. Palazzo
Lancellotti - 8. Palazzo Del Drago - 9. Case cinquecen-
tesche in Via Montevecchio - 10. Chiesa di S. Salvatore
in Lauro - 11. Chiostro, attualmente dei Piceni - 12. Por-
tico cinquecentesco - 13. Casetta in Via Coronari (secolo
XIV-XV) - 14. Casette id. (sec. XVI) - 15. Imagine di Ponte
- 16. Palazzo Vecchiarelli - 17. Casa appartenuta a Raf-
faello - 18. Palazzo Alberini - 19. Palazzo Nicolini - 20.
Casa cinquecentesca al Governo Vecchio - 21. Casa al
Vicolo dell' Avila (con la scritta *Unde Eo Omnia*) - 22.
Palazzo del Governatore e casa di Pietro Turci - 23. Casa
con decorazione graffita al Vicolo del Governo Vecchio.

Ⓐ Ⓑ Ⓒ Ⓓ Punti di vista delle prospettive
▪ Edifici di speciale importanza artistica
 o storica
------ Perimetro di zone da demolirsi ――

4. Innocenzo Sabbatini, Piazza
Benedetto Brin, Garbatella,
Rome, 1920–1922
Photograph: Library of Congress

removing later additions to noteworthy
buildings. As Giovannoni explained, *di-
radamento* not only provided light and air
to the old tight quarters of the city, it also
opened new points of view.[22] Wenter-
Marini gave several examples of this type
of pruning in his projects for Trento. In one,
he proposed freeing the apse, southern flank,
and east end of the Chiesa delle Orsoline
along Via Maffei to provide a striking visual
focus that would partially close the view as
the street slipped off to the right. In another
scheme, Wenter-Marini would have liber-
ated the apse of San Pietro in Trento as well
as the "splendid" Cappellina di San Simo-
nino with selective demolitions that would
also have joined the small street called Vi-
colo San Marco with the larger Via San Pietro.

These theories were put into practice in
the creation of new architecture in the
Roman garden suburbs of Garbatella and
Aniene, both begun in 1920. Sponsored by
the Istituto per le Case Popolari di Roma,
both Garbatella and Aniene were designed
according to the principles of the reasoned
picturesque, contextualism, and vernacular

5. Gustavo Giovannoni and Massimo Piacentini, *Plan of Garbatella*, Rome, 1920
G. Giovannoni, *Vecchie città ed edilizia nuova* (Turin, 1931)

architecture as propounded over the preceding years by Gustavo Giovannoni and Marcello Piacentini, and more generally by the Roman Associazione Artistica fra i Cultori di Architettura (fig. 4). Giovannoni himself designed the plan for Garbatella (fig. 5) in conjunction with Massimo Piacentini and the plan for Aniene by himself.[23]

Toward this time in Milan, a group of young architects whose beginning careers had been interrupted by military service in World War I attempted to create a modern architecture both Italian in identity and specific to Milan. They chose to do so through reference to the city's neoclassical heritage. As Giovanni Muzio later explained, "We jealously sought and wanted an absolute Italian quality [*Italianità*]. Sometimes perhaps we fell into regionalism, but it seems to me a great merit to have always remained very faithful to the major thrust of our tradition, alive and ongoing for centuries. This came from the profound conviction that the essential schemata and the universal and necessary elements of architecture of the classical periods are always true. The proof resides in their continuing survival in stylistic expressions, each time different, from ancient Rome to our times."[24]

Muzio gave a stylistic direction to this sentiment in the design of a large apartment building on the corner where the major thoroughfare Via Principe Umberto (today

Via Turati) meets Via Moscova before it turns toward the train station. Before the closed scaffolding had been entirely removed from the new edifice, it created a public scandal. The novel aspect prompted a strong reaction (figs. 6, 7). The Milanese newspaper *Il secolo* accused it of having introduced into the city German decadence, which was a catchall insult used to cover not only real influences of foreign architecture but even, as in this case, something totally new and hence unexpected. The two-hundred-member Milanese Collegio degli Ingegneri ed Architetti voted, with only eight abstentions, in favor of the building's demolition. The populace of Milan dubbed it the Ca' Brutta, the ugly house, a name that it has retained to this day.

The apartment building certainly seemed strange at the time. There was nothing to which it could readily be compared. The eight-story edifice had no principal facade. If one were familiar with the Parisian *maison de rapport*, then it might have been possible to recognize the type in the overall profile with the maids' quarters under the mansard roof. Yet, even then, both the overall appearance and details would conspire against too facile a comparison. The Milanese building was ordered into three horizontal zones: a travertine-clad base, a middle zone of gray stucco, and a white stucco upper zone. In the middle zone were decorative details executed in white; in the upper, ornaments colored red, black, or yellow. The ornamentation itself comprised freely rendered elements of the classical vocabulary of architecture that made the surface appear as a thinly layered membrane either built up or cut away to show the niches, pediments, raised panels, partial spheres, diagonal latticework, stucco treated like rusticated stone, hollow columnar shafts, ovals, circles, and false perspectives. The large building was actually two buildings connected by a giant neo-Palladian arch. Although the colored accents of the upper zone have been muted, the Ca' Brutta still appears very much the way it did when it was first built.

Little did the readers of *Il secolo* expect that the sarcasm expressed in a letter to the editor in the 16 June 1922, issue would become an actual prophesy. Milan, the writer

6. Giovanni Muzio,
Ca' Brutta, Milan, 1922
Author photograph

began, has two magnificent monuments, the Duomo and the Castello Sforzesco. The Ca' Brutta was now its third "marvel": "It is a wonderful thing, an example that perhaps will remain unique in our architectural history. A symbol of our age."[25]

The Ca' Brutta, in effect, did become a symbol of its age. Although inimitable in the strength of its accomplishments, this building stimulated a new stylistic movement that dominated the post–World War I housing boom that in many ways transformed the face of Milan. In 1927, the critic Raffaello Giolli credited the Ca' Brutta with having been the first building of what is now called the Novecento style and recalled the "sentimental explosion" that shook "the entire city," which was "unprepared" for the building's unexpected appearance. "And now, these other examples come to reinforce the battle. They are, however, accepted by everybody without so much as a glance or a discussion."[26] At the time of its construction, Piacentini commented that the Ca' Brutta was "Italian, even Milanese."[27]

Milanese Novecento buildings in the 1920s followed the example of the Ca' Brutta in creating thinly layered facades built up with the classical vocabulary of architecture used in a decorative manner. As on the Ca'Brutta, these classical elements served a dual purpose. On the one hand, they were intended to obviate the monotony that architects throughout Europe since the turn of the century had worried would characterize the new, larger, and potentially anonymous apartment buildings that were being built. At the same time, they were also signs of Italian, and in this case Milanese, identity.

This theme of Italian identity informed the editorial direction of *Domus*, the magazine that promoted the decorative Novecento style, which it termed *lo stile moderno*. In the opening editorial of the first

7. Giovanni Muzio,
Ca' Brutta, Milan, 1922
Author photograph

aedicule that seemed to be used as an emblem of the home. As entrance portals (fig. 8), around doorways, over entrances, on facades in single or multiple forms (figs. 9, 10), around windows, and as the form of the glass doors that separated the apartment building's entrance hall from the courtyard (fig. 11), the aedicule became the sign par excellence of the decorated Novecento style.

By the late 1920s, the decorative Novecento style had become the representative style for the city of Milan. Milan was represented at the Fiera di Tripoli in 1927 with a Novecento building. The 1928 Fiera Campionaria di Milano was dominated by Novecento structures. Architecture was admitted to the 1928 Venetian Biennale with Gio Ponti's white and luminous Rotunda as a Novecento rendition of the Roman Pantheon. Italy itself was represented by a Novecento building at the 1929 International Exhibition in Barcelona. Finally, Giuseppe Piermarini's Villa Reale (1777–1780) in Monza was refashioned with Novecento rooms to host the Fourth International Exposition of the Decorative Arts in 1930. The centerpiece was Muzio's Hall of Italian Marble, a celebration of the variety and beauty of Italy's glorious traditional building material.

For a moment it seemed as if the next generation of talented Italian architects would follow the lead of decorative Novecento architecture. Pietro Lingeri's Villa Meier (1926) used classical columns and niches in the Novecento manner.[29] Similarly, Giuseppe Terragni's first executed work, the remodeling of the lower floors of the Albergo Metropole Suisse (1927), Como (fig. 12), was also one of the finest realizations of the decorative Novecento style with its forcefully modeled, flattened urns in shallow niches, its thinly layered pilasters framing the doors, the modeling of the thick window reveals, and the chromatic contrast between the beige wall and the dark green accents.

Yet Lingeri and Terragni at this time associated themselves with five other recent graduates of Milan's Politecnico as the Gruppo 7 to declare, in a series of manifestos published between December 1926 and May 1927, the birth of Italian rationalist architecture. Inspired largely by Le Cor-

issue (January 1928), Gio Ponti explained that the Italian house — in contradistinction to Le Corbusier's dictum that "the house is a machine for living" — was more than a shelter from the elements. It was a setting for Italian life. Its identity was marked by types of rooms and their classically inspired decor: "in vestibules and galleries, in rooms and stairs, with arches, niches, vaults, and with columns it regulates and orders in spacious measure the settings for our life."[28] Perhaps the most poignant and pervasive of these signs was the pedimented classical

8. Apartment house, entrance portal, Milan, 1930
Author photograph

9. Dwelling, Milan, c. 1930
Author photograph

10. Emilio Lancia and Gio Ponti, Casa Borletti, courtyard facade (detail), Milan, 1927–1928
Author photograph

11. Apartment building, glass wall between entrance hall and courtyard, Milan, c. 1930
Author photograph

12. Giuseppe Terragni, Albergo Metropole Suisse, remodeling (lower floors), Como, 1927
Author photograph

busier's *Vers une architecture* (1923) and Walter Gropius' *Internationale Architektur* (1925), the Gruppo 7 was intent upon creating a contemporary architecture particularly attentive to functional requirements and constructed with modern materials made into forms that evoked the spirit of a machine civilization interpreted in a manner that still conveyed a sense of Italian identity. With the gradual acceptance of this new vision of architecture throughout the West in the 1930s, Italian rationalism simultaneously developed into a dominant way of approaching architecture in Italy.

In its four-part manifesto, the Gruppo 7 both acknowledged the pluralism of modern movements in architecture and affirmed its commitment to creating a recognizably Italian version of the new international architecture. The industrial aesthetic that the Gruppo 7 so admired in the architecture of Gropius, Kosina, Mendelsohn, Korn, and Luckhardt it saw as a third tendency in German modern architecture with more promise than the others that were attempting a

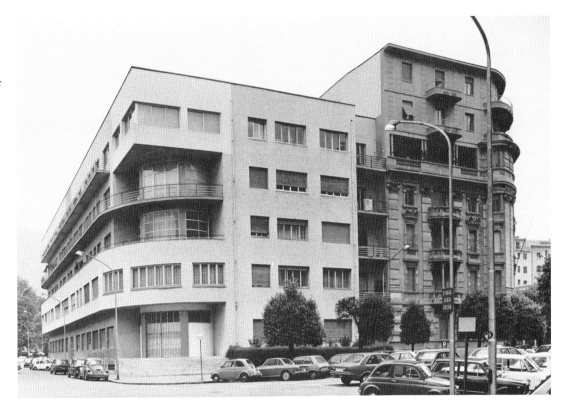

13. Giuseppe Terragni, Casa del Fascio, Como, 1933–1936
Author photograph

14. Adalberto Libera with Mario De Renzi, Postal Center for the Quartiere Aventino, Rome, 1933
Author photograph

15. Giuseppe Terragni with the engineer Attilio Terragni, Novocomum, Como, 1929
Author photograph

modern version of either the Italian classical or the German Gothic tradition. Similarly, with respect to Italy, the Gruppo 7 acknowledged the achievements of its Novecento predecessors in sweeping away stylistic revivals, while faulting them for having "fallen into a pure decorativism, in the insincerity of an architecture that varies its effects through the means of expedients, alternating broken pediments, candelabras, pine cones, and crowning obelisks."[30]

Reviewing the national ethnic characteristics that distinguished the most modern Austrian, German, Dutch, and French architecture, the Gruppo 7 sought to define the particularly Italian heritage that would guide its work. "With us in particular, there is such a classical substratum, the spirit (not the forms, which is very different) of tradition is so profound in Italy that obviously and almost mechanically the new architecture cannot avoid having a typically Italian imprint." More specifically, the Gruppo 7 pledged to eschew the "absolute *asymmetry*, as much in the massing as in the elements" that characterized the most recent German and Dutch architecture. Although aesthetically engaging, this did not

accord with the "Italian aesthetic." "The classical foundations that are in us require if not an absolute symmetry, then at least a play of compensation that balances the different parts. This, as well as other considerations, is a secure guarantor of independence for Italian architecture and a profound reason for originality"[31] (figs. 13, 14).

There was, of course, no one distinguishing attitude toward design that could be characterized as the essential Italian aesthetic identity. The Roman Associazione Artistica had been promoting a modern Italian architecture based on the native tradition of an asymmetrical, picturesque vernacular. Now the Gruppo 7 was appealing to the classical tradition of high architecture as the fundamental Italian identity that was so much a part of the group's nature that it would guide the creation of a distinctly Italian rationalist architecture within the broader framework of a new international culture.

Although the breadth of the Italian rationalist movement in the 1930s would prevent universal adherence to these principles, many of the most important constructions by the leading Italian rationalists

did accord with them. This was accomplished by an aesthetic orientation that favored symmetrical compositions and box-like forms emphasizing mass, in harmony with the spirit of Italian Renaissance palazzo architecture. At the same time, these rationalists grounded their interest in abstract geometrical forms in the contextual approach to design that had been promoted by the Roman Associazione Artistica. Hence, Terragni's Novocomum in Como (1929) echoed the forms of the earlier apartment building that occupied the other half of the block (fig. 15). Libera's elementary school in Trento (1931–1933) recalled the old city wall whose line it followed and echoed the forms of the surrounding buildings: the old wall with projecting bastions to the right, the tower of the Castello del Buon Consiglio that dominated the scene, and to the left the volumetric relationship of the historic Torre Verde and its neighboring building. Capponi's apartment building (fig. 16) on Lungotevere Arnaldo da Brescia in Rome (1926) appeared as a modern analogue to the complex late baroque geometries of Filippo Raguzzini's Piazza Sant'Ignazio (1727–1735). Similarly, Aschieri's Casa di Lavoro per i

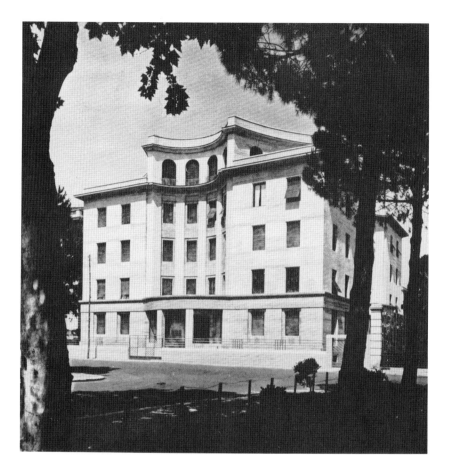

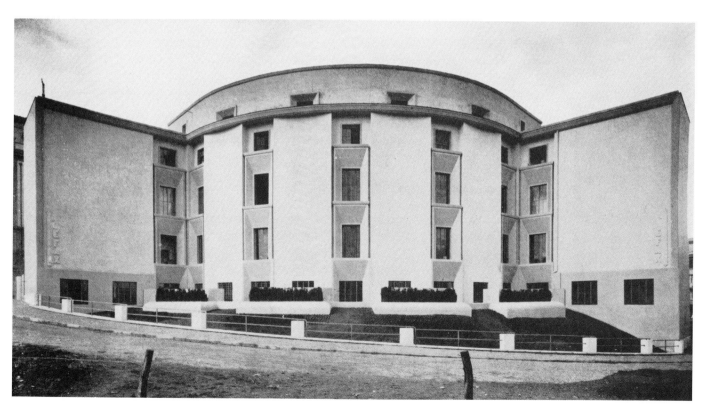

Ciechi di Guerra (1931) (fig. 17) prompted Piacentini to observe: "There is no doubt that Pietro Aschieri is Roman."[32]

The Italian rationalist movement served as a stimulus to the Milanese Novecento architects in the 1930s to abandon their decorative use of the classical vocabulary of architecture and to create a second Novecento style based upon a geometric patterning within the fabric of the facade (fig. 18). Signs of Italian identity were now to be found not in classical aedicules but in the more generically geometrical elements, such as the loggias used to this end in Ponti's Casa Marmont (1933–1934). Like the Italian rationalists, the geometric Novecento architects responded to the geometric configurations of important buildings on the site, as did Ponti and Lancia in the two apartment buildings at Porta Venezia, the Palazzo SIVEM (1934) (fig. 19) and the Casa Torre Rasini (1934) across the street from Rodolfo Vantini's paired neoclassical entrance pavilions (1827–1833). Just as Muzio had initially celebrated in the Ca' Brutta the Italian tradition of applied classical elements that extended from Brunelleschi through nineteenth-century neoclassicism, so too, in the gridded brick or clinker facades of buildings such as the entrance to the Università Cattolica of Milan (1928–1929) and the Palazzo dell'Arte (1932–1933), he drew inspiration from the late sixteenth-century architecture of Mantua, Parma, and Ferrara.

The Italian rationalists had launched their movement within the context of the culture of architecture. The issues they addressed were those that had preoccupied progressive Western architects since the nineteenth century. The terms of their reconciliation of national identity and international signs of modernity parallel those invoked by the champions of *arte nuova* at the turn of the century. Neither the Gruppo 7 in its four-part manifesto of 1926–1927 nor Adalberto Libera in his 1928 essay "Art and Rationalism" paid significant attention to Italian fascism. As Dennis Doordan has observed, reviewers in the general as well as the architectural press who discussed the First Italian Exposition of Rationalist Architecture of 1928 generally ignored fascism as well.[33]

Yet there were two timely opportunities for the Italian rationalists to join the culture of architecture with the culture of fascism and to marry the earlier European cultural nationalism with the new and specifically fascist political nationalism. The Gruppo 7 ignored the public debate about the nature and legitimacy of fascism occasioned by the Congress of Institutions of Fascist Culture in March 1925. It also let pass by the public inquiry into the relationship of art to fascism sponsored by the newspaper *Critica fascista* in October 1926, just before the publication of the Gruppo 7's four essays. Yet neither the *Critica fascista*'s survey nor the Congress of Institutions of Fascist Culture was an indifferent event. As Philip Cannistraro has argued, fascism's need to legitimize itself in face of charges that it was an anticultural, opportunistic, and violent political movement assumed particular importance in the aftermath of the murder of the socialist leader Giacomo Matteotti.[34]

The Italian rationalists' interest in associating their movement with fascism began to develop with the First Italian Exposition of Rationalist Architecture, held in the Palazzo delle Esposizioni in Rome in March–April 1928. The exhibition took place with the "approval and patronage of the National Fascist Syndicate of Architects and the National Fascist Syndicate of Artists."[35] In their preface to the exhibition catalogue, Adalberto Libera and Gaetano Minnucci abandoned the political agnosticism of the earlier rationalist publications. The old Italian desire to lead world architecture, expressed by the progressive champions of *arte nuova* in 1902 and then again by the Gruppo 7 in 1926–1927, was now recast with stock phrases about the new possibilities afforded by Italian fascism:

Our movement has a single, high motive: the desire to bring Italy to its position even in the mother art that is architecture. What was not possible yesterday — because of the disastrous crisis caused after the war by the outbreak of the egoism of the masses and the ineptitude of the government — today, when the Italian people is rediscovering its equilibrium and is reinvigorating its forces under the symbol and the spirit of the Roman People, the revived energies can understand and create once again.

18. Giovanni Muzio,
apartment building, Via
Giuriati, Milan, 1930–1932
Ferdinando Reggiori, *Architetture di
Giovanni Muzio* (Milan, 1936)

*And especially liberating ourselves from the
old-fashioned approach of our decorative
decadence, by returning to the notions of our
ancestors, founders of empire: builders. The
Italians, whether colleagues or the general
public, who are residues of the old way of
thinking, can neither comprehend nor call for
this [renewal]. Rather it is for us, the young,
with the true Fascist spirit, to follow the call
of our ancestors . . . and to make great the
new Italian architecture. . . . This architecture
will be carried to the maximum splendor
with which the Italian People must
reconquer, even in this art, that position that
the Builders of Rome had assigned it in the
world.*[36]

At the Second Italian Exposition of Ration-
alist Architecture in Rome, inaugurated by
Mussolini on 30 March 1931, the ration-
alists identified their movement even more
forcefully with fascism as they pleaded with
Mussolini for both recognition and work.

Although no group was accorded the of-
ficial status of *architettura di stato*, the Ital-
ian rationalists built important buildings to
represent the fascist state: in 1932 the ex-
hibition to celebrate the Tenth Anniversary
of the March on Rome (fig. 20), in 1933 the
Italian Pavilion at the Chicago World's Fair,
and in 1935 a pavilion at the International
Exposition in Brussels. For these occasions,
the rationalists developed an architectural
idiom that conveyed the sense of grandeur
deemed appropriate to the imperial vision
of fascist rhetoric. At the Chicago World's
Fair the architects combined monumental
grandeur with images of modern transpor-
tation in keeping with the fair's theme, "A

Century of Progress," and as a reflection of
the fascist interest in portraying fascism as
a force of modernization. Through perma-
nent buildings intended as signs of fascist
cultural achievement, Italian architects,
many of them rationalists, created a version
of a stripped classicism in an effort to create
a *stile Littorio*, a fascist modern style. These
included the Città Universitaria in Rome
(1931–1933) and the new government cen-
ter projected for the Esposizione Universale
of 1941–1942 (figs. 21, 22) which was never
held, but still was built as EUR.

This monumental fascist architecture
complemented the image of imperial gran-
deur fostered by Mussolini in the vast clear-
ing operations in Rome. Marcello Piacentini,
once the champion of picturesque, contex-
tual design, the "prose of architecture," now
became a leading figure in the creation of
wide, symbolic thoroughfares such as Via
dell'Impero, which cut across the Roman

Forum, and Via della Conciliazione leading to Saint Peter's. Gustavo Giovannoni, formerly the advocate of *diradamento* — understood as small-scale, selective widening of old city streets to retain their essential "organic" character — now associated himself with the Burbera Group, which in 1929 proposed a major cross-axis after the manner of the ancient Roman *cardo* and *decumanus* to establish "a new monumental center" (fig. 23) arranged as an "Assyro-Babylonian" fantasy.[37]

Not all buildings built by the fascist state were conceived according to the parameters of an imperial nationalist self-image. In the individual state organizations and ministries, officials or even architects working as functionaries sometimes assimilated the culture of architecture to state building without transforming it into the rhetoric of imperial grandeur. For example, Renato Ricci, director of the Opera Nazionale Balilla, the militaristically oriented youth organization, favored the modern idioms as found in the culture of architecture. By the early 1930s, Ricci supported Italian rationalism.

Similarly, at the Ministry of Communications, the engineer directly in charge of the office that designed post offices and railroad stations had the dream of fostering modern architecture in Italy. Yet the style,

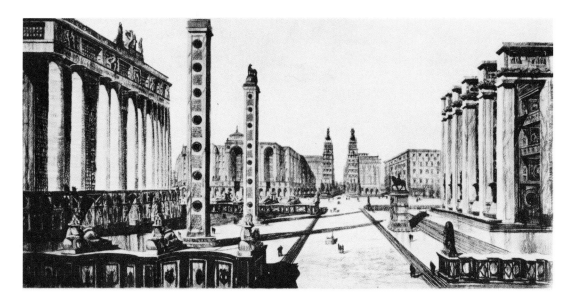

23. Gruppo Burbera, proposed "monumental center" for Rome, 1929
Architettura e arti decorative
Photograph: Library of Congress

which was generally selected by municipal authorities, cultural personages, and officials in the ministry, was determined primarily according to the parameters of the older cultural nationalism. Ferrara wanted a Ferrarese Renaissance revival post office; Pistoia wanted to use a recently constructed Renaissance revival loggia for the facade of its new post office; Palermo wanted a building fronted by Doric columns. Officials in Venice and Rome insisted on train stations that literally recalled their respective historical traditions. This pride in local building traditions, deeply rooted in Italian history, had dominated the selection of styles for such buildings in the decades preceding fascism and continued to do so throughout the fascist era.

Nationalism in Italian architecture in the first four decades of the twentieth century was integral to all of these different modern movements. Until the advent of fascism, it was dominated by an older cultural nationalism that had arisen with the romantic revolution. Working within the parameters of this ideal, architects sought to balance the conflicting demands of national identity rooted in tradition and modernity common to contemporary Western culture. With the advent of fascism there came a second component of the romantic legacy, a political nationalism, which emerged as one of the totalitarian forms of government that plagued Europe in the aftermath of World War I. This development superimposed another set of values on the earlier cultural nationalism, with complex results. In some cases, architects of modern movements formed within the context of the older cultural nationalism transformed and at times betrayed their earlier ideals to create a new type of nationalist idiom expressive of fascist imperial ideology. In other cases, the modern styles associated with the older cultural nationalism were simply assimilated to the fascist cause without major changes. In rare examples, a building such as Terragni's Casa del Fascio of Como (1933–1936) succeeded in simultaneously embodying the ideals of both Western avant-garde architectural culture and fascist imperialism. The seeming paradox of these different outcomes serves to caution against any simplistic explanation of nationalism, modernism, culture, or style in studying not only Italian architecture, but also the modern architecture of any country in this same period.

NOTES

This article has been adapted with permission from the MIT Press from my book *Modernism in Italian Architecture, 1890–1940* (Cambridge, Mass., 1991).

1. Alfredo Melani, "L'Art Nouveau at Turin, II" *The Architectural Record* 12 (December 1902), 750.

2. Herbert Croly, "The New World and the New Art," *The Architectural Record* 12 (June 1902), 137.

3. "Die Architektur der Internationalen Ausstelung für moderne dekorative Kunst in Turin 1902," *Architektonische Rundschau* 18 (November 1902), 86.

4. Vittorio Pica, *L'arte decorativa all'Esposizione di Torino: Gli edifici* (n.p., n.d.); A. Frizzi, "Prima Esposizione Internazionale d'Arte Decorativa Moderna apertasi in Torino nel 1902: L'ingresso principale," in *Torino 1902: Polemiche in Italia sull'arte nuova*, ed. Francesca R. Fratini (Turin, 1970), 193, 180.

5. Gustave S[oulier], "L'Exposition Internationale d'Art Décoratif à Turin," *L'Art décoratif* 8 (June 1902), 129.

6. Alfredo Melani, "L'arte nuova e il cosidetto stile Liberty," *L'arte decorativa moderna* 1 (February 1902), 59.

7. Alfredo Melani, "L'Esposizione Internazionale d'Arte Decorativa odierna in Torino, II: Il palazzo, le gallerie, i padiglioni," *Arte italiana decorativa e industriale* 11 (May 1902), 37.

8. Giovanni Angelo Reycend, "Il concorso per gli edifizi della Prima Esposizione Internazionale d'Arte Decorativa Moderna e il progetto D'Aronco," *L'arte decorativa moderna* 1 (January 1902), 5–7.

9. Marcello Piacentini, "Nuovi orizzonti dell'edilizia cittadina," *Nuova antologia* 57 (1 March 1922), 61–62.

10. Gustavo Giovannoni, "L'ambiente dei monumenti," in *Questioni di architettura nella storia e nella vita* (Rome, 1929), 188.

11. Gustavo Giovannoni, "Relazione sulla Zona Monumentale di Roma, letta nell'Assemblea delle associazioni artistiche, tecniche, archeologiche del 1° febbraio 1910," in *Associazione Artistica fra i Cultori di Architettura – Roma, Annuario 1908–1909* (Rome, 1910), 75.

12. Marcello Piacentini, *Sulla conservazione della bellezza di Roma e sullo sviluppo della città moderna* (Rome, 1916), 7, 9.

13. Marcello Piacentini, "Estetica regolatrice nello sviluppo della città," *Rassegna contemporanea* (April 1913), 33; Piacentini 1922, 68.

14. Gustavo Giovannoni, "Per la ricostruzione di città e di borgate italiane distrutte," *Nuova antologia* 272 (16 March 1917), 157.

15. Giorgio Wenter-Marini, "Nuovi problemi edilizi di Trento," *Studi Trentini* (1921), 346–347.

16. Piacentini 1913, 34.

17. Piacentini 1922, 65.

18. Review (signed "p.r.") of Marcello Piacentini, *Per la restaurazione del centro di Bologna* (Rome, 1917), *Architettura e arti decorative* 1 (May–June 1921), 119.

19. Gustavo Giovannoni, "Il 'diradamento,' edilizio dei vecchi centri: Il quartiere della Rinascenza in Roma," *Nuova antologia* 250 (1 July 1913), 61.

20. Giovannoni 1913, 62, 63.

21. Giovannoni 1913, 70.

22. Giovannoni 1913, 58, 62.

23. Innocenzo Costantini, "Le nuove costruzioni dell'Istituto per le Case Popolari in Roma: La borgata giardino 'Garbatella,'" *Architettura e arti decorative* 2 (November 1922), 119; Bruno Regni and Marina Sennato, *Innocenzo Sabbatini: Architettura tra tradizione e rinnovamento* (Rome, 1982), 21.

24. Giovanni Muzio, "Alcuni architetti d'oggi in Lombardia," *Dedalo* 11 (August 1931), 1092–1093.

25. Giuseppe Maranini, "Un nuovo monumento milanese," *Il secolo* (16 June 1922).

26. Raffaello Giolli, "Cronache milanesi: Case nuove," *Emporium* (August 1927), 112–113.

27. Marcello Piacentini, "Edilizia milanese," *Architettura e arti decorative* 2 (October 1922), 85–86.

28. G[io] P[onti], "La casa all'italiana," *Domus* (January 1928), 7.

29. For an illustration, see G. Canella and V. Gregotti, "Il Novecento e l'architettura," *Edilizia moderna* (December 1963), 25.

30. Il Gruppo 7, "Architettura," *Rassegna italiana* 18 (December 1926), 852.

31. Il Gruppo 7, "Architettura (II): Gli stranieri," *Rassegna italiana* 19 (February 1927), 133–136; Il Gruppo 7, "Architettura – IV: Una nuova epoca arcaica," *Rassegna italiana* 19 (May 1927), 471.

32. M[arcello] P[iacentini], "La nuova Casa di Lavoro per i Ciechi di Guerra, arch. Pietro Aschieri," *Architettura* 11 (January 1932), 3.

33. Dennis P. Doordan, "Architecture and Politics in Fascist Italy: Il Movimento Italiano per l'Architettura Razionale, 1928–1932," Ph. D. dissertation, Columbia University, 1983, 56; Dennis P. Doordan, *Building Modern Italy: Italian Architecture 1914–1936* (New York, 1988), 74.

34. Philip V. Cannistraro, *La fabbrica del consenso* (Rome, 1975), 18.

35. This was announced on the publicity poster for the exhibition. See Michele Cennamo, ed., *Materiali per l'analisi dell'architettura moderna: La Prima Esposizione Italiana di Architettura Razionale* (Naples, 1973), cover and p. 95.

36. Adalberto Libera and Gaetano Minnucci, "Introduzione alla Esposizione," in Cennamo 1973, 105–106.

37. Renato Pacini, "La mostra dei piani regolatori a Roma," *Emporium* 70 (November 1929), 272.

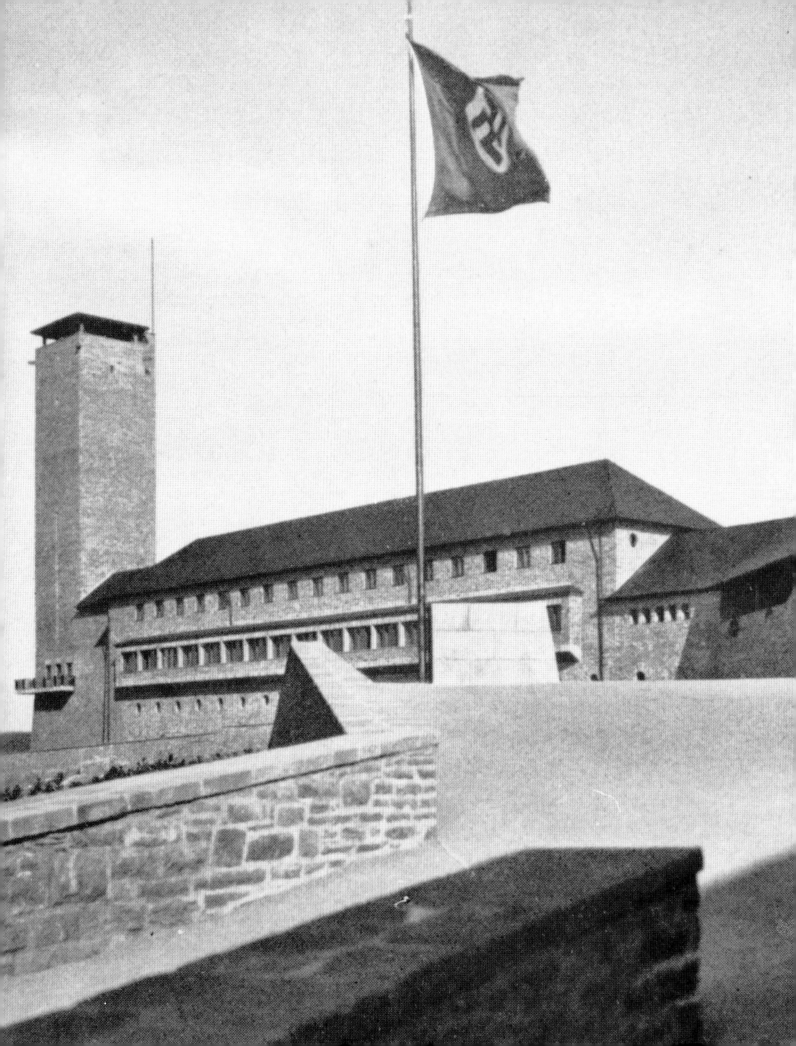

BARBARA MILLER LANE
Bryn Mawr College

National Romanticism in Modern German Architecture

Most writers about modern German architecture believe that some form of neoclassicism has been the focus of nationalist feeling since the beginning of the nineteenth century. Recent interest in "romantic classicism" has given Karl Friedrich Schinkel and Leo von Klenze new prominence in our awareness, while scholars and critics concerned with postmodernism have found a new importance in the work of Heinrich Tessenow and Albert Speer. Thus, the most recent general histories of architecture[1] now illustrate Klenze's Walhalla of 1839–1842 both as an instance of Greek revival and as an early monument to German nationalism, and Speer's Nuremberg Party Congress Grounds of 1934 as the most representative building of the nationalist side of National Socialism.[2] And certainly Schinkel's and Klenze's Greek revival was both purer and more nationalist than Sir Robert Smirke's, while Speer's work was intensely ideological and self-proclaimedly neoclassical.[3] The power of the classical tradition was so great in Germany that it was possible and persuasive for Eliza M. Butler to write of the "tyranny" of Greece — to see an ideal of Greece dominating German philosophy, aesthetics, art, literature, and education, at least in the nineteenth century.[4] Twentieth-century Germany was a birthplace of modernism — of the Bauhaus and the international style — and as such fostered a rebellion against nationalism and against historical traditions of all kinds. But the role of neoclassicism in architecture under the Nazi regime has seemed to attest to the strength of the classical tradition in the twentieth century and its continuing association with German nationalism.[5]

Thus, architectural historians now know a great deal about the history of neoclassicism in Germany in the nineteenth and twentieth centuries. What has been less well observed is the importance of another architectural tradition for German nationalism, what one might call a medievalizing tradition. Ordensburg Vogelsang (fig. 1), erected by Klemens Klotz in the Eiffel Mountains from 1934 to 1936 as a training school for the Nazi political leadership,[6] resembles, in a distant way, many of the castles of the neighboring Rhineland or of Thuringia and East Elbia: its name was intended to recall the fortifications of the Teutonic Knights and other border lords of the Middle Ages. But Ordensburg Vogelsang is also distinctively modern. With its simple massing, asymmetrical arrangement, banded windows, and overall lack of ornament, it is reminiscent of Willem Dudok. In its asymmetry and its combinations of wood and masonry, it looks ahead to Alvar Aalto.[7] I will argue that Ordensburg Vogelsang grew out of an architectural tradition in nineteenth- and twentieth-century German architecture that was almost as widespread as the neoclassical, and perhaps even more closely associated with German nationalism: the medievalizing tradition. This

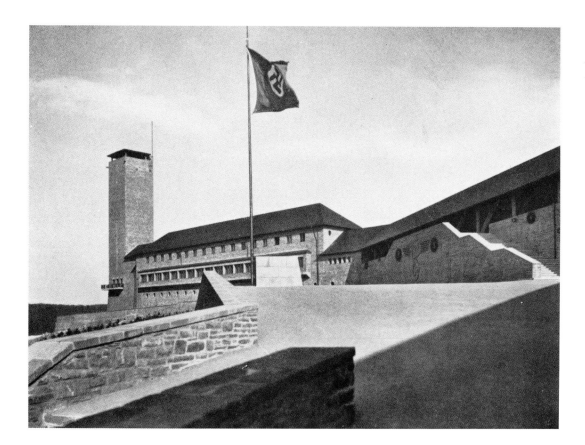

1. Clemens Klotz, *Ordensburg Vogelsang*, Eiffel Mountains, 1934–1936
Werner Rittich, *Architektur und Bauplastik der Gegenwart* (Berlin, 1938), 30

tradition was also associated with the avant-garde in ways that have not yet been fully understood.

In order to talk about a medievalizing tradition in modern German architecture, I have found it useful to import a term that is usually applied to Scandinavian architecture of the period from 1900 to about 1914: *national romanticism*. That term was coined in the 1920s by Swedish architectural historians to describe the work of Ragnar Öst-berg, Lars Israel Wahlman, Carl Westman, and other Swedish architects whose work looked back to an idealized medieval past.[8] Each of these architects was inspired partly by timber architecture, both domestic and religious, and partly by castles and other buildings surviving from the fifteenth through the eighteenth centuries. Each bewailed the lack of an older indigenous medieval tradition and looked for inspiration on some occasions to prehistoric sources.[9] Each was deeply inspired by the ideas and publications of national historians and medieval archaeologists. The first writers about

these architects called them national romantics, or romantic nationalists, because they idealized the distant past, and also from time to time invented it. In their quest for national roots, these architects were often superbly innovative: Wahlman, for example, supported his Engelbrekt Church (1906–1914) in Stockholm with paraboloid arches, and designed for suburban dwellings highly crafted timber-clad villas of unusual shape and plan.[10] Hence, in Sweden, a passion for medieval history and a contribution to the avant-garde went hand in hand in the last years before World War I.

It is now generally acknowledged that the same could be said of the architecture of Denmark, Finland, and Norway during the same years. Much has been written recently, for example, about Martin Nyrop, Henrik Bull, Lars Sonck, and the firm of Lindgren/Gesellius/Saarinen, and the ways in which their work contributed to that of later Scandinavian architects. The term *national romanticism* is therefore now in general use to describe a kind of medievalism

in early twentieth-century Scandinavian architecture that made a great contribution to modernism.[11]

A final component of this, by now conventional, discussion of Scandinavian architecture is the theory of Leonard Eaton and Dimitri Tselos that Henry Hobson Richardson's work was somehow imported wholesale into the architecture of northern Europe from about 1900 onward, and that Richardsonian Romanesque gave a tremendous impetus to the idealized version of the past, which then contributed to European modernism. Eaton and Tselos discuss Germany to a limited extent, but their main focus is on Sweden, Denmark, and Finland.[12] Their argument is persuasive enough on the face of it: Richardson was greatly admired in northern Europe after 1900, and many buildings from that period do resemble his work. In the Scandinavian countries, where an extensive indigenous architecture from the early Middle Ages was lacking, and where most of the national romantic movement dates from after 1900, it is tempting to assume that architects derived some of their primitive-looking models from the United States. But the Richardsonian argument works less well for Germany, where medieval architecture was plentiful and old, and where the Romanesque was associated from the early nineteenth century with an extreme nationalistic fervor. It is much more likely that Romanesque revivalism in Germany paved the way for the reception of Richardson's work, both in Germany and in the Scandinavian countries, and that the connections between Scandinavian architecture and that of Germany were far more important and frequent than was the relationship of either one to the United States.[13]

The term national romanticism, as it has been developed to describe Scandinavian architecture, is also a useful phrase for characterizing German revivalism in the later nineteenth century: German architects too sought an ever earlier past as an inspiration and were often frustrated by the lack of models; German architecture too was closely associated with the development of formal archaeology and historical scholarship; and German architecture too was precociously innovative. German scholars have recently begun to publish extensively on a few aspects of late nineteenth-century art and architecture.[14] But the larger story of national romanticism in modern German architecture, which ought to provide a missing link in our understanding of the relationships between historicism and modernism, has not yet been told.

Returning to Klotz and the sources of Ordensburg Vogelsang — to the sources of some kind of idealized and nationalist medieval past — we should look first to the Romanesque and Germanic revivals of the earlier nineteenth century, which I will describe briefly. These revivals consisted in the progressive rediscovery of ever earlier prototypes for a "national" architecture through scholarship, archaeology, restoration, rebuilding, and increasing imitation in new building. After a brief description of these developments, it will be possible to consider at some length the transformations of early nineteenth-century revivals that occurred after the unification of Germany in 1871 and particularly under the patronage of William II, the third emperor of the new Bismarckian empire, and the one who led Germany into World War I. I will also deal briefly with the persistence of medieval revivalism during the Weimar Republic and the years of Nazi rule. Finally, I will conclude with some speculations about the period after World War II, and ask whether the tradition of medieval revival has continued to be linked to German nationalism.

First we need to establish what is meant by German nationalism, and what, for that matter, is meant by Germany. These are familiar questions to the historian of German politics, but they have been less closely attended to by historians of German architecture. For most of its history, "Germany" has been a linguistic entity without stable geopolitical boundaries. The Germanic languages were spoken in the early Middle Ages across all of northern Europe. High German, or modern German, developed in a very restricted area of south-central Europe and spread without regard to political boundaries. As the power of Rome receded, Germanic kingdoms appeared in all of northern Europe, but these had little political identity until some were absorbed into that curious entity, the Holy Roman Empire, which itself drew inspiration from the Roman Em-

pire. In the thousand years between the establishment of the Holy Roman Empire in 800 and its demise in 1806, its boundaries shrank and swelled, including at some times modern France and Austria, parts of modern Hungary and Poland, and much of modern Italy, and at other times only the central areas between the Rhine and the Oder, the Alps and the Baltic. During that millennium, several score of German-speaking principalities and one multinational empire, the Austro-Hungarian, grew up within, or largely within, the boundaries of the Holy Roman Empire. From the time of the Reformation forward, these states and principalities were divided from one another not only by political tradition, but also by religious affiliation. On the eve of the drive for national unification, around 1789, three states seemed to offer potential leadership: Prussia in the northeast (with small holdings along the Rhine), ruled by the Hohenzollerns, and Protestant; Bavaria in the southeast, ruled by the house of Wittelsbach, and Catholic; and the Austro-Hungarian Empire, Hapsburg, Catholic, and, of course, only partially German.

When the German romantics at the end of the eighteenth century began to write about the regeneration of Germany and to call for a new belief in its history, art, literature, and language, they were passionate in their desire for the nation, but uncertain about what the nation was to be. Johann Gottfried Herder, in 1784, wrote about a whole set of northern peoples, Nordic, but also the heirs of the Germanic peoples in general and sharply distinguished from the Slavs. Herder also wrote about a German *Volk*, or people, who were themselves the heirs of this Germanic tradition, an idea that helped to inspire the work of the Brothers Grimm and others in collecting folk tales and in exploring folk art.[15] Initially, it should be stressed, such ideas were apolitical. As they came during the early nineteenth century to have an increasingly political focus, this focus was often liberal or democratic: early nineteenth-century literature and historical writing, for example, were filled with nostalgia "for the — real or supposed — freedom of the Middle Ages seen in the towns and in primitive germanic society."[16] Many of the varieties of German nationalism re-tained these populist associations even after the failure of the revolutions of 1848 to achieve a united Germany under liberal or democratic auspices.

By the mid-nineteenth century, among German nationalists, the real "Germany" had one of three shapes: (1) the area of northern Europe once occupied by the Germanic tribes, or "northern peoples" in Herder's phrase; (2) the areas of central Europe in which modern German was spoken or written, which included Alsace-Lorraine in the west, Schleswig-Holstein in the north, the Tyrol in the south, and East Prussia, Silesia, western Poland, Bohemia and Moravia (modern Czechoslovakia), and Austria; and (3) that part of central Europe with relatively defensible boundaries, which could realistically be drawn together in a secure way, without too great a threat of intervention by France, Russia, or Austria-Hungary. It was the last idea, the so-called small German or *kleindeutsch* solution to national unification, that was implemented by Bismarck's policy of "blood and iron" between 1862 and 1871. The resulting German state was thus dominated by Prussia, excluded Austria, and was significantly Protestant. But the second, pan-German or *grossdeutsch* idea, which had inspired many political leaders in the early and middle nineteenth century, regained a powerful influence after unification; it appealed to organizations such as the Pan-German League, to the people close to Emperor William II, and to the emperor himself. In this later pan-Germanism, the nation was seen as Prussian-dominated and either as Protestant or as Christian in a sense relatively unrelated to modern Catholicism. Such ideas developed from the 1880s onward in a political context of imperialism and aggressive foreign policies; at the same time they absorbed contemporary social Darwinism and racial definitions of culture. Pan-German ideas were behind many Germans' enthusiasm for the war of 1914, while pan-European ideas (the offspring of Herder's equation of Germany with the "northern peoples") certainly contributed to Hitler's vision of a new order, at least after he had begun to accumulate successes in battle. The lack of congruence between geography and a sense of nationhood has always helped

to shape the political ideas of both German nationalists and German statesmen. And this has continued to be the case, as Germany's boundaries have changed in this century, shrinking in 1918 to exclude Alsace-Lorraine, Czechoslovakia, Austria, the "Polish corridor" from Poland through West Prussia (including the province of Posen); expanding under Hitler to reabsorb those territories, the Tyrol, and, in a sense, Norway, France, and the Low Countries; contracting again in 1945 approximately to the 1918 version (minus East Prussia and Silesia), but with the further transformation of "Germany" into two countries, divided by an Iron Curtain. In 1990, those two countries were reunited again in a single Germany.

Restorations, Revivals, and the Search for a National Architecture, c. 1814–1888

Although the German romantic writers had been writing about the nation for more than thirty years before Napoleon crossed the Rhine, it was the Napoleonic invasions that decisively aroused the national consciousness for the first time. One aspect of the invasions was the destruction of major works of medieval architecture in the Rhineland. Both intellectuals and political leaders responded to this destruction with a strong sense of the symbolism of these buildings for German nationalism. From the late eighteenth century onward, the romantic love of ruins had been strong in Germany, as in other European countries. For a short time this *Ruinromantik* was transformed into a political program, when leading thinkers such as Josef Görres proposed to leave the destroyed buildings as they were, in order to arouse anger and hence stimulate national revival.[17] Germany's monarchs, however, pursued an intensive rebuilding and restoration program in the post-Napoleonic period. One of the first of these projects to be begun was the Cathedral of Cologne, where restoration under Prussian leadership came to include new Gothic revival construction.[18] Other Gothic restorations proceeded at the same time, and Gothic revival still had very important proponents in the later nineteenth century. For

example, August Reichensperger, politician, essayist, preservationist, and activist, believed Gothic revival, though associated with Catholicism, to be the most Germanic style. Great attention continued to be paid to the preservation of urban Gothic buildings, and Gothic revival gradually came to be a particularly favored style for town halls.[19]

Although Gothic restorations predominated initially, the restorations of the first post-Napoleonic period also included the great churches at Speyer (fig. 2) and Mainz. Some of this restoration work was hard to distinguish from new construction, nor was it always archaeologically correct, especially at first. The west facade at Speyer, for example, was designed by the rather innovative Romanesque revival architect Heinrich Hübsch, and interior mural painting was very free in its inspiration.[20] The first post-Napoleonic restoration work occurred among the churches of the Rhineland, but soon historic secular buildings joined their ranks. One of the first major restorations of an early medieval castle was the work at the Wartburg, which was important to German nationalism as the site of border defenses in the eleventh century, as a center of chivalric culture in the twelfth, as Luther's asylum in the sixteenth, and as the meeting place of the intensely nationalistic student movement from 1817 onward. Restorations at the Wartburg began in 1838 and continued until 1867 (fig. 3). During the period of extreme fragmentation and disunity that followed the Napoleonic wars, many different rulers and governments interested themselves in history and in the preservation of historic buildings.

From the 1840s to about 1870, German nationalism intensified again. These were years of industrialization and increased hopes for unification, on the one hand, and of political upheaval, on the other. During the early 1840s, when a pan-German unification had been sought by many nationalists, popular affections had begun to focus on the great medieval empires: those of the Hohenstaufen (1138–1254), the Salians (1024–1125), or the Saxons (919–1024). After the failure of the revolutions of 1848, when German nationalism became less liberal and more dominated by the leadership of Prussia, and as it simultaneously gained an in-

creasingly broad popular following, both popular enthusiasm and historical scholarship continued to be inspired by the imperial theme. At this time, restoration activities increased very greatly in number and tended to be devoted to ever earlier periods in the medieval past. For example, restorations were begun in the interior of Charlemagne's Chapel (792–805) at Aachen in 1845; at the Abbey Church of Maria Laach (eleventh to thirteenth centuries, restored beginning about 1850); at Saint Michael, Hildesheim (early eleventh century, restored beginning in 1855), and at the quite ruinous churches of Saint Michael, Fulda (ninth to eleventh centuries, restored 1854), and Saint Cyriacus at Gernrode (tenth century, restored beginning in 1865). The church at Gernrode (fig. 4), one of the earliest built under the patronage of Otto the Great (936–973) in the Harz Mountains, during the period when Otto was developing that area as a Christian bastion against Slavic incursions, was much written about as a prototype for other very early churches, such as those of Mainz, Augsburg, and Worms, and also as an instrument of "German" colonization in the "east."[21] The church of Saint Servatius at Quedlinburg, near Gernrode, was also "discovered" at about the same time, along with the almost adjacent Church of Saint Wipert, with a crypt of about 930. Because of its apparent antiquity and the presence of some very early portions, Saint Servatius was also widely discussed and illustrated.[22]

Restoration and preservation were accompanied by many attempts, often by well-to-do antiquarians like Sulpiz Boisserée, to describe particular buildings that had been damaged or lost. This procedure led to efforts like those of Georg Moller or Christian Stieglitz to define and catalogue "German" architecture itself. Such writings in turn gave rise to future scholarly works and helped to prompt continuing restoration activities.[23] Cataloguing, restoration, and historical scholarship thus worked together. From the earliest decades of the century, the cataloguing or "inventorying" of architectural monuments began to receive the patronage of monarchs and princes, which stimulated further knowledge of, and speculation about, the past. From 1843 to 1877, for example,

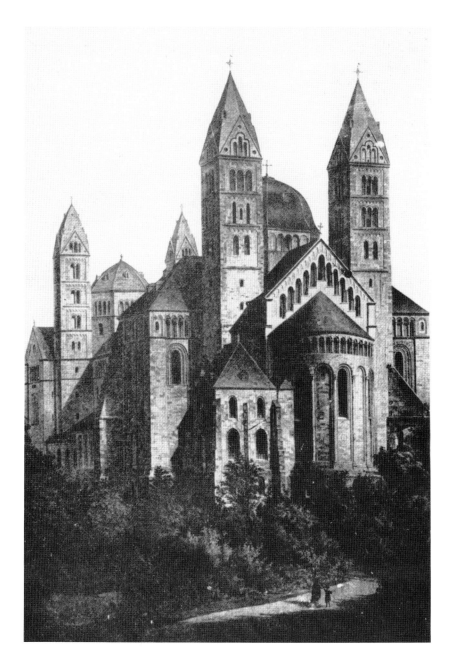

2. *Speyer Cathedral,*
1030–1106
Photograph: Linda G. Gerstein
collection

the leading scholar Ferdinand von Quast was employed by the state of Prussia to create an "inventory of the buildings of the Kingdom of Prussia," an effort that was soon paralleled by similar enterprises in the other German states. The organization and publication of such inventories was further coordinated after the unification of Germany under the leadership of Prussia in 1871. Soon afterward, the whole procedure led to exhaustive nationwide compilations, such as those of Georg Dehio and Gustav von Bezold. Historical writing accompanied and

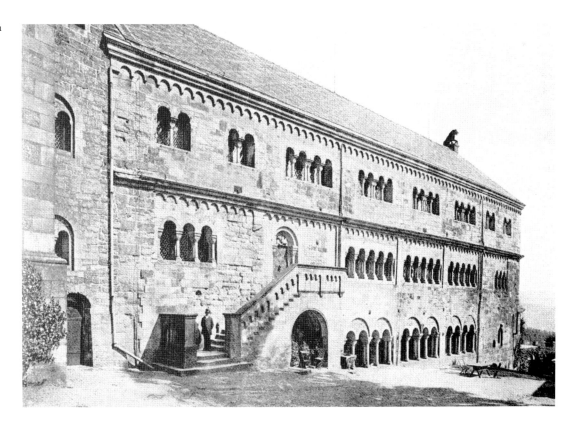

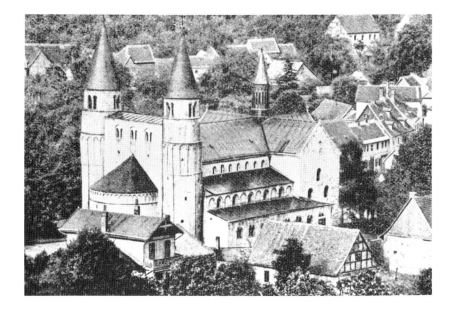

was continually strengthened by these compendia, whose authors themselves often turned to large-scale works of synthesis about the nature of German architecture.[24]

Herder and the German romantic movement had laid the basis for the study of history in Germany and for the view that it was in the Middle Ages that the nation could first be identified. Herder, and indeed most German romantics, wrote little specifically about architecture, but his ideas about folk culture and folk art contributed to an enthusiasm among nationalists for medieval architecture, and for folk traditions in building. Among the giants of late eighteenth-century literature it was, of course, Goethe, in his 1772 homage to Strasbourg Cathedral, who for a time persuaded individual architects and statesmen of the Germanness of the Gothic.[25] In consequence of the relatively undifferentiated view of the Middle Ages held by the early romantic writers, the first histories of German architecture focused on what was medieval without making many distinctions between early and late, Gothic and Romanesque, or indeed between Western medieval and Byzantine. But as architects and art historians continued to discuss the nature of German architecture, the equation of German and Gothic faded away.[26]

This transition can be seen clearly in the publications of the leading Berlin historian and art historian Franz Kugler, a scholar

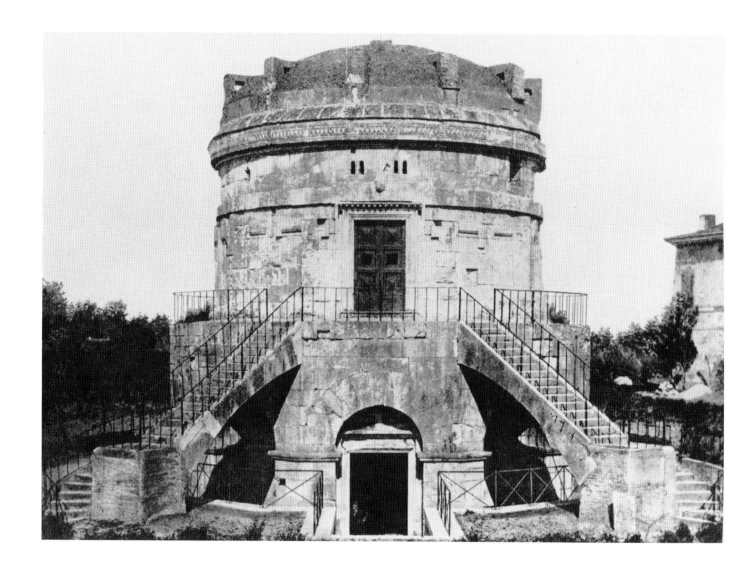

5. *Mausoleum of Theodoric,* Ravenna, c. 526
Albrecht Haupt, "Die äussere Gestalt des Grabmals Theoderichs zu Ravenna," *Zeitschrift für Geschichte der Architektur* 1 (1907–1908), 11
Avery Architectural and Fine Arts Library, Columbia University, New York

who helped to shape the future understanding of architectural history in Germany for much of the next hundred years.[27] Kugler's *Handbuch der Kunstgeschichte* of 1842 described all Gothic art as "Germanic" and all Romanesque as "Byzantine."[28] By 1859, in contrast, his *Geschichte der Baukunst* assured readers that "Gothic" was a French style. Romanesque, on the other hand, was the creation of "peoples of a Germanic nationality."[29] The definition of the Romanesque set forth by Kugler and his followers was extremely elastic, however. Already in 1842, Kugler gave great prominence to the mausoleum of the Ostrogothic king, Theodoric (489–526), as a predecessor of the Romanesque.[30] Soon German writers began to describe this strange, towerlike structure (fig. 5) as "Germanic" and as one of the

vehicles whereby the most ancient national architecture gained influence upon Charlemagne and upon successive German emperors through Charlemagne's Chapel at Aachen.[31] In this way, the Ostrogoths were assimilated into the conception of the Germanic peoples held by many architectural historians.

Kugler's follower, Wilhelm Lübke, who served as the editor of later editions of Kugler's works and was himself the author of the most widely used history of architecture of the 1860s to 1880s, followed a very similar pattern: everything before the Gothic was more worthy of study, because it was more "German."[32] Kugler's and Lübke's profusely illustrated multivolume architectural histories reached a large, generally educated audience for the first time. They

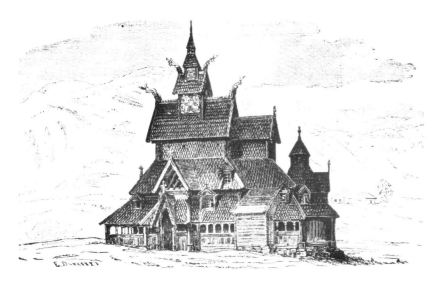

6. *Andreaskirche*, Borgund,
Norway, c. 1150
L. Dietrichson and Holm Munthe,
*Die Holzbaukunst Norwegens in
Vergangenheit und Gegenwart*
(Hanover, 1893), pt. 1, fig. 70

7. *Imperial Palace*, Goslar,
c. 1030–1050
Dehio 1923, 1, pt. 1, fig. 233

began very quickly to affect the thinking and work of preservationists and, after unification, official policy as well. Thus, from the 1870s, official preference was given to the restoration and preservation of early medieval monuments. This emphasis, many scholars believe, has continued to affect German preservation efforts up to the present day.[33]

Kugler also initiated an interest in wood architecture, grave mounds, and prehistoric monuments such as dolmens, as the earliest sources of a national architecture. His *Handbuch der Kunstgeschichte* of 1842 began with a consideration of graves, dolmens, and rune stones, based on contemporary archaeological writing; the *Geschichte der Baukunst* included extended discussions of the patrimony of Germanic wood architecture. Lübke's history carried these ideas forward in the 1870s.[34]

In 1880 the archaeologist and professor

of applied arts, Paul Lehfeldt, took up the theme of wood architecture in a particularly influential way. In a major address to the Berliner Bauakademie, Lehfeldt set forth an extended account of the history of wood architecture, which emphasized its national and Germanic origins.[35] Building on Lehfeldt's work, Robert Dohme's *Geschichte der deutschen Baukunst* of 1887 saw in "Germanic hall buildings" the origins of Romanesque architecture, and suggested that contemporary peasant architecture might give some indication as to the appearance of such buildings. Generally, before the turn of the century, comprehensive histories of art and architecture made little effort to illustrate this early Germanic wood architecture, but Kugler, Lübke, and Lehfeldt devoted considerable space to extant medieval buildings, such as stave churches, in the Scandinavian countries, suggesting that these buildings might, in a roundabout way, give some indication of the earliest "Germanic" architecture (fig. 6).[36]

Increasingly after 1871 historians and preservationists also gave prominence to the earliest imperial palaces. These were believed to have been organized around a great hall, which itself had originated in Germanic wood architecture; hence the imperial audience hall was seen as descending from the meeting halls of great tribal chieftains as depicted in the *Edda* and in *Beowulf*.[37] The Wartburg was the earliest fortress or palace to be discussed in these terms, but in the 1870s and early 1880s the palaces of Goslar and Gelnhausen, together with Burg Dankwarderode in Braunschweig, were the subjects of scholarly debate, architectural publicity, restoration, and nationalistic fervor.[38] Gelnhausen, the twelfth-century palace of Henry VI, was thought to have been built by Frederick Barbarossa, Holy Roman Emperor from 1152 to 1190, whose reign and personality attracted so much nationalistic feeling in the period after German unification.[39]

Goslar and Burg Dankwarderode, too, because of their associations with earlier emperors, were linked to pan-Germanism and to an ancient Germanic past. Goslar, the imperial palace of the Salian emperors Conrad II and Henry III, built from approximately 1030 to 1050 in the Harz Mountains

(fig. 7), was established as a national monument by Kaiser William I soon after the victory over the French. Restorations were begun and carried forward for nearly fifty years: they included a great hall, where a painting cycle on great events in national history, especially the foundation of the new empire, was begun in 1873.[40]

From the 1820s to the early 1880s, national feeling, historical scholarship, Romanesque restoration, and popular appreciation for medieval architecture had become increasingly intertwined, so that they reinforced one another. From the 1840s onward, the process of making inventories was proceeding rapidly enough to permit sophisticated and comprehensive histories, such as those of Kugler and Lübke, to find a wide audience. At the same time, a growing architectural profession displayed, through professional instruction and practice, increasing interest in ever earlier medieval architectural prototypes. Up until the 1870s or 1880s, the leading historians and architects were very close to one another. In fact, many historians were practicing architects, and many architects were preservation cataloguers or archaeologists at the same time.[41]

From the 1830s through the early 1870s, the restoration of Romanesque churches in the Rhineland inspired a very active neo-Romanesque movement in new building. Churches by architects such as Heinrich Hübsch, Johann Claudius von Lassaulx, Ernst Friedrich Zwirner, and their followers employed round-headed arches and relatively blocky massing to approximate, though usually on a smaller scale, some features of churches like Speyer and Maria Laach. Hübsch, in fact, was one of the earliest proponents of the idea that the Romanesque could form the basis of a national style. In his influential *In welchem Style sollen wir bauen?* he compared Maria Laach to the perfection of the Parthenon.[42] This neo-Romanesque movement, often also referred to as the *Rundbogenstil*, was not merely imitative; rather, it represented an effort to devise a "modern" style that was rooted in round-arched forms drawn principally but not exclusively from the early medieval period. Initially the movement was most extensive in the Rhineland. But from the third decade of the century, Ludwig Persius,

Friedrich August Stüler, Friedrich Hitzig, and Richard Lucae also brought to their work and teaching in Berlin the simple massing and round arches, sometimes combined with polychromy, of the *Rundbogenstil* as it was developing in the Rhineland.[43]

During the same years, individual German monarchs began to show enthusiasm, not only for the preservation of early medieval architecture, but also for a neo-Romanesque style for new state-supported buildings. Beginning with the Ludwigskirche in Munich by Friedrich von Gärtner (1829–1844), Ludwig I of Bavaria often chose a round-arched, simple, and blocky style for his new buildings. (This very powerful monarch gave his favor alternately to neo-Romanesque, neoclassical, and neo-Renaissance styles in order to express his aspirations to national leadership.) Ludwig's mad grandson, Ludwig II, king of Bavaria from 1864 to 1886, is a little harder to take seriously as a national leader, but his pseudo-medieval and fantastic Neuschwanstein Castle, under construction from 1869 to 1886 in southern Bavaria, was widely known and influential in its details.[44] Frederick William IV of Prussia, a man who was very fond of the medieval empires and who many liberal but pan-German nationalists hoped would lead the way to a new greater German state, hired Schinkel and Zwirner to build him an imitation Rhenish castle at Stolzenfels, near Koblenz. He also gave support to architects like Stüler, in the belief that they could develop a national style that was Protestant rather than Catholic.[45] The link between Protestantism, neo-Romanesque, and nationalism was a prerequisite for future Hohenzollern patronage of early medieval styles.

The *Rundbogenstil* continued to be one of several choices for German architects and patrons from the 1830s onward. With the foundation of the German Empire in 1871, the stage was set for the proliferation of the neo-Romanesque as a national style under Hohenzollern patronage and under the leadership of Berlin architects.[46] For the first two decades after unification, the *Rundbogenstil* flourished among a wide variety of Prussian buildings: barracks, railroad stations, and lesser government offices. For major monumental buildings, however,

8. Franz Schwechten, *Kaiser-Wilhelm-Gedächtniskirche*, Berlin, 1891–1895
Photograph: Barbara Miller Lane collection

Transformations of Medieval Models under Emperor William II, 1888–1918

On the eve of the accession to power of William II, scholars and popular writers generally agreed as to the four principal components of a German national architecture: (1) church architecture with simple massing, squat round arches, and barbaric-looking capitals and decoration; (2) imperial palaces with great audience halls and a fortresslike character; (3) a monumental cylindrical kind of building, exemplified in the Tomb of Theodoric; and (4) a wood architecture with large open halls. On the basis of these ideas, which saw precedents in ever simpler and more distant times, William II proceeded to pursue an extensive and influential patronage of an increasingly imaginary Germanic architecture. At the same time, between 1888 and 1914, forms that were distantly medieval in one way or another became so familiar in German architecture that it is possible to speak of the creation of a new vernacular. Architects and patrons from all walks of life drew upon these forms for a great variety of purposes. So too, as we will see, did the most innovative architects of the new avant-garde.

William II's first monumental commissions for his capital were churches: the Gnadenkirche built by Max Spitta from 1891 to 1895, dedicated to the memory of the Empress Augusta, and the much better known Kaiser-Wilhelm-Gedächtniskirche, a memorial to William I, built from 1891 to 1895 by Franz Schwechten from Cologne, who would become a principal architect to William II (fig. 8). In these memorials to his grandparents, William revealed his interest in medieval architecture, as well as the state of his information and misinformation about it. Spitta, for example, was encouraged to use rather late medieval models for some of his buildings for the emperor. Sent to the Rhineland to study Romanesque churches, Spitta operated under the mistaken impression that the thirteenth-century parish churches in Rhenish Sinzig, and the parish church in Gelnhausen, were much earlier, and proceeded to use them as models for his own Gnadenkirche.[49] Schwechten's Kaiser-Wilhelm-Gedächtniskirche resembled more closely the Rhenish churches of

William I (1871–1888) preferred the neobaroque as an expression of the new imperial power, and this preference was reflected also in the choice of neobaroque and neo-Renaissance styles for Germany's new parliament building, the Reichstag.[47] It was only under William II that developments in scholarship, preservation, and architecture were drawn together, first in national patronage for a neo-Romanesque style and then, very shortly thereafter, in the development of an innovative style based on early medieval and Germanic prototypes.[48]

9. Bodo Ebhardt,
Hohkönigsburg, Schlettstadt,
Alsace, 1899–1908
Oskar Döring, *Bodo Ebhardt: Ein
deutscher Baumeister* (Berlin, 1924),
fig. 208
Avery Architectural and Fine Arts
Library, Columbia University,
New York

Speyer (fig. 2), and Maria Laach and also drew extensively on recent neo-Romanesque churches of the Rhineland.[50] But Schwechten—and his patron—thought of both Romanesque and early Christian architecture as "Germanic," so that the interior of the church included early Christian and "Byzantine" elements, such as mosaic decorations. The memorial hall at the front of the Kaiser-Wilhelm-Gedächtniskirche contained mosaics and reliefs illustrating the history of the houses of Hohenzollern and Hohenstaufen, with many references to Frederick Barbarossa, so that the rule of the new emperor appeared to be firmly rooted in an early, Germanic past.[51]

The emperor's reasons for encouraging this mixture of motifs were not, of course, restricted to a somewhat misinformed passion for medieval architecture. The invocation of the Hohenstaufen emperors implied in the Gnadenkirche and made explicit in the Gedächtniskirche was important to the emperor's rule for political reasons as well. Already during the first moments after unification, the decision to designate the ruler of the new united Germany as an emperor, rather than by some other title, revealed the intention of the royal family to assert a con-

nection between the Hohenzollern house and the greatest of the imperial rulers of the past. Since the beginning of the nineteenth century, from the days of Napoleonic occupation, Frederick Barbarossa (1152–1190), or "red beard," had begun to be the subject of a messianic literature that held that he would rise again to lead Germany forth to renewed national triumphs. William I, the grandfather of William II and the first ruler of the united Germany, was often described in contemporary nationalist literature as the new Barbarossa: "white beard on the red beard's throne." William II was drawing on—and making use of—these pre-existing sentiments in the memorial church.[52] And it was significant that William chose a church to symbolize this connection: Since the Hohenzollerns were Protestant, William was seeking to show that Protestantism could lay claim to a hitherto Catholic imperial tradition.

William II also took an active part in the conception and design of many state buildings as time went by, and increasingly he favored earlier and more barbaric-looking models.[53] In addition, he pursued an innovative and influential program of castle and palace construction and reconstruction, which was at the same time tied to a spe-

10. *Hohenstaufenburg,*
Kaysersberg, Alsace (residence
of the imperial Landvogt of
Alsace), c. 1300, ruins
Bodo Ebhardt, *Deutsche Burgen als
Zeugen Deutscher Geschichte* (Berlin,
1925), 41

cific vision of the medieval period. Here too, the emperor's patronage asserted a link between Hohenzollern and Hohenstaufen, between the present and the distant past. The castle and palace work, however, carried with it more ominous political implications than the emperor's churches. It was particularly the legacy of early border fortresses, and their traditional associations with both defense and aggression, that interested William II.

The first of these efforts was the Castle of Hohkönigsburg, a Hohenstaufen castle near Schlettstadt, or Sélestat, in recently annexed Alsace, which dated originally from the twelfth century, though the extant remains were mainly from the fifteenth. The ruinous fortress was presented to the emperor by the citizens of the town soon after his accession. In 1899, William hired Bodo Ebhardt, a young Berlin architect with a passionate antiquarian interest in castles, to collect material on medieval fortresses throughout the German-speaking lands, to study Hohkönigsburg in the light of this

material, and to rebuild the castle. Attempting to approximate the forms and materials of several medieval eras, Ebhardt constructed what was virtually a new building out of the ruins of the old. The final building complex was characterized by simple masses in an asymmetrical arrangement: two sets of round towers with predominantly late medieval forms were linked by massive walls of red sandstone, which surrounded a slender rectangular keep inspired by the watchtowers of the Hohenstaufen period (fig. 9). Ebhardt added to the exterior a number of nationalistic decorative features, including the arms of William II, and outfitted the new ceremonial interiors with supposedly medieval decorations and furnishings. Although many local citizens and some German preservationists bitterly criticized Ebhardt's imaginative reconstruction, the emperor was pleased: He gave Ebhardt the title "Architect to the German Emperor and King of Prussia," and rewarded him with a professorship in Berlin.[54] Like the Kaiser-Wilhelm-Gedächtniskirche, Hohkönigsburg represented the emperor's eagerness to tie Hohenzollern to Hohenstaufen, the Second Empire to the first. But this time the occasion was a fortress, in an area only recently annexed by Germany.

With the support of the imperial family and members of the court, Ebhardt went on to found the Union for the Maintenance of German Castles, which conducted annual tours of famous castles and fortresses for wealthy patrons, the so-called *Burgenfahrten*.[55] This official castle enthusiasm then filtered down and began to affect scholarship. It is from about the turn of the century that serious histories of German castles began to be written, first by Bodo Ebhardt himself and then by Wilhelm Pinder and others.[56] Although Ebhardt was devoted to "accurate" restoration, he also was fond of ruins, not only as a source for historical study, but also as a reminder of the distant, premedieval origins of many fortresses. His publications, therefore, often depicted castle ruins and thus provided an extremely simplified imagery for imitation (fig. 10). Ebhardt's admirers regarded him as a principal contributor to the entire preservation movement and as a major force in reviving

11. Franz Schwechten,
Imperial Palace, Posen,
1905–1910
Zentralblatt der Bauverwaltung 20
(1910)
Avery Architectural and Fine Arts
Library, Columbia University,
New York

German masonry work and other building trades.[57]

The same desire to erect an imperial castle in a border area lay behind the construction of William's palace in Posen (Poznán), that provincial capital on the Warthe River whose surrounding Polish territory, acquired by Prussia in 1815, had been a site of continuing friction between Germans and Poles. Here, between 1905 and 1911, Franz Schwechten erected for the emperor a huge castlelike palace of great masses, asymmetrically arranged and faced in rough-cut stone (fig. 11). The principal element of the east block of this elaborate structure was a "Germanic" audience hall. At the rear of this great room was the imperial throne, executed in white Pentelic marble; it faced frescoed representations of the eight great emperors of the Middle Ages.[58] The palace in Posen was modeled in conception on Goslar, Gelnhausen, and Burg Dankwarderode and formally owed something to Hohkönigsburg and to the churches at Gernrode and Quedlinburg. It offered an encyclopedic set of references to all the ideas about the Middle Ages that most interested William II. As a whole, however, it resembled no specific building. With Hohkönigsburg, it marks a departure from history and archaeology into the twin realms of archaism and innovation.

Much the same could be said of William's patronage of wood architecture from the 1890s onward. It will be remembered that scholars like Lehfeldt, Lübke, and Dohme had asserted that wood-frame "hall buildings" represented the earliest form of Germanic architecture. None of these writers was yet sure what such buildings would have looked like. Dohme suggested that contemporary peasant architecture or sur-

12. Holm Munthe, *Imperial Hunting Lodge "Rominten,"* East Prussia, 1891
Dietrichson and Munthe 1893, pt. 2, fig. 1

viving wood-and-plaster buildings from the later Middle Ages might offer some guidance; Kugler and Lübke illustrated the twelfth-century stave church at Borgund (fig. 6) as a possible example of this type of construction. It was this latter argument that inspired the emperor. On one of his annual visits to Norway (which soon became a major enterprise of the whole court), William met Holm Hansen Munthe, a young architect who was designing houses and hotels in imitation of the kind of Germanic wood architecture that Lübke, Lehfeldt, and Dohme had written about. The emperor brought Munthe to Germany to build Rominten, the hunting lodge in East Prussia where he spent a considerable portion of the year, and from which he often conducted the government of the empire (fig. 12). The hunting lodge was very large and elaborate. As part of the complex of buildings, William had Munthe build an imitation stave church, modeled on that of Borgund.[59]

While in Germany, with the encouragement of the emperor, Munthe published an important book on Norwegian wood architecture (1893), built a boathouse for the emperor at Spandau, and directly inspired the work of some other architects working for the emperor. The landing stage for the imperial steamboat, which took the emperor back and forth to his private railway in Spandau, also shows the influence of

Munthe's work.[60] Munthe's work may also have inspired similar timber buildings in Sweden and Finland by Wahlmann, Gallen-Kallela, Sonck, and Gesellius/Lindgren/Saarinen. And, taken together with William's castles and palaces, it represents the same kind of combination of imaginary old and imagined new that has been termed national romanticism in discussions of the architecture of the Scandinavian countries.

William II had seen as the appropriate monument to his grandfather a neo-Romanesque church. After William I's death, a number of nationalist organizations, veterans' leagues, student organizations, and local communities also began to erect a series of nationalist monuments. The first group, which were dedicated to William I and involved the emperor to a great extent, drew upon early medieval prototypes, simplifying and romanticizing them.[61] Another group of monuments, which began to be erected in 1890 (when Bismarck was discharged as chancellor by the emperor) but became much more numerous after Bismarck's death in 1898, were dedicated to Bismarck as the unifier of the nation. Some writers believe that this effort, also the work of ultranationalist organizations, represented disaffection with the emperor.[62] Whatever may be the truth about the Bismarck monuments (and their politics is not well understood), their placement was often at the borders of the empire. Hence, they were clearly representative of a strong pan-German sentiment not unlike that implied by William's castles and palaces.[63] Unlike the monuments to William I, most of the Bismarck monuments were not representational; rather, they took the form of simplified towers or columns. Many thus derived from the castle towers popularized by Hohkönigsburg and Bodo Ebhardt's publications. Many others, such as the Bismarck Tower built by Wilhelm Kreis at Lössnitz, Dresden, in 1902, drew upon the imperial and barbarian imagery of the Tomb of Theodoric (fig. 13).[64]

At about the same time, monuments to the war dead of the nineteenth century began to be erected, some by national organizations and some by local ones. At Wachenburg near Weinheim on the Rhine, for example, the local chapter of the national

13. Wilhelm Kreis, *Bismarck Tower*, Lössnitz, Dresden, 1902
Carl Meissner, *Wilhelm Kreis* (Essen, 1925), pl. 2

14. Bruno Schmitz, *Völkerschlachtdenkmal*, Leipzig, 1898–1913
H. Schliepmann, *Bruno Schmitz* (Berlin, 1913), pl. 29
Avery Architectural and Fine Arts Library, Columbia University, New York

students' organization (the Burschenschaft, which tended to pan-Germanism) hired the architect Artur Wienkoop to add on to an old ruin a new castle modeled on Goslar and on the Wartburg. The new building was to be a monument to the war dead of 1870.[65] And in 1894, a patriotic society in Leipzig began to plan a centennial monument to the "Battle of the Nations" of 1813, the famous battle in which the tide of the Napoleonic wars had supposedly been turned at Leipzig. The burghers of Leipzig hired Bruno Schmitz, the architect of the Kaiser Wilhelm monuments. His colossal structure, begun in 1898 (fig. 14) was a kind of mixture of castle and Tomb of Theodoric, writ very large.[66] These forms were abstracted from any real precedent and by the late 1890s stimulated a powerful and aggressive nationalistic response. One of the students' organizations that called for the erection of Bismarck monuments, for example, published the following statement: "As in earlier times the ancient Saxons and Normans set above the corpses of their fallen heroes rough stone towers topped by fiery torches, so we will honor our Bismarck on all the heights of our homeland."[67]

Thus, the national monuments that were either encouraged or inspired by the emperor, together with the emperor's castles, his memorial churches, and his patronage of wood architecture, had transformed the Romanesque revival into something increasingly abstracted from the past, but strongly nationalistic. Like William II, earlier royal patrons of imitation medieval architecture – such as Frederick William IV of Prussia or Ludwig II of Bavaria – had also been nationalist, willing to romanticize the medieval past, and pan-German. But it was William's particular accomplishment to popularize among a broad audience a fondness for early medieval architecture. The *Nordlandsreisen*, the *Burgenfahrten*, the castles and administrative buildings, and of course the monuments, heralded as they were by national competitions, all gained a wide public for the kind of buildings favored by the emperor. So too did the continuation of preservation activities which, encouraged by the emperor, were increasingly restricted to Romanesque and earlier buildings. Scholarship, aided by the emperor's patronage, also increasingly emphasized early medieval themes.[68] This kind of pub-

15. Theodor Fischer,
Erlöserkirche, Stuttgart, 1908
Wasmuths Monatshefte für Baukunst
1 (1914–1915), 49, fig. 151
Avery Architectural and Fine Arts
Library, Columbia University,
New York

16. Firm of Lachmann and
Zauber, *Grave of the
Lachmann and Katz families*,
Jewish Cemetery, Berlin-
Weissensee, 1901
*Blätter für Architektur und
Kunsthandwerk* 29 (1906), 57
Avery Architectural and Fine Arts
Library, Columbia University,
New York

professional architects.[69] The new buildings constructed under the emperor, and especially the monuments, displayed a radically simplified imagery, easily understood by a broad audience. Much of this imagery — especially, for example, that of the Völkerschlachtdenkmal — was extremely warlike in its associations. It is tempting to assume that, as the practice of medievalism in architecture increased in Germany, it reflected an increase in aggressive nationalism of a very militaristic character.

William II was himself increasingly militaristic in the last years before World War I. Certainly some of the architects who admired him and his architectural patronage must have shared in this militarism. Yet medieval forms of an abstracted kind came to be so widespread in their use in Germany in the last two decades before World War I that they came to be detached from any particular political point of view, from any view about what would be the "right" boundaries for Germany, even though for most people they still retained an association with nationalism.

For example, heavy masonry and pseudo-Romanesque or perhaps "Germanic" forms predominated in a wide variety of religious buildings during the last years of the Second Empire. Christoph Hehl's work in the 1890s for Protestant churches was of this sort, as were the numerous Catholic churches by Theodor Fischer and his school. Fischer's 1911 Church of the Savior in Stuttgart (fig. 15) exemplifies this tendency.[70] From the early 1890s, the churches of Germany revived the early medieval forms and images not, we can assume, because of their imperial associations, but because of their simplicity, which seemed more spiritual. In a society increasingly secular and often hostile to a particular confession, Catholicism as well as Protestantism could profit by the national associations of these forms. Similarly, Jewish synagogues and funerary monuments, such as the family mausoleum (1901) by the firm of Lachmann and Zauber in Berlin-Weissensee (fig. 16), often employed abstracted Romanesque forms. Here, very rough and heavy masonry and exceptionally low, barbaric-looking arches served to stress the German identity of the Jews in an increasingly anti-Semitic society.[71]

licity was reinforced by the rapid increase of publications, both scholarly and of the guidebook type, which associated early medieval architecture with German or Germanic nationality, and by the increasing prominence of such subjects in the magazines and journals for preservationists and

The same observations could be made about many other buildings. Official buildings of all types and at all levels, such as the Cologne police headquarters of 1907 (fig. 17) employed rough-cut masonry and round-headed arches, as well as interior decoration based on "Germanic" motifs. One might assume that the motive in cases such as the Cologne police station was to associate in people's minds the power of the local police with that of the imperial officials in Berlin. But instead, contemporary sources show that the pseudo-medieval forms (low doorways, few stairs, low ceilings, many open spaces, as well as "Germanic" decoration) were chosen for their apparent accessibility, to achieve a certain sense of familiarity. At the same time, the rough masonry and the castle associations were thought to reassure passers-by about the efficiency with which wrongdoers were being walled off from the rest of society.[72]

17. Julius Kohte et al., *Police Headquarters*, Cologne, 1904–1907
Zentralblatt der Bauverwaltung 27 (1907), 369
Avery Architectural and Fine Arts Library, Columbia University, New York

18. Paul Bonatz and F.E. Scholer, *Railway Station*, Stuttgart, 1911–1928
Gustav Adolf Platz, *Die Baukunst der neuesten Zeit* (Berlin, 1927), 278

19. Hans Poelzig, *Turmbau der Oberschlesischen Eisenindustrie*, Posen, 1911
Zentralblatt der Bauverwaltung 21 (1911), 409
Avery Architectural and Fine Arts Library, Columbia University, New York

20. Hans Poelzig, *Superphosphatschuppen, Chemical Factory*, Luban, 1912
Zentralblatt der Bauverwaltung 35 (1925), 335
Avery Architectural and Fine Arts Library, Columbia University, New York

These buildings were not specifically imitative of Speyer, the Wartburg, Goslar, or the Tomb of Theodoric. Instead, their architects were adopting the round-headed

arches and rough-cut stone of early medieval building for a great variety of purposes: to suggest spirituality, to lay claim to a national identity, to evoke images of strength and simplicity, or to refer to the primitive populism of a kind of mythical German past. While we might expect some of these references in a police station, they appear in churches and synagogues too. And not only there.

Similar forms, if increasingly abstracted, occur in much of the prewar work of Hugo Licht, Friedrich von Thiersch, Karl Hocheder, Theodor Fischer, and Paul Bonatz. Museums, theaters, exhibition buildings, warehouses, and railroad stations appear in the last fifteen years before the war in some variant of abstracted Romanesque revival. Most of these architects employed such forms at least partly because of their primitivism and simplicity; each was striving to formulate a new style, both modern and "German." One type of result of this effort is illustrated by Paul Bonatz' railroad station in Stuttgart, begun in 1911 and often published as one of the principal sources in Germany of the modern movement before World War I (fig. 18). The simple, unornamented, cubic masses, asymmetrically arranged, do indeed look ahead in their composition to the Bauhaus buildings of 1926. But at the same time, there were obvious links—in the masonry and in the fortresslike appearance—both to the emperor's buildings and to national romanticism as it was developing at the same time in the Scandinavian countries.[73]

Even among those prewar architects who did not make explicit reference to any specific historical prototype, echoes of Germanic and national forms reappeared. In Hans Poelzig's steel pavilion from the International Exposition of Steel and Iron at Posen in 1911, for example, the resemblance to the Tomb of Theodoric, and to some of the national monuments, is very clear, even though the building was intended to display the current state of technology in steel and iron (fig. 19). Poelzig's chemical factory at Luban (1912) was also very monumental and from some vantage points resembled a simplified castle (fig. 20). Poelzig liked the implications of handicraft that he saw in masonry buildings; he also

21. "Alt Berlin," Berliner
Gewerbeausstellung XIII,
Berlin, 1896
Zentralblatt der Bauverwaltung 6
(1896), 451
Avery Architectural and Fine Arts
Library, Columbia University,
New York

liked the massiveness of the Romanesque
revival and appreciated the simplicity of
forms attributed to the early Middle Ages.[74]
But Poelzig also wanted to achieve an en-
tirely new architecture, suitable to a new
Germany in an industrial age. It is in Poel-
zig's work, especially of the last few years
before the war, that we see most clearly the
links between national romanticism and the
avant-garde in Germany.

By 1914, then, medieval revivalism had
produced in German architecture a varied
set of images, all of which seemed nation-
alist and German, but not all of which had
militaristic or warlike implications. Some
approximated archaeologically correct im-
itations of early medieval buildings; some
were imaginary reconstructions of build-
ings from time periods so distant as not yet
to be fully understood. And some were
closely akin to the most innovative avant-
garde architecture. If we look at German
expositions and fairs from the 1890s through
the first two decades of the twentieth cen-
tury, it is clear that medieval references had
come to be so broadly popular, for a wide
range of reasons, that it was almost a
necessity to use them in any popular un-

dertaking. At the German Architecture Ex-
position in Dresden in 1900, for example,
one section was called a "Germanic border
settlement,"[75] and displayed a series of sim-
ple wood and stucco turrets. At the Inter-
national Trade Exposition held in Berlin in
1896, a major display called "Old Berlin"
consisted of simplified castlelike structures
(fig. 21). Thus, the most distant "Ger-
manic" antiquity was now associated with
the best new things to look at in exposi-
tions.[76] An imaginary past had come to sym-
bolize a progressive and unified nation,
looking ahead to an idealized future.

Medievalism and Modernism, 1918–1945

Even though national romanticism or early
medieval revivalism had achieved a dif-
fused popularity in the last years before
World War I, the fact remains that the em-
peror had been a major patron of such ar-
chitecture. After Germany's defeat in war
and dismemberment at the peace confer-
ence, both right and left turned against the
memory of the emperor's rule. Revolution-
aries of the center and left had overturned
the imperial government and created the

Weimar Republic, the first republic to be experienced by Germany as a nation state. When revolutionaries of the right under Hitler's leadership overturned the Weimar Republic in 1933, they also did not return to empire or monarchy, but instead initiated a new form of authoritarian rule. Considering the extent of revulsion against William II's policies after 1918, one would expect that no one would continue to be interested in the kind of architecture he was known to have favored.

And indeed the Weimar Republic did see a widespread rejection of historicist architecture of all types. The Bauhaus was founded in Weimar in 1919 in order to achieve a new art and architecture that would symbolize a new society, divorced from the old. Walter Gropius as director of the Bauhaus first heralded an international style that would bridge national boundaries. The government of the Weimar Republic gave extensive public support to modernism long before the new architecture secured government patronage anywhere else. Thus, when historians write of Germany in the late 1920s as the birthplace of the modern movement, they are correct.

Yet this conventional view of the Weimar Republic as the incubator of the international style remains, at best, a half-truth. The scholarship that had contributed to the popular interest in early medieval forms during the Second Empire continued to a great extent along earlier paths. The same people – Wilhelm Pinder, Albrecht Haupt, Georg Dehio – who had written basic works in the prewar period continued to write and teach about the same subjects during the Weimar Republic, and in some cases during the Nazi period too. After 1918, scholars found themselves less immune to political issues than they had earlier believed themselves to be. Some, like Dehio, found it more problematical to write about "German art" after a war that had made many people suspicious of "German" nationalism.[77] Others, like Haupt, rapidly became outspokenly racist in their search for a truly Germanic architecture.[78] Yet these different views still seemed compatible with one another in ways that they would not be after World War II. As the best new scholars of the Weimar Republic – writers such as Paul Frankl, for

example – continued to investigate the early Middle Ages and to refine their definitions and periodization, they drew in a respectful manner on the work of such different writers as Haupt and Dehio.[79] Thus, an apparent consensus as to the importance of the early Middle Ages – and as to the important monuments – continued in writing about German architecture throughout the Weimar Republic. At the same time, the popularity of medieval sites among architects and the public continued. It was especially the 1920s that saw a proliferation of handbooks and guidebooks describing Germany's castles, Romanesque churches, and wooden architecture as its most distinctive national heritage.[80]

Just as many prewar tendencies in scholarship persisted after the war, so too simplified and abstracted medievalism continued to find favor across a wide spectrum of patrons and among the most diverse architects. If most people now disliked or rejected the emperor, many Germans still honored the war and dreamed of a new nation reconstituted and strong. In 1925, for example, the German War Graves Commission chose to commemorate the Battle of Tannenberg with a national monument in Hohenstein, East Prussia. The choice of battle and site for a national monument was symbolic of a restored greater Germany: Tannenberg had been the location of the defeat of the Teutonic Knights in 1410 by a Polish-Lithuanian army and of the first great victory of the Germans over the Russians in August of 1914. At the Peace Conference of 1918, East Prussia had been separated from the rest of Germany by the interposition of the Polish Corridor, and in 1925 the disposition of the whole area around Tannenberg was in dispute. A national competition for the design of the monument attracted entries from relatively progressive architects.[81] First prize went to a castlelike, fortresslike structure depicted with a rising sun to suggest the dawn of a new era (fig. 22). The final version was far less explicitly historicist than, say, the Völkerschlachtdenkmal, but it was obviously inspired by ruinous castles of the type that had been published by Bodo Ebhardt (fig. 10). A commentator in the *Zentralblatt der Bauverwaltung* spoke of the

22. Johannes and Walter
Kruger, *War Memorial*,
Tannenberg, 1924–1927
Zentralblatt der Bauverwaltung 45
(1925), 289, fig. 1
Avery Architectural and Fine Arts
Library, Columbia University,
New York

"dolmenlike" character of the forms, which, by referring back to prehistoric models, were both especially Germanic and especially well understood by the general public.[82] Thus, during the Weimar Republic, some government agencies continued to sponsor early medieval forms in order to express an assertive nationalism.

The Weimar Republic was a period of significant new church building. The earlier associations of Romanesque and neo-Romanesque forms with both nationalism and spirituality continued to influence church design, so that a simplified Romanesque continued to be used in churches of both denominations. But at the same time, references to the past in church buildings, as in war monuments, became ever more simplified and attenuated. Dominikus Böhm, the leading church architect of the Rhineland (and a student of Theodor Fischer), showed this development within his own work over a relatively short period of time. In Böhm's Saint John the Baptist, built in Neu-Ulm from 1923 to 1926, the arches are distantly Gothic, but the rough-cut masonry and squared off, castlelike tower (fig. 23) recalled the simplified medievalism of Poelzig or Bonatz. Böhm's later churches,

such as Saint Engelbert in Cologne-Riehl (1930), were far more imaginatively abstracted from tradition, but retained a sense of simplified heavy massing, rough masonry, and a few explicitly imitative touches such as the campanile at Saint Engelbert.[83]

Throughout the 1920s, there continued to be a remarkable persistence of references to the medieval past. Some artists and architects of the avant-garde, in fact, briefly reasserted an enthusiasm for the Gothic. The Bauhaus manifesto, with its call for a return to a medieval guild structure as the basis of a new society, and its promise to build the "cathedral of socialism," began with Lyonel Feininger's woodcut of a Gothic cathedral.[84] Peter Behrens used exaggerated Gothic detailing to give an emotional character to some of his buildings in the early 1920s, as did Fritz Höger in his Chilehaus in Hamburg.[85] But more commonly, architects employed heavy massing and some kind of rough stone to imply a mixture of references — to handicraft, to spirituality, to a long-enduring past, and to some kind of abstracted version of nationalism — references that because of their very abstraction resembled the earliest medieval precedents at the same time that they suggested some-

23. Dominikus Böhm, *Church of Saint John the Baptist*, Neu-Ulm, 1923–1926
Platz 1927, 472

25. Fritz Höger, *Scherk Factory*, Berlin, 1926
Zentralblatt der Bauverwaltung 46 (1926), 509, fig. 1
Avery Architectural and Fine Arts Library, Columbia University, New York

24. Franz Roeckle, *Institut für Sozialforschung*, Frankfurt, 1924
Platz 1927, 281

thing radically new.[86] Franz Roeckle (another student of Theodor Fischer) designed for the Frankfurt Institut für Sozialforschung (the famous center for radical social theory led by Erich Fromm, Theodor Adorno, Walter Benjamin, and Herbert Marcuse) a heavy massive structure with explicitly barbaric-looking detailing (1924; fig. 24). Roeckle also built a number of synagogues in a similar manner before proceeding to become a leading proponent of the international style in Frankfurt.[87] It is significant that Roeckle initially sought for a radically new style in the most distant Germanic past, before turning to the solutions of the modernists. Apparently he saw no conflict between these two approaches to the avant-garde. For Roeckle, and perhaps for other architects of the Weimar Republic, the international style represented a different way to realize a modern German architecture, through greater abstraction rather than a repudiation of the national past.

Somewhat more typical of the buildings of the 1920s and early 1930s, and even closer in resemblance to the Tannenberg Memorial, was Fritz Höger's Scherk Factory (1926; fig. 25). The factory, despite its fine brick detailing in the Hanseatic Gothic tradition, appeared in its blocky massiveness to reflect an earlier past. This simple cubic masonry structure, with most of its decorative

features and most obvious historical references stripped away, continued, with a few exceptions, to be characteristic of Höger's work throughout his career. The most obvious later examples were his Evangelical Church in Berlin on the Hohenzollernplatz (1928); the funerary chapel at Delmenhorst (1930); the town hall at Rüstringen (1927), and the water tower at Bad Zwischenahn (1938).[88] Much of Fritz Schumacher's work in Hamburg was also very like that of Höger.[89] A sampling of the *Zentralblatt der Bauverwaltung* during the late 1920s and early 1930s shows that a large number of similar works were executed during that period, some in stone, some in brick.[90] Until recently, historians have neglected these buildings and the lives of their makers. But contemporaries still regarded these structures as entirely innovative, and at the same time understood their implied references to the past. In the mid-1920s, for example, a major biographical dictionary described Höger as a "pioneer of the revivification of Nordic brick architecture."[91]

Some architects of the 1920s offered even more flamboyant recollections of the primitive and barbaric in an effort to be innovative. The towers of Bernhard Hoetger's Modersohn-Becker house at the Böttcherstrasse in Bremen (1918–1927) revived the imagery of the Tomb of Theodoric in a fantastic setting. In his café at the Worpswede Art Colony of 1925 (fig. 26), Hoetger took the kind of wood-frame structure supposed to have been erected by the earliest Germanic tribes, added an abstracted roof "dragon" from Norwegian models, and bent the profiles of the building into a bizarre and somewhat nightmarish result.[92] Even Walter Gropius and the staff of the Bauhaus made a brief gesture toward early medieval and barbaric prototypes in the house for the Berlin timber merchant, Adolf Sommerfeld (fig. 27). The Sommerfeld house resembled in some of its features both the emperor's hunting lodge and the wooden villas of Wahlman in Sweden and Sonck or Saarinen/Gesellius/Lindgren in Finland.

Such works, along with some of the buildings of Höger, Böhm, and Behrens from the early 1920s, are often described as "expressionist" and seen as part of a short-lived phase in avant-garde architecture, a phase

that was decisively set aside by the introduction of the international style in the middle 1920s. But such an interpretation, while true in a limited sense for a few architects like Roeckle, Gropius, and Behrens, was not characteristic of many others. In the Weimar Republic, there existed a broad spectrum of medieval references in architecture, in far greater numbers than has usually been understood. Most of these architects—not all, but most—disliked the imperial form of government and the politics and foreign policy for which it stood. But, as Poelzig or Fischer had done before 1914, many architects saw such themes not so much as political, but as paths to either a spiritual or an innovative architecture. Thus, for most of the years of the Weimar Republic, the avant-garde and nationalism shared a common vocabulary of forms. Some of this continuing consensus began to break down as architecture began to be newly politicized between about 1925 and 1933, as some architects began to charge the international style with "bolshevism," and as

26. Bernhard Hoetger, *Café,* Worpswede, 1925
Wasmuths Monatshefte für Baukunst und Städtebau 12 (1928), 425, fig. 9
Avery Architectural and Fine Arts Library, Columbia University, New York

27. Walter Gropius and Adolf Meyer, *Sommerfeld House,* Berlin, 1920–1921
Museum of Modern Art, New York

28. Hanns Dustmann and Robert Braun, *Hitler Youth Home,* Melle, c. 1936
Rittich 1938, 119

the Nazi movement began to make political capital out of such claims.[93]

The Nazis opposed not only the international style, of course, but expressionism too. After Hitler came to power in 1933, Walter Gropius, Ludwig Mies van der Rohe, Ernst May, and Bruno Taut found it necessary to emigrate; so too did Bernhard Hoetger. Poelzig, Böhm, Höger, and Behrens stayed, but found little favor with the new regime.[94] Hitler's own most favored architecture was Troost and Speer's neoclassicism. Yet if not most, then many official commissions went to buildings that, like Ordensburg Vogelsang (fig. 1), combined medievalism and modernity. Was this a throwback to the traditions of the empire? Ordensburg Vogelsang, clearly, depended more on the Stuttgart railway station (fig. 18) than on Hohkönigsburg (fig. 9). Both were executed in rough-cut masonry, each had an asymmetrically arranged tower and window openings grouped in a way that accentuated the asymmetry of the masses. Perhaps, it could be argued, the Bonatz building simply prefigured the buildings of the international style, while Vogelsang looked back to them. This would be a point of view very congenial to historians who see a linear progression away from historical models as characteristic of the development of modernism. But such a view fails to take into account the long evolution of medieval revivalism in German architecture, an evolution in which the castle at Posen depended partly on Hohkönigsburg and partly on other ruinous castles and in which many innovative buildings, including the Stuttgart railroad station, shared similar antecedents. Thus, references to the early Middle Ages continued to retain in the 1930s associations with nationalism, populism, and innovation. Such a tradition was especially suited to Nazi patronage, which always claimed to be representing a new, even revolutionary, regime. Nazi writers and leaders claimed to be, in their politics and in their architecture, creative for the twentieth century as well as rooted in a national past. Perhaps the surprising thing is that not all the buildings of the Third Reich looked like Vogelsang. Indeed, it was much harder to explain the relationship between Speer's buildings and the official ideology than to

explain the ideological context of Vogelsang.[95]

The other kind of "Germanic" architecture given extensive patronage by the Nazi regime was wood architecture, usually a half-timbered, wood-and-plaster, domestic-looking style, as in the Hitler Youth hostel (fig. 28). Roofed sometimes in thatch, sometimes in shingle, such rural-looking buildings were prominent among the offices of the Labor Front and the hostels of the Hitler Youth and also were adapted for explicitly modern and urban tasks, such as federal administration offices, broadcasting stations, and garages.[96] This folk style was explicitly modeled on contemporary peasant buildings, as well as on half-timbered work still surviving from the later Middle Ages. It was therefore very congenial not only to those Nazi leaders who believed in a rural component in Nazi ideology but also to those who believed that such wood-frame architecture represented the earliest form of Germanic architecture. This idea, which goes back at least as far as Lübke, had led initially to an interest in timber buildings under the emperor and may have contributed something to the forms employed by Hoetger and Gropius. By the later 1920s and early 1930s, however, European archaeology had begun to show that the oldest and most primitive wood buildings in the area then thought of as German were probably wood and plaster, so that very few of the plank or log structures of the earlier type continued to be built under the Nazi regime.[97]

National Romanticism since 1945

After 1945, "Germany" shrank far within any of its earlier perimeters. Lacking the Polish Corridor, Silesia, East Prussia, the Tyrol, Alsace-Lorraine, to say nothing of France, the Low Countries, and Norway, and soon divided in two by the Iron Curtain, Germany (or the two Germanies) was suddenly and shockingly uprooted from the past. The massiveness of German defeat, the gigantic movements of populations that defeat entailed, and the trauma of self-knowledge in the face of publicity about the Holocaust led to new attitudes to the past. For many Germans on both sides of the cur-

tain, the memory of history became suspect; the study of history came to be riddled with omissions.

And yet the results in architecture are not entirely what one would expect.[98] Although much of Germany's history in its built form was eradicated by bombing, great efforts in both east and west have been made at restoration and preservation.[99] Wood-and-plaster buildings are, of course, no longer built as new government office buildings, but they are still energetically attended to by preservation authorities. Castles are still preserved as tourist attractions as well. And very extensive attention has been paid to the rebuilding, once again, of the major secular and religious buildings of the Middle Ages, including those of both the Romanesque and Gothic periods. In some cases, zeal for historical exactitude, together with a particular enthusiasm for the medieval period, has produced entire new townscapes. But the scholarship connected with this preservation effort deals almost entirely with the specific history of particular places, and until very recently it neglected many of the concerns of earlier medieval historians: Castles have not been studied very much, nor has wood architecture, nor prehistoric.[100] Scholarly writing about medieval architecture is less extensive than it once was, and what does exist differentiates clearly between early Christian, Romanesque, and Gothic. No sweeping claims are made by scholars about the appropriateness to German nationalism of any particular period or style. On the other hand, the history of "German" architecture continues to be written, the emphasis continues to be on the Romanesque and earlier periods, and the canon of what is defined as German has not changed very much since Lübke and Dohme.[101]

In the early postwar years, West Germany was quicker than any other country to adopt the technologically innovative steel-and-glass towers and reinforced concrete structures of modernism.[102] But in new buildings, the symbolism of the old was often retained and reflected upon in new ways. In the 1950s, West Berlin decided to preserve the remnants of the Kaiser-Wilhelm-Gedächtniskirche. Egon Eiermann was commissioned to erect a modern steel-and-

29. Gottfried Böhm, *City Hall,*
Bensberg, 1965–1967
Gottfried Böhm and the German
Information Service

glass tower next to it as a new memorial
(1961–1963). Initially the juxtaposition was
supposed to indicate to the public the
triumph of modernity over the remnants of
an undesirable past. But the church has now
come to represent the persistence of the old,
its survival in the face of the depredations
of the present.[103] This reversal of meaning
took place rather quickly.

Even more interesting as an example of
the poignant and problematical pairing of
old and new is the work of Gottfried Böhm,
the son of Dominikus Böhm.[104] In the new
town hall at Bocholt (1973–1977), the
younger Böhm joined a solid, castlelike mass
with a modern glass rectangle, and set them
both on an island in the Aa River (near the
Rhine) which served as a moat. A few years
earlier, Böhm had been commissioned to
build another town hall, for Bensberg near
Cologne, a town whose center had been par-

tially destroyed by bombing. Böhm chose
to build the new town hall into the old
ruinous castle, joining a new, reinforced
concrete "castle" to the old towers and wood-
and-plaster outbuildings (figs. 29, 30). The
resulting building is a play upon the forms
of the past, as are many of Böhm's other
buildings, but it does not repudiate them;
rather, it encapsulates and comments upon
them. There is no evidence that Böhm was
intentionally returning to any of the polit-
ical ideas of the empire or the Weimar Re-
public and certainly not to any of those of
the Third Reich. He must have been aware
of the ideas and work of the German expres-
sionists, and his buildings do have some
kinship with those of his father and his con-
temporaries. But what seems clear is that,
at Bensberg, Böhm was rooting his building
in a visible past, in response to a local pride
that was no longer so much national as civic.

30. Gottfried Böhm, *City Hall, Bensberg*, 1965–1967
Gottfried Böhm and the German Information Service

Thus he self-consciously returned to the persistent and pervasive vernacular that began to evolve with the birth of German nationalism in the early nineteenth century and with the birth of the German nation-state in the later nineteenth century. As the winner of the prestigious international Pritzger Prize in 1986, Böhm is now regarded as one of the principal figures of the international avant-garde. Böhm's work thus represents another episode in the evolution of a German architecture, in which a medieval past forms a bridge to an imagined future. National romanticism, stripped of many (but not all) of its political, archaeological, and scholarly accoutrements, still exists in Germany.

Conclusion

This article is in no sense a complete account of medieval revivals, or nationalist thought, or German scholarship, or the evolution of historic preservation. Rather I have touched on most of these issues briefly in order to discover certain persistent patterns in German architecture since the period of unification. In the process, I have done great violence to the obvious discontinuities in modern German history. No other modern country has experienced so many cataclysmic events, events that have deeply transformed politics, society, and even the definition of the nation itself. Most histories of Germany treat these disjunctions; it is common to divide the modern history of the country into as many as seven distinct periods, and to focus above all on the effects of war, revolution, and counterrevolution. The architectural historian, proceeding in this manner, would lay great emphasis on the conservatism of the emperor's empire, the modernity of the Weimar Republic, and the renewed backward-looking character of

the Third Reich. Indeed this is a common, and in many respects truthful, account of the development of modern art and architecture in Germany: without it, we cannot understand the ways in which, for example, modern artists disliked the emperor, or the Bauhaus teachers saw themselves as breaking away from an evil past, or the Nazi leaders saw themselves as rediscovering a better national tradition. But in emphasizing such disjunctions, it is inevitable that important continuities will be overlooked. It is easy to forget that the history of Germany since unification has lasted only a little over a century and that many of the events of the empire, or even of the period before unification, are still present within local or familial memory. Literature and scholarship, moreover, have a particularly lasting quality; the ideas expressed in them hang on tenaciously. And buildings, even partially destroyed buildings, last longer than ideas. When nationalist literature, scholarship, political patronage, architects' preferences, and popular enthusiasm reinforce one another as they did under the empire, a powerful lasting imagery is created, which can serve as a vehicle either for conservation or innovation. It is this quality of offering multiple possibilities, of seeming both familiar and yet very old and distant, of allowing association to diverse definitions of nationalism and patriotism, of the past and of the future, that has made national romanticism such an enduring tradition in Germany. It may also be true that the experience of historical discontinuity itself has led many Germans to value a familiar set of images to an unusual extent, at the same time that they see as part of the national tradition a tendency to innovation in technology and building design. It is necessary, then, to look at the continuity in one strain of German architecture — that which refers back to the most distant medieval past — in order to understand the relationships between architecture and nationalism in modern German history.

NOTES

This article developed initially out of a paper given at a symposium on "avant-garde and regional form" at the Wissenschaftskolleg zu Berlin in June of 1986. I wish to thank my colleagues at the Wissenschaftskolleg for their comments at that time. For later criticism and suggestions, I am greatly indebted to David Cast, Linda Gerstein, Cecil L. Striker, Pekka Korvenmaa, Jane Caplan, Michael Lewis, and Catherine Y. Gilbert. Any errors of fact or interpretation are my own.

1. Final substantive revisions to this paper were completed early in 1989; therefore it does not incorporate the results of research conducted after that date.

2. For example, David Watkin, *A History of Western Architecture* (New York, 1986), 420; Spiro Kostof, *A History of Architecture: Settings and Rituals* (New York, 1985), 718.

3. On Speer, see Barbara Miller Lane, "Architects in Power," in *Art and History*, ed. Robert I. Rotberg and Theodore Raab (New York, 1988), 283–310.

4. Eliza M. Butler, *The Tyranny of Greece over Germany* (Cambridge, 1935).

5. This emphasis on the classical tradition is also common in Germany. But it has been effectively modified by Thomas Nipperdey, "Nationalidee und Nationaldenkmal in Deutschland im 19. Jahrhundert," in *Gesellschaft, Kultur, Theorie: Gesammelte Aufsätze zur neueren Geschichte* (Göttingen, 1976), 133–173, and has been challenged by the series on imperial culture edited by Ekkehardt Mai and Stephan Waetzoldt (see below, note 14).

6. The Ordensburgen were commissioned by Robert Ley, leader of the Labor Front, originally for recreational purposes. Soon, however, Ley conceived of them as training schools for young political leaders. Eventually they were used by the SS. See Barbara Miller Lane, *Architecture and Politics in Germany 1918–1945*, 2d ed. (Cambridge, Mass., 1985), chap. 8; Ewald Bender, "Die Ordensburgen Vogelsang und Crössinsee," *Monatshefte für Baukunst und Städtebau* 20 (1936), 293–312; and Ewald Bender, "Die Ordensburgen Vogelsang und Crössinsee," *Kunst* 75 (1937), 204–209. See also Hermann Giesler, *Ein Anderer Hitler: Bericht seines Architekten Hermann Giesler* (Leoni am Starnberger See, 1977), 116–118. Giesler, architect of Ordensburg Sonthofen, writes (116) of Ley's desire to return to the "Ordensgedanke der Stauferzeit." A recent discussion of the history and restoration of Ordensburg Vogelsang is Ruth Schmitz-Ehmke, *Die Ordensburg Vogelsang: Architektur, Bauplastik, Ausstattung* (Cologne, 1988).

7. The most innovative aspects of the building were the exterior massing and materials. Interior spaces, which included several large halls for dining, schooling, and group activities, were arranged in a fairly traditional manner. The interior was finished in wood and plaster with many instances of exposed beams.

8. Johnny Roosval, historian of Swedish medieval churches, used the term very extensively in *Swedish Art: The Kahn Lectures for 1929* (Princeton, 1932).

Hakon Ahlberg, architect and prolific architectural writer, spoke of a "national school" that was "individualist" and "romantic": *Swedish Architecture of the Twentieth Century* (London, 1925), 11, 18. A German edition appeared in the same year. According to Pekka Korvenmaa, the term was sometimes employed in Finland between 1895 and 1905; see Akso Salokorpi, Pekka Korvenmaa, and Paul Kivinen, *Lars Sonck 1870–1956* (Helsinki, 1981), especially the chapter by Kivinen, "Early Period – National Romanticism 1894–1907," 13–61.

9. Ahlberg 1925, 14–17; Ragnar Östberg, *Auswahl von Schwedischer Architektur der Gegenwart* (Stockholm, 1908); Hakon Ahlberg, "Carl Westman och nationalromantiken," *Byggmästaren* 33 (1954), 254–257; Elias Cornell, *Ragnar Östberg Svensk Arkitekt* (Stockholm, 1965). For recent Swedish scholarship, see Henrik O. Andersson and Fredric Bedoire, *Swedish Architecture: Drawings 1640–1970* (Stockholm, 1986).

10. On Wahlman, see Sven Ivar Lind et al., *Verk av L. I. Wahlman* (Stockholm, 1950); and Ahlberg 1925, 17.

11. Lisbet Balslev Jørgensen et al., *Danmarks Arkitektur*, 6 vols. (Copenhagen, 1979); Stephan Tschudi-Madsen, "Veien Hjem: Norsk Arkitektur 1870–1914," in Knut Berg, ed., *Norges Kunsthistorie*, 5 vols. (Oslo, 1981), 5:7–108; Sixten Ringbom, *Stone, Style and Truth: The Vogue for Natural Stone in Nordic Architecture* (Helsinki, 1987); Ritva Tuomi (Wäre), "On the Search for a National Style," *Abacus: Museum of Finnish Architecture Yearbook* 1 (1979), 57–96; Lise Funder, *Arkitekten Martin Nyrop* (Copenhagen, 1979); Stephan Tschudi-Madsen, *Henrik Bull* (Oslo, 1983); Salokorpi, Korvenmaa, and Kivinen 1981; Riitta Nikula, *Armas Lindgren 1874–1929* (Helsinki, c. 1986). The use of the term by Watkin 1986, 536, is typical of the most recent general histories.

12. Dimitri Tselos, "Richardson's Influence on European Architecture," *Journal of the Society of Architectural Historians* 20 (1970), 156–162; Leonard K. Eaton, *American Architecture Come of Age: European Reaction to H. H. Richardson and Louis Sullivan* (Cambridge, Mass., 1972). Eaton gives some examples of Richardson's influence before 1900: Boberg, Gavle Fire Station, Gavle, Sweden (1890); Boberg, Electric Works, Stockholm (1892); Carl Möller, Workers' Institute, Stockholm (1893–1894); Ludvig Peterson, Högönas Store, Stockholm (1889–1891); and Martin Nyrop, Town Hall, Copenhagen (1892–1905). The best recent revisions of Eaton and Tselos come from Finland; see especially Tuomi (Wäre) 1979.

13. Neither Tselos nor Eaton gives much account of the probable influential role of German periodicals in bringing knowledge of Richardson to Scandinavia. The best summary of publications in Germany on Richardson is Monika Arndt, "Das Kyffhäuser-Denkmal: Ein Beitrag zur Iconographie des zweiten Kaiserreiches," *Wallraf-Richartz-Jahrbuch* 40 (1978), 75–127, n. 129. Also useful is the work of Arnold Lewis; see his "European Profile of American Architecture," *Journal of the Society of Architectural Historians* 37 (1978),

265–282. In general, it should be remembered that by about the middle of the nineteenth century, German was the *lingua franca* for the intellectuals of most of Europe's smaller countries, and that German scholarship and publications were dominant in many fields in Scandinavia and the Low Countries.

14. Principally the several series supported by the Fritz Thyssen Stiftung: Stephan Waetzoldt's series, "Kunst, Kultur und Politik im Deutschen Kaiserreich," and the series "Die Bauwerke und Kunstdenkmäler von Berlin," edited by the Senator für Stadtentwicklung und Umweltschutz, all published by Gebrüder Mann. See especially, in the latter, Vera Frowein-Ziroff, *Die Kaiser Wilhelm-Gedächtniskirche* (Berlin, 1982); and, in the former, Ekkehard Mai, Jürgen Paul, and Stephan Waetzoldt, eds., *Das Rathaus im Kaiserreich* (Berlin, 1982); Ekkehard Mai and Stephan Waetzoldt, eds., *Kunstverwaltung, Bau- und Denkmal-Politik im Kaiserreich* (Berlin, 1981); Ekkehard Mai, Hans Pohl, and Stephan Waetzoldt, *Kunstpolitik und Kunstförderung im Kaiserreich* (Berlin, 1982); Klaus Nohlen, *Baupolitik im Reichsland Elsass-Lothringen 1871–1918* (Berlin, 1982); and Ekkehard Mai, Stephan Waetzoldt, and Gerd Wolandt, *Ideengeschichte und Kunstwissenschaft im Kaiserreich* (Berlin, 1983).

15. Johann Gottfried Herder, *Ideen zur Philosophie der Geschichte der Menschheit* (Leipzig, 1784). The idea of the two cultural streams appeared first in Herder's work in his *Journal meiner Reise im Jahr 1769* (n.p., 1769). His ideas about literature appear primarily in *Von deutscher Art und Kunst* (Hamburg, 1773); *Alte Volkslieder* (Leipzig, 1774); and *Von Ähnlichkeit der mittlern englischen und deutschen Dichtkunst* (Leipzig, 1774).

16. Raoul Charles Van Caenegem, *Guide to the Sources of Medieval History* (New York, 1978), 188–189.

17. Thomas Nipperdey, "Kirchen als Nationaldenkmal: Die Pläne von 1815," in *Festschrift für Otto von Simson zum 65. Geburtstag*, ed. Lucius Grisebach and Konrad Renger (Berlin, 1977), 412–431.

18. Restoration was begun in the 1820s; the foundation stone for the new sections was laid down in 1842. Restoration and new building lasted well into the twentieth century. See, among others, Nipperdey 1977, 1976.

19. Reichensperger (1808–1895) was, among his other activities, editor of the *Kölner Domblatt*. See Georg Germann, *Gothic Revival in Europe and Britain: Sources, Influences and Ideas* (Cambridge, Mass., 1973), 99–101; and Michael J. Lewis, "August Reichensperger and the German Gothic Revival," Ph.D. dissertation, University of Pennsylvania, 1989. Gilbert Scott was hired to build a new neo-Gothic Church of Saint Nicholas in Hamburg after the fire of 1842; Gabriel von Seidl built an extension to the late medieval town hall in Bremen (1909–1913); Georg von Hauberisser built a new neo-Gothic town hall in Munich (1867–1874; extension by Hauberisser, 1899–1909). The Gothic revival style was actually often favored for town halls: see Mai, Paul, and Waetzoldt 1982. On the reconstruction and preservation of largely Gothic townscapes, see Michael Brix, *Nürnberg und Lübeck im 19. Jahr-*

hundert: *Denkmalpflege, Stadtbildpflege, Stadtumbau* (Munich, 1981).

20. Philipp Weindel, *Der Dom zu Speyer* (Speyer, 1972); Jochen Zink, *Ludwig I. und der Dom zu Speyer* (Munich, 1986); Walter Haas, *Der Dom zu Speyer* (Königstein im Taunus, 1984); and Klaus Döhmer, *"In welchem Style sollen wir bauen?" Architekturtheorie zwischen Klassizismus und Jugendstil* (Munich, 1976).

21. Wilhelm Lübke, *Geschichte der Architektur von den ältesten Zeiten bis zur Gegenwart*, 6th ed., 2 vols. (Leipzig, 1884–1896), 1:539–540. First published in 1855, Lübke's text remained substantially unchanged from the fourth edition of 1875 through the sixth of 1884–1896. I have used both the sixth and the fourth editions (4th ed., 2 vols. [Leipzig, 1875]).

22. Saint Servatius may, like Saint Cyriacus of Gernrode, have originated also in the reign of Otto the Great, but it was rebuilt in both the eleventh and the fourteenth centuries. The first large-scale publication was Franz Kugler and Karl Ferdinand Ranke, *Beschreibung und Geschichte der Schlosskirche in Quedlinburg und der in ihr vorhanden Alterthümer* (Berlin, 1838). Kugler republished this analysis, which strongly emphasized the importance of Quedlinburg, in his *Geschichte der Baukunst*, 3 vols. (Stuttgart, 1856–1859), and in his *Handbuch der Kunstgeschichte* (Stuttgart, 1842, 1861, 1872). Similar references appear in Lübke 1884. Two main western towers were added to the church at Quedlinburg between 1862 and 1882. See also Klaus Voigtländer, *Die Stiftskirche St. Servatius zu Quedlinburg: Die Geschichte ihrer Restaurierung und Ausstattung* (Weimar, 1988).

23. See, for example, Georg Moller, *Denkmäler der deutschen Baukunst* (Darmstadt, 1815–1821); Christian L. Stieglitz, *Über altdeutsche Baukunst* (Leipzig, 1820); and other works discussed in Albrecht Mann, *Die Neuromanik: Eine rheinische Komponente im Historismus des 19. Jahrhunderts* (Cologne, 1966), 9–11. On the origins of a "romantic cult of monuments," and its influence upon restoration activities in the first half of the nineteenth century, see Brix 1981, 54–88, 141–152, 198–222.

Sulpiz Boisserée (1783–1854), friend of Schlegel, Moller, Görres, Lassaulx, and Quast, published a monumental and definitive history and description of Cologne Cathedral from 1823 to 1832; it was he who noted its dependence on Amiens, thus raising questions in some minds as to the "Germanness" of the building. He also helped to develop an early definition of Romanesque architecture and emphasized in his writings the importance of architecture as national expression. Boisserée was consulted throughout the first half of the century by most preservationists and inventarists. See Sulpiz Boisserée, *Tagebücher 1808–1854* (Darmstadt, 1978); and Germann 1973, especially 48–49.

24. Felicitas Buch, "Ferdinand von Quast und die Inventarisation in Preussen," in Mai and Waetzoldt 1981, 361–382. In the same volume, see Hans Peter Hilger, "Paul Clemen und die Denkmäler-Inventarisation in den Rheinlanden," 383–398; Wolfram Lübbeke, "Georg Hager und die Inventarisation der Bau- und Kunst-

denkmäler in Bayern," 399–417; and Volker Plagemann, "Georg Dehios 'Handbuch der deutschen Kunstdenkmäler'," 417–430. See also Georg Dehio and Gustav von Bezold, *Die kirchliche Baukunst des Abendlandes* (Stuttgart, 1884–1901); and especially Georg Dehio, *Handbuch der deutschen Kunstdenkmäler* (Berlin, 1906–1912). Both Robert Dohme, *Geschichte der deutschen Baukunst* (Berlin, 1887), and Lübke 1875 contain many additional references to inventories, such as those by Ludwig Puttrich (1783–1856) and Heinrich Otte (1808–1890). See Ludwig Puttrich, *Denkmale der Baukunst des Mittelalters in Sachsen*, 2 vols. in 4 (Leipzig, 1836–1852); Ludwig Puttrich, *Systematische Darstellung der Entwicklung der Baukunst in den obersächsischen Ländern vom X. bis XV. Jahrhundert* (Leipzig, 1852); Heinrich Otte, *Geschichte der deutschen Baukunst* (Leipzig, 1861–1871); Heinrich Otte, *Geschichte der romanischen Baukunst in Deutschland* (Leipzig, 1874; new ed. 1885); Heinrich Otte, ed., *Zeitschrift für christliche Archäologie und Kunst*, 2 vols. (Leipzig, 1856–1858) (ceased publication). Both Dohme and Lübke also refer to guides of the 1860s, including Lübke's own inventory of the medieval buildings of Westphalia (see Lübke 1884, 1:116). According to Dohme 1887, i: "Durch die Inventarisierung der Denkmäler ist die baugeschichtliche Arbeit für Deutschland in ein neues Stadium getreten."

25. *Von deutscher Baukunst* (n.p., 1772). See also works cited by Germann 1973, 84–89, 40 (on Goethe's confusion over terminology).

26. See especially Germann 1973, 45–52, 151–152 (which treats the work of Johannes Wetter, Franz Mertens, and August Reichensperger in the 1830s and 1840s).

27. Kugler (1808–1858) was a professor at the Royal Academy of Art in Berlin; himself an architect, dramatist, and poet; educational reformer within the Prussian Ministry of Culture; and collaborator of Jacob Burckhardt. Kugler wrote the central handbooks of art and architectural history that would be used and modified for half a century. In all his work, he stressed the importance of the medieval over the classical for German architecture, and this emphasis lasted well into the twentieth century. As well as the *Handbuch* and the *Geschichte der Baukunst*, the immensely prolific Kugler wrote histories of Frederick the Great; Spanish, French, and Italian painting; and Greek architecture and sculpture (he was one of the first to discuss the role of polychromy in Greek architecture). These works, and most of the others, went through many editions and were translated into several languages, including English. Kugler dedicated the *Handbuch der Kunstgeschichte* to Frederick William IV. His work was still being cited in the 1940s and 1950s: see Eberhard Hempel, *Geschichte der deutschen Baukunst* (Munich, 1949; 2d ed., 1956).

28. Kugler 1842, 416, 513–516. Both, together with early Christian and Islamic art, were labeled "romantic," to distinguish them from classical art.

29. Kugler 1856–1859, 3:5; 2:5–8, 392.

30. Kugler 1842, 347.

31. Kugler 1856–1859, 1:398–399; Lübke 1875, 1:274–278; 1884, 1:404–406. The historiography of the Tomb of Theodoric is very complicated and cannot be traced in any detail here. Suffice it to say that after the work of Kugler and Lübke, the equation of the Tomb of Theodoric with an early Germanic architecture was carried forward by Dohme's *Geschichte der deutschen Baukunst* in 1887. A long debate then ensued as to how Germanic the tomb really was, although few denied the idea altogether. The principal advocate of the Germanic character of the tomb in the later years of the empire was Albrecht Haupt, with many articles in the *Zeitschrift für Geschichte der Architektur* and two very influential books: *Die älteste Kunst insbesondere die Baukunst der Germanen von der Völkerwanderung bis zu Karl dem Grossen* (Leipzig, 1909); and *Das Grabmal Theoderichs des Grossen zu Ravenna* (Leipzig, 1913). The most authoritative modern works are Robert Heidenreich and Christian Johannes, *Das Grabmal Theoderichs zu Ravenna* (Wiesbaden, 1971); and Friedrich Deichmann, *Ravenna: Hauptstadt des spätantiken Abendlandes* (Wiesbaden, 1974). On discussions of the Tomb of Theodoric in relation to the conception of the Kaiser-Wilhelm-Gedächtniskirche, see Frowein-Ziroff 1982, 44–46.

32. Wilhelm Lübke (1826–1893) was a friend of Kugler, Theodor Fontane, Jakob Burckhardt, and Carl Schnaase, whose art-historical methodology influenced him. Lübke taught at various times at the Berliner Bauakademie, at the Eidgenössische Polytechnikum in Zurich (where he followed in Burckhardt's shoes), and at the technical universities in Stuttgart and Karlsruhe. See notes 21, 41, 43; see also Wilhelm Lübke, *Lebenserinnerungen* (Berlin, 1893).

33. Plagemann 1981, 417–430.

34. Kugler 1842, 5–13; Kugler 1856–1859, 2:13–14, 568–578; Lübke 1875, 1:476–480; 1884, 1:668–674. Both Lübke and Kugler relied on Heinrich Otte's *Zeitschrift:* see note 24 above. Kugler and Lübke might also have known of the work of Scandinavian archaeologists through the "authentic . . . ancient Scandinavian model" house exhibited at the Paris world's fair of 1867. See Erik Nordin, *Träbyggande under 1800-talet, Debatt och verklighet* (Stockholm, 1972), 57. For their knowledge of stave churches, Kugler and Lübke drew upon the work of the painter and professor of art at the Dresden Academy, I. C. Dahl, *Denkmale einer ausgebildeten Holzbaukunst in den Landschaft Norwegens* (Dresden, 1837).

35. Paul Lehfeldt, *Die Holzbaukunst* (Berlin, 1880), iii, 95–98, 106–115. On the original wood architecture as the truest architecture of the Germanic peoples (96), Lehfeldt refers to Gottfried Semper, *Der Stil in den technischen und tektonischen Künsten oder praktische Aesthetik*, 2 vols. (Munich, 1860–1863), 2:294. For a good summary of the development of this idea in the generation after Lehfeldt, see Otto Stiehl, *Der Wohnbau des Mittelalters*, 2d ed. (Leipzig, 1908).

36. See notes 34, 35, above. Figure 6 is Borgund, believed to be the oldest Norwegian stave church, extensively illustrated by Dahl 1837 and republished by Kugler 1856–1859, 2:576, and Lehfeldt 1880, 108. In

addition to stave churches, Lehfeldt also illustrated the half-timbered buildings characteristic of late medieval towns in central Europe. Dohme's ideas were also developed by Friedrich Seeselberg, a prolific writer and teacher of medieval architecture at the Berlin Technische Hochschule from the 1890s to the 1920s. In a lavishly illustrated two-volume work entitled *Die Früh-mittelalterliche Kunst der germanischen Völker unter besonderer Berücksichtigung der Skandinavischen Baukunst in ethnologisch-anthropologischer Bergründung* (Berlin, 1897), and in a number of articles in professional journals as well, Seeselberg argued that there was a direct link between prehistoric graves and forts and Scandinavian stave churches on the one hand, and the Romanesque masonry buildings of the Middle Ages on the other hand. Seeselberg's work, with its emphasis on the importance of the rounded forms of Germanic forts, also gave confirmation to the idea that the Tomb of Theodoric was Germanic in origin, and that it had influenced the chapel of Charlemagne in Aachen.

37. This point is made by Dohme 1887, 1, 110; but also suggested in Lübke 1875, 1:369. According to Dohme, historians should also look at contemporary peasant architecture, in order to arrive at some idea of what the original wood architecture had looked like.

38. See, for example, "Die Burg Dankwarderode in Braunschweig," *Zentralblatt der Bauverwaltung* 3 (1883), 479–481; and Ludwig Winter, *Die Burg Dankwarderode zu Braunschweig* (Braunschweig, 1883). Lübke included extended discussions of these buildings based on the work of Winter, Puttrich, and others: Lübke 1875, 1:369–374; 1884, 1:531–538.

39. Peter Munz, *Frederick Barbarossa: A Study in Medieval Politics* (Ithaca, 1969), esp. chap. 1, "The Kyffhäuser Legend," and chap 3. See also note 58, below; Elisabeth Fehrenbach, "Images of Kaiserdom: German Attitudes to Kaiser Wilhelm II," in *Kaiser Wilhelm II: New Interpretations*, ed. John C.G. Röhl (New York, 1982), 269–285; and Theodor Schieder, *Das deutsche Kaiserreich von 1871 als Nationalstaat* (Cologne, 1961).

40. Monika Arndt, *Die Goslarer Kaiserpfalz als Nationaldenkmal* (Hildesheim, 1976).

41. For example, on Lübke's relationships with the Berlin circle of architects, see Lübke 1893, 183; and Norbert Alewald, *Der Baumeister Maximilian Nohl 1830–63* (Bonn, 1980). See also note 43 below.

42. Heinrich Hübsch, *In welchem Style sollen wir bauen?* (Karlsruhe, 1828; rpt. 1983), 39. On the first phases of the neo-Romanesque, see Mann 1966. On Hübsch and his role in architectural theory, see Döhmer 1976. A comprehensive restoration of Maria Laach to match its earliest Romanesque portions was strenuously sought by Hübsch and Sulpiz Boisserée, greatly favored by both the Kaiserin Augusta and her grandson William II, and carried further during both the Weimar Republic and the Third Reich. See P. Theodor Bogler, *Maria Laach* (Munich, 1974).

43. Persius (1803–1845) and Stüler (1800–1865) worked closely with Schinkel and enjoyed the patronage of

Frederick William IV. Persius was a professor at the Berliner Bauakademie and a friend of Lübke, who dedicated his books to him. Lucae (1829–1877) was first teacher and then director of the Berliner Bauakademie (1869–1877). Hitzig (1811–1881), close collaborator of Lucae and author of some of Berlin's most important monumental buildings, was president of the Akademie der Künste from 1875 to 1881. See Eva Börsch-Supan, *Berliner Baukunst nach Schinkel, 1849–1870* (Munich, 1977); Manfred Klinkott, *Die Backsteinbaukunst der Berliner Schule: Von K. F. Schinkel bis zum Ausgang des Jahrhunderts* (Berlin, 1988); Mann 1966; and Michael Bringmann, "Studien zur neuromanischen Architektur in Deutschland," dissertation, Heidelberg University, 1968.

44. Ludwig's other castles, Herrenchiemsee and Linderhof, were neobaroque.

45. Stolzenfels castle, begun in 1836, is illustrated in Claude Mignot, *Architecture of the Nineteenth Century in Europe* (New York, 1984), fig. 116. See also Ludwig Dehio, *Friedrich Wilhelm IV von Preussen: Ein Baukünstler der Romantik* (Berlin, 1961); and Werner Bornheim gen. Schilling, "Stolzenfels als Gesamtkunstwerk," in *Die Kunst des 19. Jahrhunderts im Rheinland*, ed. Eduard Trier and Willy Weyres, 5 vols. (Düsseldorf, 1980), 2:329–342. On nineteenth-century castles in general, see Renate Wagner-Rieger and Walter Krause, eds., *Historismus und Schlossbau* (Munich, 1975); and Ursula Rathke, "Schloss und Burgenbauten," in Trier and Weyres 1980, 2:343–362.

46. After unification, Berlin became a center for architectural education and publication to a greater extent than ever before. For example, it was now a center for the publication of professional journals, with significant rivals only in Munich and Leipzig. Much of my research has focused on the *Zentralblatt der Bauverwaltung*, the official publication of the Prussian Building Administration, founded in 1881, which became one of the most widely read architectural publications in imperial Germany. The frequency of articles in that journal dealing with the Romanesque, with ever earlier medieval architecture, and with wood architecture, is very great. For examples of typical articles from the first decade, that is, before there could have been significant influence from Richardson, from Scandinavia, or indeed from William II himself, see: Karl Schäfer, "Die Kirche zu Idensen," 3 (1883), 111–113; "Die Burg Dankwarderode in Braunschweig," 3 (1883), 479–481, and 5 (1885), 205–206; "Mitteilungen über ein in Gelnhausen freigelegtes romanisches Haus," 5 (1885), 437–439; Hans Lutsch, "Wanderungen durch Ostdeutschland zur Erforschung volksthümlicher Bauweise," 7 (1887), 63, 67, 376, 388, and 8 (1888), 15–17, 27–29, 133–135 (on wood-frame and plank buildings); "Unsere Hünengräber," 11 (1891), 157–158; and "Älteste Architekturformen aus Quedlinburg," 11 (1891), 233–235.

47. William I was less interested in architecture as a political tool than were his brother Frederick William IV and his grandson William II. He did see to it, however, that many new buildings were erected in Strassburg after the annexation of Alsace-Lorraine, including a new imperial palace in a neobaroque style. See Noh-

len 1982, especially "Der Kaiserpalast," 45–94. The Reichstag was built to Paul Wallot's designs from 1884 to 1894. The choice of design was not the emperor's, but the result of international competitions that began in 1872; the juries were made up of members of parliament together with many of Berlin's leading architects. Thus, despite the burgeoning interest in early medieval forms as the basis of a national style, German architects were not willing in 1884 to choose a Romanesque palace to house their new parliament. On the Reichstag, see especially Michael S. Cullen, *Der Reichstag: Die Geschichte eines Monumentes* (Berlin, 1983).

48. See especially Julius Posener, *Berlin auf dem Wege zu einer neuen Architektur: Das Zeitalter Wilhelms II* (Munich, 1979).

49. Frowein-Ziroff 1982, 106. The parish church in Gelnhausen, as well as the palace, was thought to have been built by Frederick Barbarossa. For a good general introduction to architecture under William II, see Conrad Bornhak, *Deutsche Geschichte unter Kaiser Wilhelm II*, 3d ed. (Leipzig, 1922), chap. 8. The best general study of the emperor's reign is John C.G. Röhl, *Kaiser, Hof und Staat: Wilhelm II. und die deutsche Politik* (Munich, 1988).

50. See especially the Catholic churches in Froitzheim/Düren (1868–1869) and Immendorf/Köln (1873–1874) in Mann 1966, figs. 101, 104. The Kaiser-Wilhelm-Gedächtniskirche, which was, of course, Protestant, subsequently served as a model for other Catholic churches in the Rhineland. See, for example, the church of Saint Rochus, Düsseldorf (1894–1897) (Mann 1966, figs. 105–107).

51. Alfred Grunow, *Der Kaiser und die Kaiserstadt* (Berlin, 1970), 54; Frowein-Ziroff 1982, 44, 244–304. The mosaicists depended heavily on the Ravenna mosaics, especially those in the Mausoleum of Theodoric. At the emperor's request, Schwechten also designed and built from 1893 to 1902 two "Romanesque houses" around the Augusta Victoria Square on which the Gedächtniskirche stood: These were multipurpose buildings containing commercial enterprises and apartments and were privately funded. See Peer Zeitz, *Franz Heinrich Schwechten: Kirchen zwischen Zweckmässigkeit und Repräsentation im deutschen Kaiserreich*, Ph.D. dissertation, Free University of Berlin, 1987, 36–37 and nn. 215–218.

52. Arndt 1978, 75–127, especially 76, n. 11. In her exhaustive essay on the Kyffhäuser monument (Barbarossa was supposed to arise from his slumbers in the Kyffhäuser Mountain), Arndt implies that the tendency to equate William I and Barbarossa was consistent throughout the Second Empire. It seems to me that the kind of thinking she describes was far more prevalent under William II, largely as a result of his architectural patronage. See also Frowein-Ziroff 1982; Ludger Kerssen, *Das Interesse am Mittelalter in deutschen Nationaldenkmälern* (Berlin, 1975); and Fehrenbach 1982.

53. See, for example, the Regierungsgebäude in Koblenz (c. 1901–c. 1906) by Paul Kieschke and others, where William himself corrected the drawings. There

was extensive "Nordic" ornament and, on the interior, low arches and squat columns, with capitals and other stonework carved in barbaric-looking scrollwork. The interiors of Julius Kohte's police headquarters in Cologne were very similar (fig. 17). See Bringmann 1968, 181–195, and figs. 74–78, 82, 84–87.

54. Local citizens objected to the unfamiliar profile of the building, to the Hohenstaufen imagery, and to the presence of Hohenzollern arms and decorative motifs. Many preservationists criticized the contemporary imagery of fittings and decorations, while some others saw Ebhardt as inventing an "original" building out of his own imagination. Others, however, saw Ebhardt as a major force in the development of historic preservation in Germany. See Oskar Döring, *Bodo Ebhardt: Ein deutscher Baumeister* (Berlin, 1924); the review of Döring's book in *Zentralblatt der Bauverwaltung* 45 (1925), 11; and Rathke 1980, 350. Ebhardt's own explanation of the restoration at Hohkönigsburg is presented in his *Die Hohkönigsburg im Elsass: Baugeschichtliche Untersuchung und Bericht über die Wiederherstellung* (Berlin, 1908).

55. On the *Burgenfahrten*, see especially Bodo Ebhardt, ed., *Der Burgwart: Zeitschrift für Burgenkunde und Baukunst* (Berlin-Wilmersdorf, 1924), 29–30 (published on the twenty-fifth anniversary of the founding of the Vereinigung zur Erhaltung deutschen Burgen). One of the first *Ausschussmitglieder* was Oberhofmarschall von Mirbach. The empress and her brother Herzog Ernst Günther were members, according to *Der Burgwart* 20 (1921). *Der Burgwart* published articles on wood-and-plaster farm buildings from 1911. Ebhardt went on to do more than fifty other "restorations," including Veste Coburg. He also built a restaurant at the Wartburg in a medieval wood-and-plaster style (1913–1914), the Versicherungsbank Alliance (Berlin, 1914), and other, relatively minor buildings. On Ebhardt's life, see Döring 1924.

56. Ebhardt 1924; Bodo Ebhardt, *Deutsche Burgen* (Berlin 1898–1908); Bodo Ebhardt, *Der Väter Erbe* (Berlin, 1909); Bodo Ebhardt, *Die Burgen Italiens* (Berlin, 1909); Wilhelm Pinder, *Deutsche Burgen und feste Schlösser* (Königstein im Taunus, 1913; many new editions through 1940). Pinder (1874–1947), the famous scholar of many aspects of German art history, including sculpture and baroque architecture, began his career with the study of Romanesque architecture. During the 1920s and early 1930s, Pinder was the principal professor of medieval art, first at Leipzig and then at Munich, where he attracted a significant group of international students. Under the Nazi regime, Pinder went on to a chair at Berlin. His emphasis was always upon that which was national in German art, an attitude that gained him favor under the Nazi regime and disfavor thereafter. See Heinrich Dilly, *Deutsche Kunsthistoriker 1933–1945* (Berlin, 1988).

57. Döring 1924, 137; *Zentralblatt der Bauverwaltung* 45 (1925), 11. On the developing controversy over the nature of preservation, see Georg Dehio and Alois Riegl, *Konservieren, nicht restaurieren: Streitschriften zur Denkmalpflege um 1900* (Braunschweig/Wiesbaden, 1988).

58. Charlemagne, Henry I, Otto I, Henry II, Otto III, Frederick Barbarossa, Henry VII, Frederick II. Otto Sarrazin and Friedrich Schultze, "Das neue Residenzschloss in Posen," *Zentralblatt der Bauverwaltung* 30 (1910), 453–458, especially 457. There were also mosaics, "old Nordic" decorations in the emperor's own rooms, and freestanding statues depicting the occupiers of Polish territories (457). In the audience hall were statues of Charlemagne and Barbarossa.

59. Illustrated in Holm Munthe and Lorentz Dietrichson, *Die Holzbaukunst Norwegens in Vergangenheit und Gegenwart* (Hanover, 1893), pl. 4. On Munthe's life, on the buildings at Rominten, and on the architect's influence in Germany, see the obituary in *Deutsche Bauzeitung* 32 (1898), 279. Rominten was in the Rominten heath, some ninety miles southeast of Königsberg (and nine northeast of Goldap); it was thus very close to the Russian border. Since World War II this area has been part of the Soviet Union. According to Michel Tournier, *Der Erlkönig* (Berlin, 1989), 389, the hunting lodge and nearby buildings were burned by advancing Soviet troops in January 1945. Munthe's work in Norway is discussed in Tschudi-Madsen 1981. On the Nordlandsreisen, see Fürst Philipp zu Eulenburg, *Mit dem Kaiser als Staatsmann und Freund auf Nordlandsreisen* (Dresden, 1931); and Paul Güssfeldt, *Kaiser Wilhelms II. Reisen nach Norwegen in den Jahren 1889 und 1890* (Berlin, 1890).

60. By Johannes Lange, illustrated in *Zentralblatt der Bauverwaltung* 12 (1892), 135.

61. These included the Kyffhäuserdenkmal (1890–1896), the monument at Porta Westfalica (1892–1896), and the Kaiser-Wilhelm-Denkmal am Deutschen Eck near Koblenz (1894–1897), all by the architect Bruno Schmitz. See Hans Schliepmann, *Bruno Schmitz*, 13 Sonderheft der *Berliner Architekturwelt* (Berlin, 1913); Lutz Tittel, "Monumentaldenkmäler von 1871 bis 1918 in Deutschland," in Mai and Waetzoldt 1981, 215–275; and Arndt 1978. The emperor picked the architect and gave some help in fund raising. Arndt sees the Kyffhäuser monument as the first example in nineteenth-century German architecture of a clear departure from historic precedent into innovation. She also discusses the probable influence of Richardson upon Schmitz. While some influence is very possible, I do not think it is particularly obvious in the Kyffhäuser monument.

62. Nipperdey, Golo Mann, and Hans-Walter Hedinge, as cited in Arndt 1978, n. 163.

63. Arndt 1978; Tittel 1981. The pan-German implications of the monuments were, of course, contrary to Bismarck's own views.

64. See also Arndt 1978 and her illustration of Bodo Ebhardt's project for the Bismarck-Nationaldenkmal bei Bingerbrück 1909/1910, Abb. 55, 112. Dieter Bartetzko has also observed Kreis' reference to the Tomb of Theodoric: Bartetzko, *Zwischen Zucht und Ekstase: Zur Theatralik von NS-Architektur* (Berlin, 1985), 155–157.

65. *Zentralblatt der Bauverwaltung* 26 (1906), 259–260; 33 (1913), 239–240.

66. Nipperdey 1976, 163–166; Schliepmann 1913; Tittel 1981.

67. "Wie vor Zeiten die alten Sachsen und Normannen über den Leibern ihrer gefallenen Recken schmucklose Felsensäulen auftürmten, deren Spitzen Feuerfanale trugen, so wollen wir unserem Bismarck zu Ehren auf allen Höhen unserer Heimat," quoted by Arndt 1978, 139, from *Berliner Architekturwelt* (1899), 139.

68. For example, the emperor founded the Kaiser-Wilhelm-Gesellschaft zur Förderung der Wissenschaften, an institute for basic research, reconstituted after World War II as the Max-Planck-Gesellschaft: see Grunow 1970, 75–76. One among many of the activities of this institute was the further investigation of the early medieval royal palaces: see, for example, Paul Clemen, *Die Kaiserpfalzen*, Bericht über Arbeiten an den Denkmälern deutscher Kunst, 1–3 (Berlin, 1911, 1912, 1914).

69. Professional journals multiplied very rapidly from the 1880s onward, supplementing the rather few pre-existing major journals, such as *Deutsche Bauzeitung* (Berlin, 1867–1942) or *Zeitschrift für Bauwesen* (Berlin, 1851–1931). Among the most important of the new journals were *Architektonische Bilderbogen* (Berlin, 1886–1892), *Architektonische Rundschau* (Stuttgart, 1885–1915; merged into *Wasmuths Monatshefte für Baukunst*, see below), *Die Architektur des XX. Jahrhunderts* (Berlin, 1901–1914), *Baumeister* (Berlin, 1911–1940), *Die Bauwelt* (Berlin, 1911–1941), *Die Bauzeitung* (Stuttgart, 1905–1941), *Deutsche Bauhütte* (Hanover, 1897–1941), *Moderne Bauformen* (Stuttgart 1902–1944), *Wasmuths Monatshefte für Baukunst und Städtebau* (Berlin, 1914–1941), and *Zentralblatt der Bauverwaltung* (Berlin, 1881–1935). On the history of German architectural periodicals, see Rolf Fuhlrott, *Deutschsprachige Architektur-Zeitschriften* (Munich, 1975). The *Blaue Bücher* series of profusely illustrated guidebooks, principally devoted to early medieval architecture, began in this period: Wilhelm Pinder's *Deutsche Burgen und feste Schlösser* (Pinder 1913) is typical of the series, which continued to be published into the 1940s. The national organization for historic preservation began in 1899 to publish its own journal, *Deutsche Kunst und Denkmalpflege* (Berlin, 1899–1943). And in 1907 Dehio and others began to publish an important periodical devoted solely to architectural history, *Zeitschrift für Geschichte der Architektur* (Heidelberg, 1907–1928). In the pages of this journal, new work by well-known scholars like Wilhelm Dörpfeld, Josef Strzygowski, Albrecht Haupt, and Cornelius Gurlitt was published alongside commentary on the newest major monuments of the time. According to Plagemann 1981, 417–430, the famous *Handbuch der deutschen Kunstdenkmäler* (Berlin, 1906–1912), edited by Dehio, which established priorities of preservation almost up to the present, had its genesis in a meeting of the national society for historic preservation (*Denkmalpflege*) in Dresden in 1900 and was directly supported by the emperor.

70. Christoph Hehl (1847–1911) trained in Hanover and with George Gilbert Scott. See, for example, his Evangelische Garnisonkirche, Hanover (1891–1896), published in *Deutsche Bauzeitung* 34 (1900), 108–110.

On Fischer, see Winfried Nerdinger, *Theodor Fischer, Architekt und Städtebauer* (Munich, 1988).

71. The employment of Romanesque imagery in synagogues goes back to the 1830s: see Frowein-Ziroff 1982, 56; and Harold Hammer-Schenk, *Synagogen in Deutschland: Geschichte einer Baugattung im 19. und 20. Jahrhundert*, 2 vols. (Hamburg, 1981).

72. For a more extended discussion of the Cologne police headquarters, see Barbara Miller Lane, "Government Buildings in European Capitals, 1870–1914," in *Urbanisierung im 19. und 20. Jahrhundert: Historische und geographische Aspekte*, ed. Hans J. Teuteberg (Cologne, 1983), 517–560; and Bringmann 1968, 199, 321.

73. And, of course, to Henrik Petrus Berlage's Bourse (1897–1903) in Amsterdam.

74. Posener 1979, 508–524, confirms this observation.

75. *Zentralblatt der Bauverwaltung* 20 (1900), 401–412.

76. *Zentralblatt der Bauverwaltung* 16 (1896), 295, 321, 430, 431, 450, 451. The inclusion of an "old city" display in international expositions came to be an almost habitual affair. Roosval 1932 traces the "old Stockholm" show at the Exhibition of 1897 to the Antwerp Exhibition of 1893, but it seems probable that Berlin was a more proximate source.

77. Georg Dehio, *Geschichte der deutschen Kunst*, 3rd ed. (Leipzig, 1923), preface.

78. Albrecht Haupt (1852–1933) had begun his career as an art historian with books on the early Renaissance in Spain and Portugal. He then turned to the subjects of the Tomb of Theodoric and the architecture of the Germanic tribes (see note 31). It was only after the war, when he held a post in the Hanover building administration, in the second edition of *Die älteste Kunst* (Haupt 1923, especially 37–38) and in later writings of the 1920s (for example, "Rasse und Baukunst," *Deutsche Bauhütte* 30 [1926], 135) that Haupt became explicitly racist. An equation of nation and race had been implied in much nationalist writing of the later nineteenth century (in Germany and elsewhere), but it became more explicit in the Germany of the 1920s, and also more frequently a part of discussions of the arts. See also Hans F. K. Günther, *Rassenkunde des deutschen Volkes* (Munich, 1923); Hans F. K. Günther, *Rasse und Stil* (Munich, 1926); Paul Schultze-Naumburg, *Kunst and Rasse* (Munich, 1928); and, for a general overview, Lane 1985, chaps. 5 and 6.

79. Paul Frankl, *Die frühmittelalterliche und romanische Baukunst* (Potsdam, 1926).

80. See the *Blaue Bücher* series described in note 69. Guidebooks for foreign tourists also emphasized the same kinds of sites. See, for example, Robert M. McBride, *Towns and People of Modern Germany* (New York, 1928). The Kaiser William monuments and the Bismarck monuments, however, did not receive much prominence in these guidebooks.

81. Such as Bruno Möhring, Hermann Billing, and Wilhelm Kreis. See "Der öffentliche Wettbewerb für das Tannenberg-Nationaldenkmal bei Hohenstein i. Ostpreussen," *Zentralblatt der Bauverwaltung* 45 (1925), 289–292. Gerdy Troost, wife of Hitler's first architect, Paul Ludwig Troost, compared the Tannenberg monument to the Tomb of Theodoric, and stated that Hitler had made it into a special imperial monument, where Hindenburg was buried: *Das Bauen im Neuen Reich* (Bayreuth, 1938), 34–41.

82. "Der Wettbewerb um das Tannenberg-Nationaldenkmal bei Hohenstein im Ostpreussen," *Zentralblatt der Bauverwaltung* 45 (1925), 336.

83. Illustrated in August Hoff, *Dominikus Böhm* (Berlin, 1930), 121. On Böhm, see also August Hoff, Herbert Mack, and Raimund Thoma, *Dominikus Böhm* (Zurich, 1955), which includes an extensive bibliography.

84. The first Bauhaus manifesto originally spoke of a "cathedral of socialism" as a metaphor for a new, modern architecture; the last word was then quickly changed to "freedom" and "future" in order to avoid political opposition. See Lane 1985, chaps. 2 and 3; and Marcel Franciscono, *Walter Gropius and the Creation of the Bauhaus in Weimar: The Ideals and Artistic Theories of Its Founding Years* (Urbana, Ill., 1971), chap. 4.

85. Peter Behrens, head offices of the I.G.-Farben Dye Factory, Frankfurt am Main-Höchst (1920–1924), illustrated in Watkin 1986, fig. 667. Fritz Höger, Chilehaus, Hamburg (1923–1924), illustrated in Watkin 1986, fig. 675. Also exaggeratedly "Gothic," and the subject of much controversy, was Behrens' pavilion at the Munich craft exhibition of 1922, the "Dombauhütte."

86. For examples in addition to those discussed here, see Wolfgang Pehnt, *Expressionist Architecture* (New York, 1973), especially chaps. 9. and 11.

87. Franz Roeckle (b. 1879) worked in May's office on such housing developments as the Mavest Siedlung, the Gärtnersiedlung, and the Heimat Siedlung. See *Architectural Record* 68 (1930), 346.

88. Immo Boyken, "Fritz Högers Kirche am Hohenzollernplatz in Berlin – Architektur zwischen Expressionismus und 'Neuer Sachlichkeit'," *Architectura* 14 (1985), 179–198, offers a much more comprehensive discussion of Höger's work than the title suggests.

89. Fritz Schumacher, *Strömungen in deutscher Baukunst seit 1800* (Leipzig, 1936); and Fritz Schumacher, *Stufen des Lebens: Erinnerungen eines Baumeisters* (Stuttgart, 1949).

90. See, for example, the buildings illustrated in 29 (1928), 84, 627, 629, 707, 708, 712; and 31 (1930), 15, 280, 460, 680–681, 764, 877, 893.

91. Ulrich Thieme and Felix Becker, *Allgemeines Lexikon der bildenden Künste*, 37 vols. (Leipzig, 1907–1947), 17 (1924):196.

92. See especially Werner Hegemann, "'Mendelsohn and Hoetger ist' nicht 'fast ganz dasselbe'? Eine Betrachtung neudeutscher Baugesinnung," *Wasmuths Monatshefte* 12 (1928), 419–426. Hoetger's work was self-consciously "Nordic," although some of his opponents thought he was making fun of Germanic an-

tiquity: Hegemann 1928, 420–421. See also Dieter Golücke, *Bernhard Hoetger: Bildhauer, Maler, Baukünstler, Designer* (Dortmund, 1984).

93. See Lane 1985.

94. Some who stayed, however, continued to work and to have a significant influence. See Gerhard Fehl, "Die Moderne unterm Hakenkruez," in *Faschistische Architekturen*, ed. Hartmut Frank (Hamburg, 1985), 88–122; Hartmut Frank, "Monuments in Arbeitsstil: Paul Bonatz's Public Works," *Lotus International* 47 (1985), 71–91; and Werner Durth, *Deutsche Architekten: Biographische Verflechtungen 1900–1970* (Wiesbaden, 1986).

95. For a recent discussion of the difficulties of explaining Speer's buildings in the light of Nazi ideology, see Lane 1988.

96. Lane 1985, 198–199.

97. See the articles dating from the 1920s and 1930s in Alexander Funkenberg, ed., *Haus und Hof im nordischen Raum*, 2 vols. (Leipzig, 1937). A very interesting exception to the prevalence of wood and plaster was the hunting lodge in Rominten by Friedrich Hetzelt, who was also the architect of Goering's hunting lodge Carinhall, illustrated in Werner Rittich, *Architektur und Bauplastik der Gegenwart* (Berlin, 1938), 137–138.

98. On the architecture of the postwar period, see especially Jürgen Paul, "Kulturgeschichtliche Betrachtungen zu deutschen Nachkriegsarchitektur," in *Architektur in Deutschland*, ed. Helge and Margret Bofinger, Heinrich Klotz, and Jürgen Paul (Stuttgart, 1981), 11–22.

99. On reconstruction, restoration, and preservation, see especially Jürgen Paul, "Die Wiederaufbau der historischen Städte in Deutschland nach dem zweiten Weltkrieg," in *Die alte Stadt: Denkmal oder Lebensraum?*, ed. Cord Meckseper and Harald Siebenmorgen (Göttingen, 1985), 114–156; and Jeffry M. Diefendorf,

"Konstanty Gutschow and the Reconstruction of Hamburg," *Central European History* 18 (1985).

100. This situation has been changing during the last ten years. See, for example, *Die Zeit der Staufer: Geschichte-Kunst-Kultur* [exh. cat., Württembergisches Landesmuseum, Stuttgart], 5 vols. (Stuttgart, 1977); and especially the essay on castles by Hans-Martin Maurer ("Burgen," 3:119–128) and that on the imperial palaces of the Hohenstaufen by Fritz Arens ("Die staufischen Königspfalzen," 3:129–142). The groundwork for the further study of the imperial palaces in the postwar period began to be laid in the 1960s by the Max-Planck-Institut für Geschichte in Göttingen, the direct heir of the Kaiser-Wilhelm-Institut für Deutsche Geschichte. See, for example, *Veröffentlichungen des Max-Planck-Instituts für Geschichte* 11 (1) and 11 (2) (Göttingen, 1963, 1965); Arens 1977, 141; and Robert Gerwin, *MPG: Die Max-Planck-Gesellschaft und ihre Institute: Porträt einer Forschungsorganisation*, 3d ed. (Munich, 1983), 125. Also important in supporting renewed study of the art and architecture of the early Middle Ages has been the Zentralinstitut für Kunstgeschichte in Munich.

101. See, for example, Hempel 1949.

102. See Bofinger, Klotz, and Paul 1981; and Barbara Miller Lane, "The Berlin Congress Hall 1955–1957," *Perspectives in American History* new series 1 (1984), 130–185.

103. Frowein-Ziroff 1982, 333–340.

104. Born in 1920, Böhm worked first for his father from 1947 to 1955 and then opened his own office in Cologne. See especially Bofinger, Klotz, and Paul 1981, 48–55; Hannelore Schubert, "Stadtplanung in Bensberg," *Bauwelt* 64 (1973), 1595–1602; Hannelore Schubert, "Hôtel de Ville de Bocholt," *L'Architecture d'aujourdhui* 198 (September 1978), 84–85; Peter Davey, "Böhm," *The Architectural Review* 169 (1981), 351–355; Peter Davey, "Gottfried Böhm, Pritzker Laureate," *Progressive Architecture* 67 (1986), 23–25.

WANDA M. CORN
Stanford University

Identity, Modernism, and the American Artist after World War I:

Gerald Murphy and *Américanisme*

Nationalism has been a driving force in Western art ever since the early nineteenth century, when the ideology of nation-states began to shape cultural production. In America, just as in Europe, it was the romantic intellectuals and artists — Ralph Waldo Emerson and Nathaniel Hawthorne, William Sidney Mount and Thomas Cole — who first articulated a desire for expressions reflective of their national being. Ever since, nationalism has appeared under various guises in American art — in world's fairs, in revival styles, in the work of novelists such as Herman Melville and Henry James and of painters such as Winslow Homer and Robert Henri. Each manifestation provides a discrete body of material for study, as different generations of artists and writers reconstitute their self-images and redefine their aspirations and artistic purposes.

The various appearances of nationalism in the arts do not form an unbroken historical continuum, and there are moments when nationalist discourse is far more virulent and pervasive than at others. This is the case with the period I am studying, those years during and after World War I when a number of avant-garde artists began to construct their artistic production around notions of "Americanness." Not only did they speak of sinking one's roots, tilling the soil, or working in the American grain, but they also freely applied the word *American* to works of art that on the surface have nothing obviously national about them.[1]

Alfred Stieglitz would write in 1923, for instance, that Georgia O'Keeffe's color was "rooted in America" and that "she and [John] Marin are supremely American."[2] Similarly, when Charles Demuth wrote Stieglitz that he was sending him a new painting, *I Saw the Figure 5 in Gold*, he described it as "almost American," the word *American* seeming to be a kind of shorthand for a goal he hoped he had met.[3] Artists also attached the word *American* to their adoption of a new iconography — an iconography made up of barns, factories, skyscrapers, jazz musicians, and consumer products.

The avant-garde concern with identifying Americanness was not just a New York phenomenon, but a transatlantic fascination that animated modernists abroad as well as those in the United States. During the war, George Grosz turned his Berlin studio into a self-consciously styled American setting, displaying photographs of Thomas Edison and Henry Ford, and his own imaginary painting of the port of Manhattan. In one corner he erected an Indian tepee in which he and his friends sat on stools and smoked clay pipes. He and others in his circle were so fascinated with American manners that they took on American names, spoke in American slang, and dressed in American fashions.[4] Along with many of their French contemporaries, they also infused their art with what they assumed to be American characteristics. When Albert Gleizes, Francis Picabia, and Marcel Duchamp were in war-

time New York, for instance, they all set about making art they believed to be American in spirit. Duchamp's *Fountain*, made from an American urinal, was not just a dadaist stunt, as is commonly claimed, but something of a sermon to his friends in New York about how to escape the influence of Paris and create indigenous art about a country known worldwide for its originality in plumbing and engineering. Duchamp was intent on shocking the bourgeoisie, but he was equally concerned with demonstrating the possibility of a new, Americanized modern art. While Duchamp fashioned American-style works for New Yorkers, Louis Lozowick, a Russian-American working abroad, painted skyscrapers and factories for Europeans, and was delighted when the French and German press praised his art and "stressed its Americanism."[5]

The assumption of my larger study, from which this essay is drawn, is that all this has historical significance, that modern artists do not suddenly begin to paint New York skyscrapers, incorporate the American flag into their work, or claim their art as "American" without inscribing messages that the historian can recover with the proper tools. I also assume that the emergence of the United States as a new global power during World War I and the rampant prosperity of the postwar decade are central to the problem, since the appearance of this art and vocabulary can be dated with some precision to the war years and the decade of the 1920s.

It was during the war, we need to remember, that the United States indelibly impressed itself on the European consciousness as a powerful military force, having both the equipment and the manpower to help bring the Allies to victory. In the decade following the war, when Europe was rebuilding, Americans were busy learning and teaching others how to be modern consumers, as they manufactured, advertised, and retailed new material goods in ever widening international markets. If we were to make a list of what American businesses gave to everyday life in the postwar period, it would include assembly lines, cars, gas stations, and billboards; hot-dog stands, dime stores, and movie theaters; brand-name products, such as cigarettes, cosmetics, soft drinks, and safety razors; electrical appliances, including alarm clocks, lamps, and waffle irons; tabloid newspapers and national weekly magazines; popular entertainments, such as jazz and the tango, and a ready-made fashion industry for a mass clientele. Why, we must ask, was it in this climate — one of war followed by a decade of commercial expansion and runaway prosperity — that the country's most radical artists took up the issue of Americanness?

In pursuing possible answers to such a question, I have been working along two fronts. First, I have narrated and enframed what I take to be the most vital instances of a new national thrust in American modern art, among artists as diverse as Stieglitz, Joseph Stella, and Gerald Murphy. Second, I have attempted to situate their works of art and Americanized rhetoric within the sociocultural realities of the period, particularly within the development of a new, consumer-oriented, American mass culture.

Besides trying to locate and understand these appearances of cultural nationalism within a particular historical moment, I have three other aims in my work. The first is to impose some art-historical unity on a period within modernism that is generally described in parts rather than as a whole. The ruling tendency among art historians has been to discuss postwar American modernism according to style: Man Ray and Duchamp are dadaists; Arthur Dove and O'Keeffe are organic abstractionists; Charles Sheeler, Lozowick, and Demuth are precisionists. Such a taxonomy fragments the unity of the past and suggests that there were no shared values or overarching discourses. I seek to situate all of these artists, despite their stylistic differences, within a common modernist culture where searching for an American voice was a common and conscious drive.

My second aim is to historicize the *study* of nationalism in American art. For much of this century, critics and historians have been caught up by the question: What is American about American art? While that project has recently become unfashionable, my generation of scholars was trained to think it an essential one. We were convinced that we could detect national differences not only in subject matter but in

elements of style, as we puzzled over questions such as: What made an eighteenth-century colonial portrait look American and not British? What was indigenous about the spatial construction of a landscape of the Hudson River School that could not be found in a nineteenth-century European landscape? What accounted for the realism in American cubism while French cubism was so abstract?

I now realize that these questions were first posed in the period under study here. For it was the American modernists who first sought to translate identity — that is, an understanding of what makes up the national character of the United States — not just into subject matter or revival styles, but into the fabrication of an indigenous modern style. It was the generation of the 1910s and 1920s that, in its search for a national art, concluded that Americanness resided in form and not just in content.

Finally, a third aim of my fuller study, which brings me to the subject of this essay, is to push back the date that historians generally assign to New York's ascendancy as an art center. It is commonly understood that the immigration of artists to New York during the 1930s and the years of World War II was the impetus behind the rise of a New York school of painting, which rivaled that of Paris. But the rivalry between Paris and New York did not originate in the thirties and forties but rather in the teens and twenties when the French avant-garde, for the first time in its history, began to look enviously across the seas. We have not paid enough attention to the subtle ways in which the early twentieth-century Euro-American fascination with Americanness prompted a few artists to dare to dream of establishing a new national modern art — one separate from the school of Paris. The dream was cut short by the Depression, but while it lasted, it brought forth a number of masterful works of art and gave rise to New York's competitiveness with Paris. It also fostered an ambition to make New York into an art center, a vision that would eventually be fulfilled by artistic developments after World War II.

An American in Paris

One of the modern painters most closely associated with an Americanized iconography was Gerald Murphy, an American who lived and painted in France throughout the 1920s. Often pictured as the classic postwar expatriate, Murphy is best known for his friendships with writers of the so-called "lost generation": Ernest Hemingway, F. Scott Fitzgerald, and John Dos Passos. It was Murphy who inspired the character of Dick Diver in Fitzgerald's *Tender Is the Night*. Like his writer friends, Murphy had been educated in ivy league schools, taking his bachelor's degree from Yale and a master's degree in landscaping from Harvard. And like them, when he left America with his wife and three young children in 1921, it was to escape American provinciality and lead a more cosmopolitan life abroad. He not only sought a more glamorous existence but also wanted to put distance between himself and his father's business: the Mark Cross leather goods store on Fifth Avenue in New York. Something of an aesthete, and sharing an antipathy to commerce like many other intellectuals of his generation, Murphy did not want to be a businessman, and although he did not know what he wanted to do, he knew it would have something to do with modern arts and letters.

As Calvin Tomkins so beautifully describes in his classic little book, *Living Well Is the Best Revenge*, Murphy and his wife, both of whom had money, flair, and imagination, became superb party givers and hosts in artistic circles during the 1920s.[6] Thanks to this pioneering essay, originally a *New Yorker* magazine profile, the Murphys' parties in their self-designed, ultramodern apartment in Paris, their villa in Antibes, their beach, and even, on one occasion, a rented barge on the Seine, have become today part of our storehouse of romantic lore about Americans abroad during the jazz age.

But the life Murphy carved out for himself in France, while typical of the lost generation in its abandon and hedonism, gives the lie to what is generally said about the postwar expatriates — that they were the disillusioned young, alienated from their home culture, and embarrassed if not cynical about American provinciality. Unlike those expatriates who were openly antagonistic towards their home country, Murphy took special pleasure in playing the role

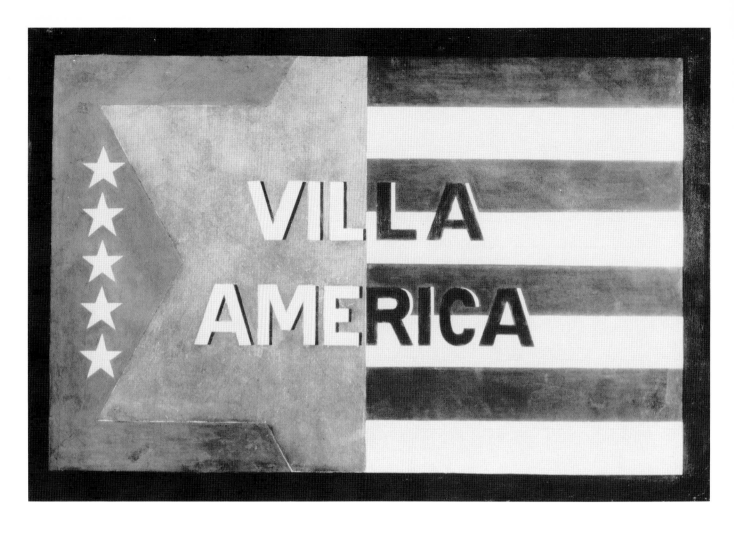

1. Gerald Murphy, *Villa America*, 1924, oil and gold leaf on canvas
Estate of the Artist, Salander-O'Reilly Galleries, New York

of the American abroad. Instead of trying to assimilate himself to European culture, as artists for generations had done (one thinks of Mary Cassatt or James McNeill Whistler), Murphy delighted in becoming a kind of exaggerated American. Indeed, in both his art and his life, he became more pronouncedly and joyously American when abroad than he could ever have been at home where no one would have noticed.

He named his home in Antibes Villa America. And when his guests arrived—a group that included at one time or another Pablo Picasso, Fernand Léger, Eric Satie, and Le Corbusier—they were greeted by a stylized American flag, which Murphy had designed and painted for the gateway to his home (fig. 1).[7] In summer, the menu at the Murphys' was apt to be tomatoes and corn, or if breakfast, waffles made on a grill imported from the United States. At the dinner hour, Murphy went through an elaborate ritual of making American-style cocktails, which were very popular among Europeans after the war. For entertainment, he played the latest records of American jazz and Broadway musicals. Occasionally, Murphy and his wife Sara would sing Negro spirituals or American folk music, and the children would dance the Charleston. "Although it took place in France," Murphy recalled later, "it was all somehow an American experience. We were none of us, professional expatriates, and Paris and the French seemed to relish this."[8]

The remarkable event during these years abroad is that Murphy, so very gifted in the social arts and without any need for income, briefly became a very fine painter. Although he had no formal training beyond the drafting courses he had taken as a student of landscape gardening at Harvard and had not frequented art events in New York, he fell in love with avant-garde painting when he

2. Gerald Murphy, *Watch*,
1925, oil on canvas
Dallas Museum of Art, Foundation for
the Arts Collection, Gift of the Artist

encountered it in Paris. He particularly admired the cubist paintings of Léger, Picasso, Georges Braque, and Juan Gris, and the fauvist color of Matisse. Taking a few months of classes with Natalia Goncharova, a Russian émigrée living in Paris, Murphy quickly learned the rudiments of modern painting. He soon began exhibiting painstakingly detailed canvases of machine-age imagery that were at home with those by artists associated with purism, the journal *L'Esprit nouveau*, and the Bernheim Jeune gallery, where he had a one-person exhibition in 1928 (fig. 2).[9] He continued to paint until the early 1930s, when financial reversals in the family business forced him to return stateside and take over the Mark Cross firm. With the additional stress of losing two of his three children to fatal illnesses, Murphy never picked up a brush again. Eight works by his hand survive today, out of what was a total oeuvre of some sixteen pieces.[10]

During his active years, Murphy had remarkable success for an artist who had never painted a canvas and who had only a few

months' training in modernist principles. Though he was in many respects an amateur, he had such an instinct for modern painting that even his first paintings were exhibited in avant-garde group shows alongside those by the very practiced hands of Robert Delaunay, Léger, and Le Corbusier, where he earned favorable comment in the French press and from his fellow artists.

What interests me here is the way in which French artists singled out Murphy's paintings for their quality of Americanness. Jacques Mauny, for instance, a young French painter who visited the United States in 1925, linked Murphy's work to what he had seen in New York of work by Preston Dickinson and Sheeler. In a 1926 article for *L'Art Vivant*, he raved about Murphy's paintings and credited him with pioneering a new American aesthetic.[11] Mauny had known Murphy's work for at least a couple of years by then, for he had made a portrait of the American that was shown in the 1924 Salon d'Automne (fig. 3).[12] But even artists who knew little about current American painting, such as Léger and Picasso, commented upon the "American" nature of Murphy's paintings. Picasso, Murphy proudly wrote home to a friend, had proclaimed one of his paintings "Amurikin — certainly not European."[13] And Léger was reported to have singled out Murphy from all the other expatriate artists abroad as the "only *American* painter in Paris."[14] Léger, Dos Passos remembered, would praise Murphy's paintings by calling them "très américain."[15]

Since both Picasso and Léger obviously intended to compliment Murphy by calling his painting American and not Fench, we must ask what the term *American* meant to them in the mid-1920s and wonder why such major French figures were so attracted to the work of a foreigner who was essentially a neophyte in the art of modern painting. Since neither of these well-established French masters had been to America (Picasso never came to this country, and Léger did not visit until 1931 and then as Murphy's guest), by what criteria did they judge Murphy's few paintings American, and why did it come so naturally to them to assign a national character to the works? In the same vein, we should also ask why Murphy took such pleasure in assuming an exag

gerated "Uncle Sam" persona in his dress and entertainments.

I will pursue these questions along two fronts. First, I will explore what the word *American* signified in Léger's and Picasso's circles in the mid-1920s, and second, I will read a Murphy painting against a similar one by Léger to see if we can detect what features must have seemed so non-French— so American—to the Parisian avant-garde in the 1920s.

Américanisme Abroad

Virtually every European center of avant-garde activity in these years engaged in some form of romance with America, one so pronounced that words were invented to describe it. The French spoke of *américanisme*, the Germans of *amerikanismus*, the Italians of *americanismo*, the Russians of *amerikanizm*. This love affair was a complicated one and varied somewhat from country to country, but it generally centered on the issue of modernity. I will discuss here only Parisian *américanisme* and those modernists, such as Picasso, Léger, and Le Corbusier, and the writers Blaise Cendrars, Philippe Soupault, and Jean Cocteau, who were so influential in Parisian circles when Murphy was there.[16]

To French observers in the early twentieth century, America's most singular characteristic was its ruthless modernity. They viewed the world across the Atlantic as so outrageously modern that it existed, as it were, on a different planet, one more aligned to the twenty-first century than to the nineteenth. As Léger once put it, using a common trope of the day, America was a country that "always acts and never looks behind."[17] This headlong rush towards the new, it was commonly understood, stemmed from the nation's youth and its lack of European refinements and humanistic traditions. Because the United States had no great past to honor that would hold it back, its citizens more easily explored and invented the new. Americans were presumed to be youthful in spirit, innocent of tradition, and considerably energetic and flexible in outlook. They were also pictured as rich, materialist, and pragmatic. Such characteristics, it was believed, led them to become

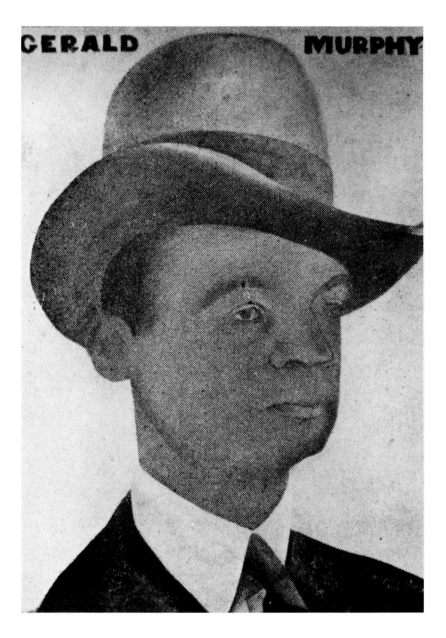

great film makers, architects, engineers, plumbers, and industrial designers. America's artists, the French agreed—with the notable exceptions of Whitman and Poe, whom they admired enormously—were but pale imitations of their own.

This view of a young, pragmatic, and ultramodern America was inevitably a comparative one. It was a we/they proposition, with the French always contrasting their own civilization and culture with the American variety. If they reduced the United States to a schema of technological prowess and machinery, giving no notice to the country's two centuries' worth of other ac-

3. Jacques Mauny, *Gerald Murphy*, 1924, medium and location unknown

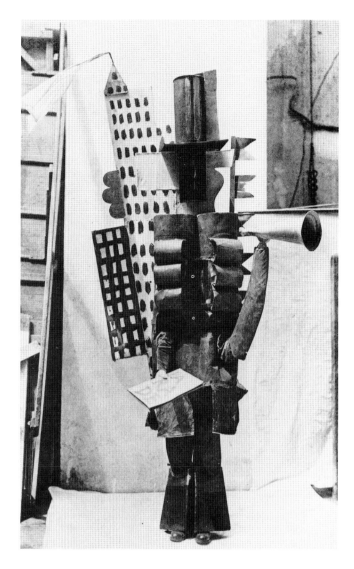

4. Pablo Picasso, *French Manager, Parade*, 1917

5. Pablo Picasso, *American Manager, Parade*, 1917

complishments, they were equally reductive in viewing their own culture as lacking modernity, as old, venerable, and tied to centuries of humanistic traditions. They compared their country's age and great classical traditions with American youth and newness.

Picasso's 1917 costumes for the cubist ballet, *Parade*, exemplified this kind of comparative stereotyping. The artist created two ten-foot-tall male barkers for the ballet, one French, the other American (figs. 4, 5). The French manager was elegant and urbane; he had a mustache and wore a top hat, white tie, and black tails. In his hands he carried symbols of his sophistication: a pipe in one and a walking stick in the other. The American manager, in comparison, was distinctly raw and unkempt. Giving him as many American references as his costume could bear, Picasso designed a Lincolnesque stovepipe hat for his head, cowboy chaps for his legs, a megaphone for one hand, and the cowcatcher of a train for his torso. While his French counterpart had the green trees of the Parisian boulevards rippling down his back, the American manager bore a stack of skyscrapers and flags.[18]

The creation of the two managers, as well as the appearance of "an American girl" later in the ballet, is but one of the many manifestations of the French avant-garde's dialogue with American culture around the years of World War I. One finds it also in the sudden appearance of American-made products in cubist still-lives — an ad for a

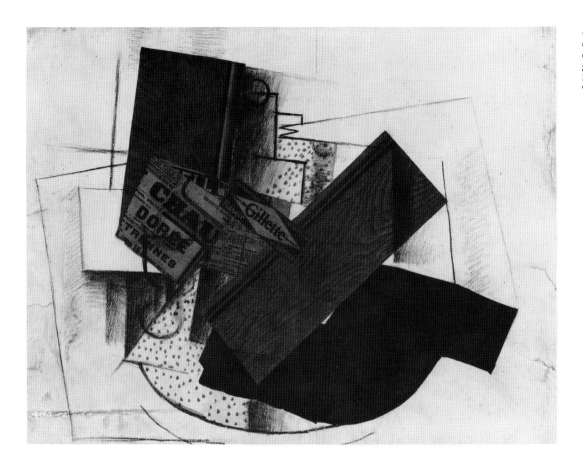

6. Georges Braque, *Still-Life on a Table: "Gillette,"* 1914, charcoal, pasted paper, and gouache
Musee National d'Art Moderne, Centre Georges Pompidou, Paris

Gillette safety razor, for instance, in a 1914 collage by Braque, and the image of a box of prepackaged Quaker Oats in a 1917 still-life by Gino Severini (figs. 6, 7). The Gillette safety razor was one of the most aggressively marketed American exports in the early part of the century; Quaker Oats was also marketed abroad and became such a popular foodstuff among the French literati that it was put on the menu at the Dôme, one of the most popular Montparnasse cafés.[19]

But probably the most serious evidence of the French avant-garde community's courting of New World culture was the fact that several of its members ventured to cross the Atlantic and live in New York City while the war was in progress. Given that members of the Parisian avant-garde rarely traveled far from home, and in wartime gravitated toward neutral European countries they could reach by train or ferry, it was an event of note that the French painters Duchamp, Picabia, and Albert Gleizes; the musician Edgard Varèse; and the writer and diplomat Henri-Pierre Roché all made the transatlantic journey to live in New York for much of the war.

What was a budding enthusiasm during the war became a more serious love affair during the period of reconstruction, when French artists were attracted to American culture as never before. While their counterparts in business looked to the ideas of American industrialists and efficiency experts, such as Henry Ford and Frederick Winslow Taylor, for ways to modernize French factories and manufacture, French avant-gardists, particularly those in cubist circles, looked to the New World for ways to bring their architecture, art, and letters into line with what they deemed to be the dominant aesthetic of their age, that of the machine. They took little interest in American modern painting and sculpture but turned rather to what they considered the fresh and innovative arts of the engineer, black musician, and film maker. They admired American engineering feats, such as the skyscraper, and American popular cul-

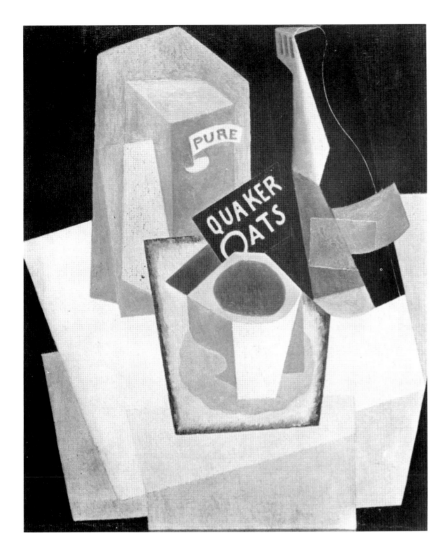

7. Gino Severini, *Nature
Morte, Quaker Oats*, 1917,
oil on canvas
Collection of Mr. and Mrs. Eric
Estorick
Photograph: Christopher Green

of Charlie Chaplin looking like a mechanical man. Using Murphy's Paris studio as a workshop, he also collaborated with the American musician George Antheil to make the film *Ballet mécanique*, for which Antheil provided "mechanistic" music hailed for its New World sound achieved through the use of wind machines, sirens, airplane propellers, and doorbells.[22]

For the French intellectuals and artists in surrealist circles, particularly those around Cocteau and Soupault, American mass culture was the primary attraction. Wanting to free their imaginations from the fetters of Old World traditions, they looked longingly across the sea, much as Gauguin had viewed Tahiti, and saw a land of freedom and youth where the natives were so unsophisticated as to be modern-day primitives. This group idolized Charlie Chaplin for his innocence and freshness of approach, as well as American blacks, whose innovations in music and dance they attributed both to their African tribal origins and the American disregard for proprieties. These intellectuals and artists collected records of American jazz and Negro spirituals, along with American comic books and Nick Carter detective stories, all of which to their eyes were new forms of "primitive" art. One of their number became so pro-American that he began to walk at a faster pace, self-consciously affecting what he called the "American tempo."[23] Another drank Coca-Cola for breakfast, declaring the traditional *café au lait* "old-fashioned and chauvinist."[24]

By the late 1920s, the influence of popular culture was so great in France that intellectual debates began to be conducted on whether the Americanization of France was or was not destroying French civilization. By no means was everyone as sanguine about America as were most avant-garde artists. Indeed, many felt that the influx of American goods and mass culture into Paris was a disaster, that Americans were barbarians, and that the presence of American culture in Paris was, as the playwright Luigi Pirandello put it, "as jarring as the make-up on the face of an aging *femme du monde*."[25] Worried about the loss of their own national culture and of the "French" way of doing things, many intellectuals called out in alarm, reminding their readers of France's

ture, particularly film, jazz, and comic books. "America has taught us to love whatever is young, and new," said one young Frenchman. "Its influence is incontestable" and makes unbearable "the little towns, the secular habits, slowness, and all this old dust that stifles our Europe."[20]

The presence of postwar *américanisme* in avant-garde circles was pervasive. In the pages of *L'Esprit Nouveau*, for instance, Le Corbusier wrote of the skyscraper and the American grain elevator and extolled the virtues of the American engineer.[21] In 1922, Darius Milhaud sailed to New York to experience the city firsthand so he could incorporate jazz rhythms and syncopations into a new French music. And in the 1920s Léger, who would make the first of several trips to America in 1931, made a relief sculpture

great humanistic traditions and centuries of classical culture. Their debates, however, focused less on the modern artist's romance with America than on the more visible signs of American influence in everyday life: the French industrialists who emulated the American factory system and adapted Frederick Winslow Taylor's ideas about assembly-line efficiency; the urban planners who wanted to bring the American skyscraper to the French city; and the French public's increasing consumption of American brand-name products, such as Quaker Oats cereal, Parker pens, and Gillette safety razors. There was also concern over an increased American presence in popular entertainment, particularly in French night life. Before the war a few American entertainments like the circus or the Buffalo Bill Wild West show had introduced the continent to a bit of Americana that pleased everyone, but the flood of new imports — movies, jazz, American bars, Josephine Baker, and the Charleston — elicited controversy. To many the new forms seemed reckless, amoral, and threatening to French order and civility.[26]

It was precisely at the height of this French discourse about American culture that Gerald Murphy flourished as a host and a painter. Partly by design and partly by circumstance, Murphy fulfilled many of the French stereotypes of the quintessential American: he was rich, stylish, and extremely modern; his manner was joyous and youthful; and he threw what seemed to be American-style parties, complete with jazz, spirituals, and cocktails. Indeed, the glamor and social success of Murphy's life in the 1920s stemmed from his ability to dramatize precisely what the French had come to believe were exotic American traits. One can say the same for the reception of Murphy's art. From the perspective of French artists in the throes of a transatlantic love affair, Murphy's paintings exemplified and reinforced the reigning stereotypes of American culture.

Transatlantic Chic

Let us then look at Murphy's work as Picasso and Léger might have perceived it in the 1920s, viewing it through the lens of *américanisme*. First, Picasso and Léger would have associated the subjects of Murphy's paintings closely with America, for unlike Léger and Picasso in the postwar period, Murphy never painted the figure, the landscape, or the café still-life. Instead he painted machinery, works of civil engineering, consumer products, and imagery reminiscent of modern advertisements.[27] His painting *Watch* depicted the mechanical workings of a pocket watch, while *Cocktail* was an elegant orchestration of the accouterments of the American cocktail tray. *Library* included a globe prominently displaying North and South America, while in *Portrait* Murphy blew up an eye, a footprint, a pair of lips, and fingerprints as if they were billboard imagery.

But it was not just subject matter that Picasso and Léger would have had in mind when they called Murphy an American painter. The Parisian's lexicon of American traits included youthfulness, innocence, and mechanical ingenuity, and stereotyped Americans as excelling in fields such as engineering and advertising. In this context, the style of Murphy's work appeared very un-French and typically American. He painted on the scale of billboards; his work was blunt and brash in color; his surfaces were machinelike in finish; his draftsmanship reminded one of blueprints or architectural drawings; and there was often about his work a Chaplinesque air of wit and innocence.

If we consider installation photographs of Murphy's paintings hanging among those of his peers, we can begin to bring these qualities into focus. In one photograph, that of Murphy's lost painting *Boat Deck*, the eighteen-foot-high painting of ocean liner ventilators and funnels is shown hanging in the American room of the 1924 Salon des Indépendants at the Grand Palais (fig. 8).[28] Murphy's painting is so large, stark, and forceful that it makes the paintings hanging on either side appear fussy and overworked by comparison. With its minimal frame (a steel casing, according to a newspaper report), its large, readable forms, its flatly painted surface, and its simple color scheme (gray, white, black, and red, the artist recalled), the painting looked like a gigantic poster or billboard next to a group of intricately broken, cubist easel paintings.[29] And in its ruler-sharp contours and smooth sur-

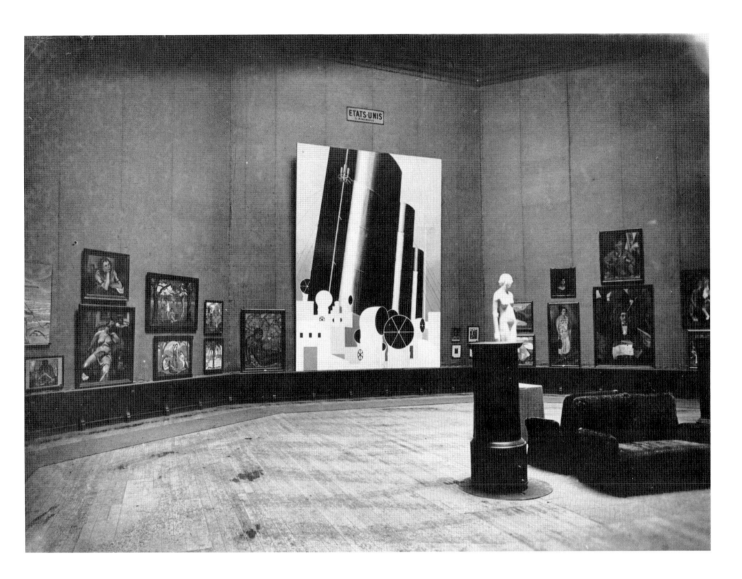

8. Gerald Murphy's *Boat Deck*, 1923 (location unknown), hanging in the 1924 Salon des Indépendants at the Grand Palais
Photograph: Christian Derouet

faces, it appeared printed rather than painted, shaped by precision tools rather than a paintbrush. Indeed, *Boat Deck* was so schematic that one of the French jurors did not want to hang it, because it struck him as being no more than an "architectural drawing."[30]

It was the same brazen independence from the prevailing styles of French cubism that made Murphy's *Razor* stand out from its French neighbors in the exhibition L'Art d'Aujourd'hui in 1925 (figs. 9, 10). *Razor* had a plainness and simplicity that contrasted dramatically with the pictorial intricacies and intellectual savvy of the cubist and purist canvases by Delaunay, Le Corbusier, and Patrick Henry Bruce that hung nearby. *Razor* was not a huge painting like *Boat Deck*; the painting's outside dimen-

sions were no larger than those of the one hanging next to it. But the scale of the still-life objects *within* the painting was enormous: a nearly three-foot-long fountain pen; a two-foot-long safety razor, and an equally overscaled box of safety matches.

It helps at this point to recall that Murphy had been raised in the retail business, where he would have handled promotional displays for windows and counter tops, and would have encountered advertising copy that routinely exaggerated the scale of commercial objects. His father's business also trained him to recognize style, quality, and the specific characteristics of individual brand names in household and travel goods. After graduation from Yale, he had even been involved in product design when he had worked on patenting a safety razor for

9. Gerald Murphy's *Razor*, hanging in the 1925 L'Art d'Aujourd'hui exhibition

Mark Cross before Gillette had captured the market.[31] Such training may have contributed to two features of *Razor* that would have been strikingly new in Parisian art at the time and that we tend to take too much for granted, given our experience with pop art in the last two decades. The first is the artist's careful depiction of the distinctive styling features of brand-name products — in Murphy's case, the Parker Duofold pen, the Gillette safety razor, and the box of Three Stars safety matches. The second is his blatant appropriation of the advertiser's visual vocabulary. To any sensitive observer, *Razor* looked very much like an advertisement. Or, to be more accurate, it looked as if the artist had married features of the loud and braggadocio style of the contemporary billboard to the most elementary of cubist structures.

Murphy's three objects in *Razor* were as immediately recognizable to his audience as Andy Warhol's Campbell soup cans were to a later generation in the 1960s. But while Campbell soup cans had been in the American home for many years before Warhol painted them, Murphy's objects were all

new to the market. They were among the startling new consumer products that flourished in the postwar period, offering time-saving convenience in streamlined, industrial-looking designs and packaging. Many of these products were closely identified in the European mind with the American way of life, a way of life associated with speed and efficiency, hygiene, comfort, and luxury goods.

In avant-garde circles, such products were admired for their clean and functional designs as well as for what in the postwar period was considered their "modernity" of purpose. These were goods that did jobs faster and more efficiently than their old-fashioned counterparts. Like the airplane and the Eiffel Tower, they were contemporary. To write with a fountain pen, type a letter, or shave oneself with a safety razor marked one as progressive. The user became "modern," someone who eschewed the past and aligned him or herself with the present. Le Corbusier, for example, considered that particular objects were indigenous to "our epoch"; they included "its fountain pen, its eversharp pencil, its typewriter, its tele-

10. Gerald Murphy, *Razor*,
1924, oil on canvas
Dallas Museum of Art, Foundation for
the Arts Collection, Gift of the Artist

phone, its admirable office furniture . . . the safety razor and the briar pipe, the bowler hat and the limousine, the steamship and the airplane."[32] Such objects also began to make frequent appearances in postwar works of art: pipes and bowler hats in Léger's paintings, for example, and pens, typewriters, rubber tires, cars, and airplanes in collages by artists as distant from Paris as Alexander Rodtchenko in Russia. In poetry, one finds the Parisian poet Soupault, in "Les Mains jointes," describing himself writing

a poem at night by candlelight "avec un stylographe Watermann [*sic*]."[33]

Murphy shared with his contemporaries an admiration for these new kinds of objects which, as he once put it, had "weight and construction" even though they were "no bigger than a man's hand." They suggested, he said, a new kind of "Nature Morte" (still-life), one of "heroic scale" and "American made."[34] So he enlarged each object and carefully mapped out those distinctive styling features that would identify each one

as of American manufacture. The box of safety matches shouts out its name – English words, not French ones – and displays its trademark of three six-pointed stars ensconced in a white oval (fig. 11).[35] The fountain pen, with its bright red surface and its gold clip and cap band, was unmistakably the fashionable, expensive, and very popular Duofold model from the Parker Pen Company. In previous years, Parker pens had been black, but in the early 1920s the company issued its Duofold model, an oversized pen (holding more ink than conventional sizes) with a vivid orange-red barrel, which advertisements claimed "rivals the beauty of the Scarlet Tanager" and is as "beautiful as Chinese Lacquer."[36] At seven dollars – a good day's pay for an American factory worker – "The Big Red" cost twice as much as other pens, but it was so stylish and functional and was marketed so effectively that it "vaulted" Parker Pen, as one pen historian put it, "into a place of international renown."[37] (Today, vintage Duofolds from the 1920s are valuable collector's items, and Parker Pen Company has reissued "The Big Red" in both expensive and cheap, mass-market replicas.)

Of the three products in the painting, the razor was the one most familiar in France. The American King Gillette had been manufacturing razors and disposable blades since the beginning of the century, and through an aggressive marketing and distribution policy, had managed by the 1920s to outstrip his competitors in the industry and dominate the international market. Gillette stores had cropped up all over the world, and advertisements vaunting the advantages of the throw-away blade and the speed with which one could shave, and promoting the stylish packaging of the razors, appeared in magazines everywhere (figs. 12, 13). (Like fountain pens, razors were sold in velvet-lined boxes that set them off like jewelry.) Murphy obviously knew the product well. Just as in the Gillette advertisements, Murphy drew his razor so that one could see its full length and the product's hallmark features: the toothed head, the blade with rounded edges, and the grip markings on the stem and turn-knob at the end of the handle.

The comparison between *Razor* and an

advertisement speaks to the second feature of Murphy's paintings that would have startled his public – the degree to which the painting looked like an advertisement or, given what Murphy called its "heroic scale," even a billboard. Exaggerating the scale of objects was a familiar advertising habit of the day, not just on billboards but also in magazines. It was common to find gigantic fountain pens lording it over skyscrapers and monstrous razors looming over the face being shaved (fig. 14).

We can appreciate how literally Murphy borrowed from the language of advertising by comparing *Razor* with *Le Syphon*, a painting made in the same year by Léger and based on a specific magazine advertisement (figs. 15, 16). Although Léger and Murphy shared an enthusiasm for the well-designed modern advertisement, they appropriated their lowbrow sources very differently. Indeed, we find in these differences another clue as to why Murphy looked so "American" to Parisian artists' eyes. For unlike Murphy, who painted the pen and razor so that they looked like the same kinds of objects seen in advertisements, Léger disguised the fact that his design was drawn from a magazine source. All that remains of the Campari ad behind *Le Syphon* is the general lines of the composition: a waiter's hand coming in from the right and pressing down on the spigot of a siphon bottle to fill a glass. Fluted and ordinary in its proportions, the glass has lost its Campari trade-

hind them. But the dynamic of the picture
is also dependent upon the cubist interplay
between the two strata. The table edges, the
rim of the glass, and the spoon all touch
and intersect the grid work behind them.
Parts of the foreground function as back-
ground, and details from behind push through
to the front plane.

Although he was something of a student
of Léger's, Murphy built his pictures dif-
ferently. He composed *Razor* using the same
two layers as Léger did—a still-life in the
foreground against abstract blocks of color—
but he barely knit the two layers together.
The blocks of background color maintain
their subsidiary role as backdrop for the ob-
jects. While there are one or two passages
in Murphy's painting where elements in the
background push through to the fore-
ground, the cubist push and pull is elemen-
tary. In Murphy's painting, the cubist struc-
ture of the picture never violates or interferes
with the integrity of the objects.

What distinguished *Razor* from *Le Sy-
phon*, then, was Murphy's insistence on re-
taining the specificity of his three still-life

12. Shop window, Gillette
in France, 1920

13. Gillette billboard,
San Francisco, 1920

14. Parker Duofold Pen
advertisement, 1926

mark, leading the unknowing viewer to
presume that this painting is yet one more
variation on the cubist café still-life.[38]

Furthermore, while the hand, bottle, and
glass are rendered in the advertisement as
separate and individual entities, in the
painting they are knit into a complex cubist
structure. As was typical of Léger at this
time, he composed the canvas of two struc-
tural layers, a literal one of rounded still-
life elements in the foreground and an
abstract one of flat planes of color in the
background. This followed his "law of con-
trasts" and his desire for a vivid pictorial
clash between volumes and planes, in this
case, the contrast between the still-life ele-
ments and the flat "wall" and moldings be-

15. Fernand Léger, *Le Syphon*, 1924, oil on canvas
Albright-Knox Art Gallery, Buffalo, Gift of Mr. and Mrs. Gordon Bunshaft, 1977

elements and their brand-name features. Like an advertiser, Murphy let the products speak. Léger, on the other hand, divested his ob- jects of their particularity and of their low- brow advertising origins by privileging pic- torial structure over the objects' material

being. Léger abstracted and departicularized what he took from the streets, while Murphy spoke bluntly in the ad man's vernacular.

To some degree, this bluntness can be attributed to Murphy's inexperience as a painter. Not a practiced artist, he painted, it is clear, without Léger's erudition. His work looks primitive or "naïf," as William Rubin has called it, when put up against the French moderns.[39] Yet one must also take into account the fact that Murphy had little desire to look like a French painter. From the evidence of his paintings and the ideas

that he jotted down in his notebook, it is clear that he envisioned himself as an American painter of the modern age who had no aspiration to paint, as the French did, cubist paintings of nudes, country landscapes, or café still-lifes. If Murphy was an innocent, it was partly because he chose to go his own way. He admired the French painters, he said late in life, but had "no desire to paint like Matisse, Picasso, or Léger, or the others."[40]

Indeed, an appropriate comparison to Murphy in many ways is not a French artist but rather an American writer of the 1920s who used themes of advertising and mass-produced products in his work and, in the case of Matthew Josephson and e.e. cummings, deliberately reworked the ad man's slogans and hyperbolic rhetoric into poetry. *Razor* is at home next to Sinclair Lewis' novel *Babbitt*, whose protagonist loves to brag of his new-fangled domestic gadgetry; or F. Scott Fitzgerald's *Great Gatsby*, in which the giant eyes of Doctor T. J. Eckleburg on a roadside billboard function as a metaphor for the tawdry god of modern materialism; or e.e. cummings' ironic use of advertising hype in "Poem, or Beauty Hurts Mr. Vinal." Like these intellectuals, Murphy perceived materialism as a dominant force in his time, one that was modern, problematic, and very American. In his notebook, he once wrote of Americans as "the race of romantic materialists" and conceived of a painting in which a "colossal scale" house and objects dwarf people. This painting, he wrote, would point up "man's good-natured tussle with the giant material world: or man's unconscious slavery to his material possessions."[41]

But whatever critique Murphy might have intended in *Razor*, he delivered it with an exceedingly light touch. Unlike his friend Fitzgerald, whose melancholy and despair about modern life pervades *The Great Gatsby*, Murphy's comment on American-style consumer culture seems humorous: oversized consumer goods in an art gallery. But in such humor there was a good degree of ambivalence. When Murphy blew up the razor and pen to "heroic scale," for example, and granted these everyday belongings status as art objects, he left his viewers ambivalent about an age in which prod-

ucts—not ideals or heroes—were the best modernity could offer. Similarly, he does not give us clear signals about how to interpret the heraldic structure of the painting that confers upon the objects such dignity and importance. Murphy grants to his composition all the pomp and circumstance of a coat of arms or a military insignia, yet the emblazoned heraldry does not belong to a noble family or a great general, but to common goods. The insignia is for the new age of mass consumerism. And in crossing the pen and razor in front of the box of safety matches and thereby restating the familiar skull-and-crossbones motif, Murphy created another powerful set of ironic references. As with the traditional skull, the white oval of the Three Stars Safety Matches stares out at us like a single unblinking eye. The painting is a tongue-in-cheek *memento mori*, reminding us of the vanity of worldly goods.[42]

As an arch-consumer of stylish goods himself, and an upper-class man of wealth and fashion, Murphy seems to have been incapable of the more biting and profound criticism of consumer society that one finds in the work of his friends, Dos Passos and Fitzgerald. But his levity and wit, I believe, was another aspect of his work that endeared him to Léger and Picasso. Not only did Murphy paint American goods on an oversized American scale, treading a thin line between advertisement and art, he also painted them with a humor and innocence that the French stereotypically presumed Americans to possess. Indeed, to Léger and Picasso, Murphy must have looked like a kind of machine-age Henri Rousseau or, to use the felicitous phrase of an American critic of the period, a "skyscraper primitive."[43] Because he was without solid foundation in the French traditions of *la belle peinture* and because he painted with such gaiety and bluntness, he would have appeared to the eyes of the French avant-garde as having the same unlearned freshness as Walt Whitman or Charlie Chaplin, two of their American idols at the time. Dos Passos summed it up well. "Americans were rather in style in Europe in the twenties," he wrote. "Dollars, skyscrapers, jazz and everything transatlantic had a romantic air. Gerald's painting when it was shown in Paris seemed the epitome of the transatlantic chic."[44]

The Beginnings of a Transatlantic Discourse

Having now identified what I think Picasso and Léger meant when they spoke of Murphy's Americanness, I suggest that what we have been considering constituted the beginning of a new transatlantic discourse between France and America. This discourse began during World War I, flourished in the 1920s, and faded during the Depression years, only to be revived again by World War II. It was one in which the French avant-garde became manifestly curious about contemporary American culture, even desirous of imitating it. Its roots were in a war during which the government of France looked to the United States for the first time for new technology and manpower, while at the same time French artists looked to American culture as a civilization that could give them what they felt they could not find at home: youth, vitality, and renewal. French artists expressed their needs through their courtship of modern American culture, the most extreme version of which was the effort a few artists made to cross the sea and visit the faraway land. For decades of Franco-American exchange before the twentieth century, American artists had made pilgrimages to Paris, but their visits were not reciprocated. French artists took little interest in traveling to New York. Beginning in World War I and continuing up through World War II, traffic between New York and Paris began to go both ways.

There is something epochal, I believe, or paradigmatic about this moment when French modernists began to look to America for inspiration. Indeed, *américanisme* announced the beginning of new cultural alignments between France and the United States. When the significant shapers of culture in Paris acknowledged that there was culture of significance in the New World, this was an admission of great import. America, France seemed to be saying, could now be a player in cultural affairs. Such an admission was intimately tied to postwar morale. At some deep level, the French love affair with the United States played out the

nation's anxiety about the decline of its once-grand civilization and expressed both a loss of faith in the culture's ability to revive itself and the desire to be reborn once again. The question was often asked during and after World War I, whether France had collapsed as the cultural capital of the Western world. Was the war the death of one great civilization and the birth of a new one? In Soupault's mind in the late 1920s, the answer to both was clearly yes. While the French poet found it painful to consider, the influences of America in France, Soupault wrote, "make us stop and think, and realize that we are no longer the center of the world."[45]

But if *américanisme* was for French artists an expression of new cultural insecurities, it was for their American counterparts a terrific boost to their confidence. For decades, American artists had assumed they were impoverished provincials and had acknowledged French superiority in all the arts. Having so long been embarrassed by their limitations and having always looked to France for cultural leadership, they wel-

comed the news from Paris that told them they were now glamorous and in style.

Their new self-confidence also depended upon the aftermath of a war that gave Americans a giddy sense of new power, prosperity, pride, and potential. Before the war no American artist had the audacity to crow as Murphy did about the material aspects of American life. But after the war, from which the United States emerged physically intact with a war-induced boom economy, there was an accompanying new spirit in American arts and letters that encouraged Americans to override their sense of inferiority, to put Paris aside, and to speak in their own tongue, even if that language was one of machines, commerce, and products. Murphy contributed buoyantly to this effort. When in 1923 the artist designed the sets for a ballet commissioned by the Ballets Suédois in Paris, he invented a curtain that spoke directly to the new state of affairs (fig. 17).[46] Blowing up a mock front page of an American tabloid with its sensationalist hype, screaming headlines, and exaggerated news stories, Murphy bluntly replicated a

one-hundred-percent American artifact. There were no concessions to those in the audience who might not know English. This was a piece of modern Americana for an audience Murphy knew to be fascinated by, even envious of, New World culture.

There is much tongue-in-cheek wit here, but in its overall presentation, the curtain announced forcefully that the United States had developed a culture of its own. In its main headline, "Unknown Banker Buys the Atlantic," Murphy played upon the popular European stereotype of the American whose wealth knows no bounds. But beneath the obvious humor, there was a historical reality. The United States was now a powerful presence in Europe; Paris could no longer claim to dominate world culture as it once had. In all his stylishness and wit, Murphy brilliantly intuited the changed world he inhabited.

NOTES

I want to thank the American Council of Learned Societies for funding a summer of research in Paris, and the National Museum of American Art, Smithsonian Institution, for the Regents fellowship that supported the year of work in which I wrote this essay. I am also grateful to Honoria Murphy Donnelly for granting me access to her father's papers and for answering my many queries, and to Michelle Meyers for her research assistance in preparing this article for publication.

1. For example, writers such as Van Wyck Brooks, Paul Rosenfeld, Waldo Frank, and William Carlos Williams, among others.

2. Alfred Stieglitz, letter of 24 August 1923 to Sheldon Cheney, Stieglitz Collection, Collection of American Literature, Beinecke Rare Book and Manuscript Division, Yale University, New Haven.

3. Charles Demuth, letter of 12 December 1929 to Alfred Stieglitz, Stieglitz Collection, Collection of American Literature, Beinecke Rare Book and Man- Division, Yale University, New Haven.

4. See, for example, Beth Irwin Lewis, *George Grosz: Art and Politics in the Weimar Republic* (Madison, Wis., 1971), 25–30.

5. Louis Lozowick, "Survivor from a Dead Age." chap. 10, p. 18, typescript, Archives of American Art, Smithsonian Institution. I thank Barbara Zabel for help in locating this document.

6. Calvin Tomkins, *Living Well Is the Best Revenge* (New York, 1971). See also Honoria Murphy Donnelly (with Richard N. Billings), *Sara and Gerald* (New York, 1982). I have depended upon these two books for biographical data.

7. The painting *Villa America* has just recently come to light. For the story of its discovery, and an analysis of it, see William M. Donnelly, "On Finding a Gerald Murphy," *Arts* 59 (May 1985), 78–80; and William C. Agee, "Gerald Murphy, Painter: Recent Discoveries, New Observations," *Arts* 59 (May 1985), 81–89.

8. As told to Calvin Tomkins in 1962 and quoted in William Rubin, *The Paintings of Gerald Murphy* (New York, 1974), 9.

9. Agee 1985, 82, identified 1928 as the year of Murphy's exhibition at the Bernheim Jeune gallery.

10. Rick Stewart, *An American Painter in Paris: Gerald Murphy* (Dallas, 1986), published all eight works in color. See also William Rubin's fine study, Rubin 1974.

11. Jacques Mauny, "New-York 1926," *L'Art Vivant* 2 (15 January 1926), 53–58.

12. Reproduced in *Bulletin de la vie artistique* 22 (15 November 1924), 498. The location of the portrait today is unknown. My thanks to Christian Derouet who sent me his essay "*Vue de New York* par Jacques Mauny," *Revue du Louvre* 4 (1987), 298, in which he reproduces Mauny's lost portrait of Murphy.

13. Gerald Murphy, undated letter to Philip Barry. My thanks to Mrs. Philip Barry for sharing the letter with me.

14. Tomkins 1971, 30.

15. John Dos Passos, *The Best Times: An Informal Memoir* (London, 1966), 146.

16. The roots of *américanisme* go back to the nineteenth century when European commentators first began to express admiration for American youthfulness, technology, and architecture. These interests increased during World War I when Europeans had more contact with Americans abroad and with American products, films, and jazz groups.

17. Fernand Léger, "New York," *Cahiers d'Art* (1931), trans. and rpt. in Edward F. Fry, ed., *Functions of Painting by Fernand Léger* (New York, 1973), 90.

18. For the fullest analysis of the ballet and its sources, see Richard H. Axsom, "*Parade*": Cubism as Theatre (New York, 1979).

19. Elizabeth Hutton Turner, "The American Artistic Migration to Paris Between the Great War and the Great Depression," Ph.D. dissertation, University of Virginia, 1985, 208.

20. Marcel Brion, quoted in "Inquiry among European Writers into the Spirit of America," *Transition* 13 (Summer 1928), 252.

21. For an excellent discussion of Le Corbusier's and other European architects' romance with American skyscrapers and grain elevators, see Reyner Banham, *A Concrete Atlantis* (Cambridge, Mass., 1986).

22. Linda Whitesitt, *The Life and Music of George Antheil, 1900–1959* (Ann Arbor, Mich., 1983), 21–41.

23. Matthew Josephson, talking about Philippe Soupault, in *Life among the Surrealists* (New York, 1962), 123.

24. Janet Flanner speaks of Pierre de Massot's addiction to Coca-Cola in her introduction to *Paris Was Yesterday 1925–1939* (New York, n.d.), xiv.

25. From a Pirandello interview, quoted in Antonio Gramsci's essay, "Americanismo e Fordismo," *L'Italia letteraria* 14 (April 1929). For an English translation of Gramsci's essay, see Quinton Hoare and Geoffrey Nowell Smith, eds. and trans., *Prison Notebooks of Antonio Gramsci* (London, 1971), 316.

26. See, for example, "Inquiry among European Writers."

27. In two instances, Murphy used themes of nature: *Doves* (1925) and *Wasp and Pear* (1927).

28. For this photograph, I thank Christian Derouet who published it in *Fernand Léger: La Poésie de l'objet, 1928–1934* [exh. cat., Centre Georges Pompidou, Musée National d'Art Moderne, Paris, 13 May–13 July 1981] (Paris, 1981), 9.

29. "American's Eighteen-Foot Picture Nearly Splits Independent Artists," *New York Herald*, Paris Edition (8 February 1924), 1.

30. Tomkins 1971, 30.

31. In a letter to Philip Platt, Paul Rosenfeld reports that their Yale classmates, "Gerald Murfey [*sic*] and Don Hyde have invented a safety razor which they call the 'Cross' razor." Paul Rosenfeld, letter dated 26 February 1913 to Philip Platt, Stieglitz Collection, Collection of American Literature, Beinecke Rare Book and Manuscript Division, Yale University, New Haven.

32. Le Corbusier, *Towards a New Architecture*, trans. Frederick Etchells (London, 1963; orig. ed. 1927), 89.

33. Philippe Soupault, *Poésies complètes, 1917–1927* (Paris, 1937), 78.

34. Quoted in Douglas MacAgy, "Gerald Murphy, 'New Realist' of the Twenties," *Art in America* 51 (April 1963), 55.

35. Murphy took liberties with the label, simplifying its overall design and giving each star a slightly different pattern. He also eliminated the words identifying the parent company as Swedish, leaving his public with the impression that, like the pen and razor, the matches were an American product. Three Stars Matches was, in fact, a Swedish label, but manufactured at various times in Britain and America. Today Three Stars Matches continue to be manufactured in Jönköping, Sweden (Swedish Match, pers. comm., 1988–1989).

36. For information on Parker Pen history, I thank my Stanford colleague Jody Maxmin for directing me to Glen Bowen, *Collectible Fountain Pens* (Gas City, Ind., 1986). See also Cliff Lawrence, *Fountain Pens* (Dunedin, Fla., 1985); and Cliff Lawrence, "Parker Duofold, Part Two," *The Pen Fancier's Newsletter* 4 (April 1981), 12–19.

37. Bowen 1986, 13.

38. Christopher Green in *Léger and the Avant-Garde* (New Haven, 1976), 272–273, identified and published the November 1924 Campari advertisement from *Le Matin* that Léger used as a source for *Le Syphon*. I am grateful to him for loaning me a photograph of the Campari advertisement for this essay.

39. Rubin 1974, 17.

40. MacAgy 1963, 52.

41. I am grateful to Honoria Murphy Donnelly for allowing me to study her father's notebook in which this idea for a painting appears.

42. Murphy loved giant eyes. He designed a flag for his custom-made schooner, *Weatherbird*, with a schematic eye that appeared to blink as it flapped in the wind, and in 1928 he included a large human eye in his painting, *Portrait*.

43. Gorham Munson, "The Skyscraper Primitives," *The Guardian* 1 (March 1925), 164–178.

44. Dos Passos 1966, 153.

45. Philippe Soupault, *The American Influence in France*, Chapbook 38, trans. Babette and Glenn Hughes (Seattle, 1930), 22.

46. The ballet, *Within the Quota*, was commissioned by Rolf de Maré of the Ballets Suédois in Paris. Murphy wrote the scenario and designed the costumes and curtains. His friend Cole Porter wrote the music.

Contributors

Wanda M. Corn's teaching and scholarship have centered on late-nineteenth- and early-twentieth-century American painting and photography. Since 1980 she has taught at Stanford University, where she will assume the Anthony Meier Family Chair and directorship of the Stanford Humanities Center next year. Her books include one defining the turn-of-the-century style of tonalism in American painting and photography, one on Andrew Wyeth, and *Grant Wood: The Regionalist Vision* (1983), which accompanied her nationally touring exhibition of Wood's work. In 1988, the *Art Bulletin* published her essay, "Coming of Age: Historical Scholarship in American Art." She is completing a book on cultural nationalism in early American modernism.

Charles Dempsey is professor and chairman of the history of art department at Johns Hopkins University, and he was the first director of the Charles S. Singleton Center for Italian studies at the Villa Spelman in Florence. The author of *Annibale Carracci and the Beginnings of Baroque Style* (1977), he has written numerous studies of the paintings of the Carracci and their Bolognese predecessors and followers, as well as of many other Italian painters of the fifteenth through the seventeenth centuries. His present research is devoted to the Carracci and their followers, problems of art historiography and criticism, and to the figures of Botticelli and Poussin.

Richard A. Etlin is the author of *The Architecture of Death: The Transformation of the Cemetery in Eighteenth-Century Paris* (1984) and *Modernism in Italian Architecture, 1890–1940* (1991). Currently he is completing a book with the working title "Le Corbusier and Frank Lloyd Wright: The Romantic Legacy" and is preparing a book-length study on the subject of Angiolo Mazzoni and the politics of style in Fascist Italy. He is professor at the School of Architecture, University of Maryland, and a fellow of the American Academy in Rome.

An authority on French sculpture, **June Hargrove** recently published *The Statues of Paris, an Open-air Pantheon: The History of Statues of Famous Men* (1989). She served as the American commissioner and coauthor of the catalogue for the official exhibition *Liberty, the French-American Statue in Art and History* (1986). Professor of European nineteenth-century art at the University of Maryland, she has concentrated in her research on the relationship of art to politics and philosophy.

Barbara Miller Lane is Andrew W. Mellon Professor in the Humanities at Bryn

Mawr College and recently was a fellow at the Wissenschaftskolleg zu Berlin. Her research interests focus on the relationships among architecture, political thought, and urban form. Publications include essays on Albert Speer, government buildings in relation to the cityscape, the Berlin Congress Hall of 1955–1957, and Nazi ideology. Among her books is *Architecture and Politics in Germany, 1918–1945* (1968, 1985). She is working on a study of the history of national romanticism in Germany and the Scandinavian countries.

Renate Prochno has been researching and teaching the subject of British and American painting of the eighteenth and nineteenth centuries and is the author of the monograph *Joshua Reynolds* (1990). *

Now assistant professor at the University of Munich, she has studied at Münster, Munich, and London and has held a J. Paul Getty Postdoctoral Fellowship at Johns Hopkins University.

Nancy J. Troy teaches at Northwestern University, where she is associate professor and chair of art history. Author of *The De Stijl Environment* (1983) as well as numerous articles on twentieth-century Dutch art and architecture, she also specializes in modern French painting, architecture, and design, and recently published *Modernism and the Decorative Arts in France: Art Nouveau to Le Corbusier* (1991). Her current project, "Couture and Culture," focuses on Paul Poiret and the marketing of modern art in pre–World War I Paris.